HAMILTON

HAMILTON

PORTRAITS OF
THE REVOLUTION

JOSH LEHRER

FOREWORD BY LIN-MANUEL MIRANDA
PREFACE BY THOMAS KAIL

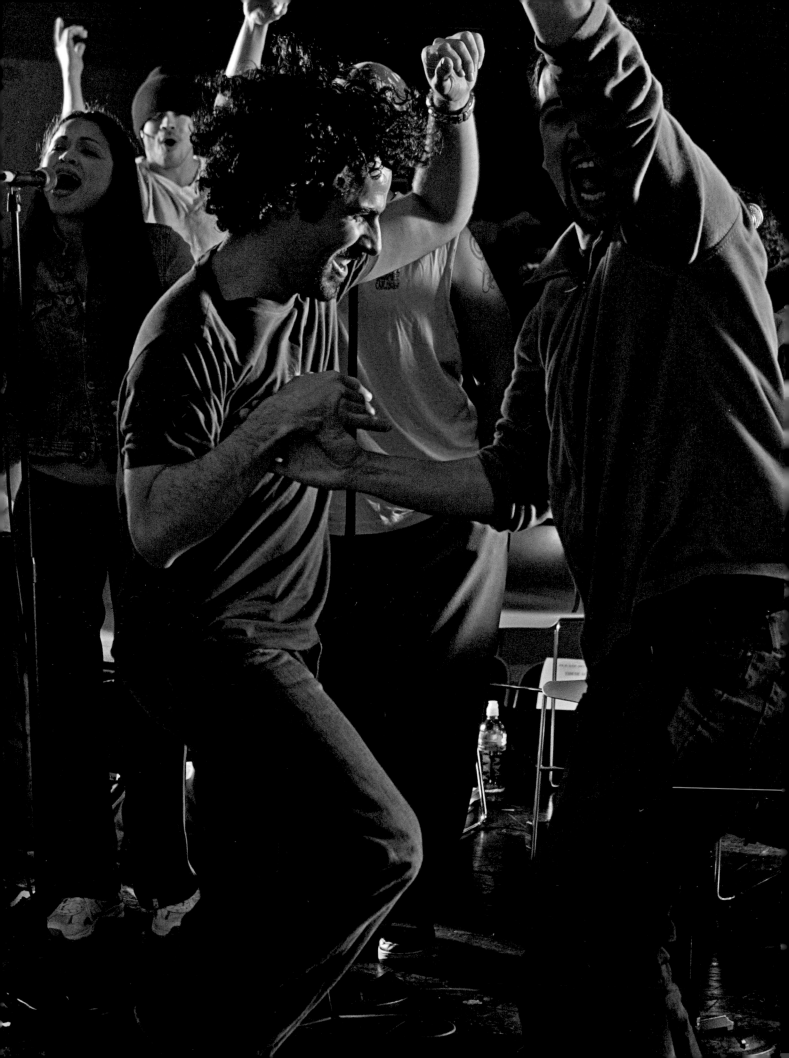

FOREWORD

—

LIN-MANUEL MIRANDA

Elizabeth Schuyler Hamilton was still alive when the Petzval lens was invented in the 1840s.

A little less than 200 years later, we reached out to Josh.

"I want to shoot some portraits of you and the cast. But this time it's different."

Indeed, I've known Josh Lehrer since my Broadway debut, *In the Heights*, where he documented the entire process through a series of unforgettable photographs. There is one in particular I'll never forget, from our Off-Broadway sitzprobe, the first time the cast sang with their orchestra, and my first time as a composer I'd heard my score as it was meant to be played. As we reached the climax of "96,000," an exuberant number where the neighborhood of Washington Heights celebrates one of their own winning the lottery, my brilliant musical director, Alex Lacamoire, was so inspired that he stopped conducting and began dancing with the cast. Josh's picture captures the moment perfectly: when a cast becomes a family, when a song becomes a block party, when a musical truly soars for the first time in its young life.

So my answer was yes, even though I had no idea what a Petzval lens was. I trust Josh and I love his work.

To even sit for these portraits is to be transported to another time. It's an extremely slow exposure (no high-speed sitzprobe shots for the Petzval, thanks very much). But in sitting for the portrait — or more accurately, standing — you find yourself feeling connected to the subjects at the dawn of photography — where in holding still, a deeper truth is revealed. Just as we endeavored to eliminate any distance between this story from the past in the present with *Hamilton*, so too do Josh's portraits connect this gorgeous, diverse cast with another era.

A little less than 200 years from now, these portraits will remain.

Thank you, Josh Lehrer.

PREFACE

—

THOMAS KAIL

The beauty – and the challenge – of theater is trying to create a series of moments that happen just that once, and then possibly never again. And then to repeat them over and over during the course of a run, as if for the first time.

So there is repeated motion from one show to the next, as well as dialogue, lyrics, or notes that will be repeated. But of course they are never exactly the same.

In theater, you either were there to witness, or you just heard about it. It existed and then it was gone. So how do you capture these moments? Can you? We try. Every Broadway show, at some point before it opens, will have a photo call. A photo call for a show often occurs during a specific time set aside for a photographer to shoot while the cast is performing a full run-through.

On occasion, you will just run a few musical numbers or scenes while a photographer clicks away. This can certainly yield dynamic moments. It can give the viewer of the images a sense of what and who will be on stage. It serves an important purpose.

Josh Lehrer endeavors to achieve something else in the contents of this book. Josh has spent a tremendous amount of time and energy over the last few years trying to capture something even more ephemeral: the intersection of the performer and the character in a single portrait.

Josh has accomplished this extraordinary goal with clarity, elegance, and timelessness. He captures these images in a setting outside of the content of the show, allowing an existence to appear that we might never see in the show itself, which is a double gift. He lets our actors – and their characters – live outside of the world we, and they, know them in. It is a rare thing he is sharing with the world.

In casting *Hamilton*, our creative team has worked hard to find talented humans who possess essential qualities that sync up with those of their character's. Each cast member is asked to bring themselves to their role – both in spirit and physicality. Working with a camera lens from the 1840s, Josh has made pictures that are, in fact, portals. These portals allow you to glimpse the external and the internal in a single frame.

Thank you to each of the actors who stood for Josh. Thank you to Josh for standing with them – and creating a safe space for them to reveal and be celebrated, in this way.

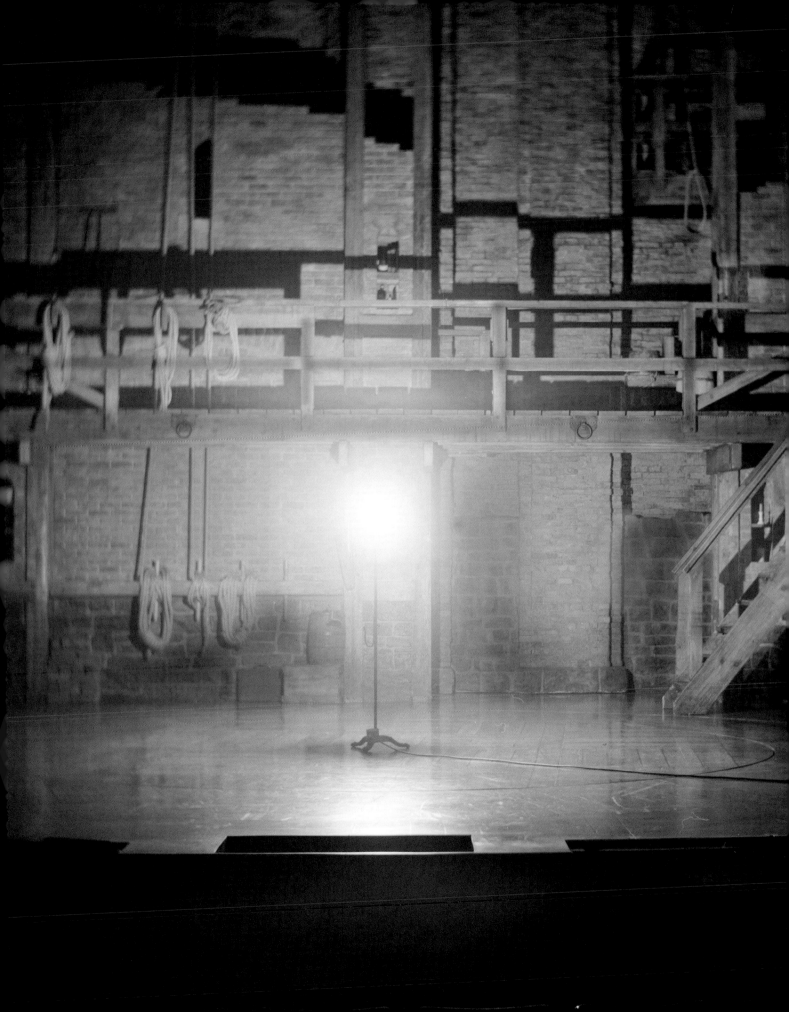

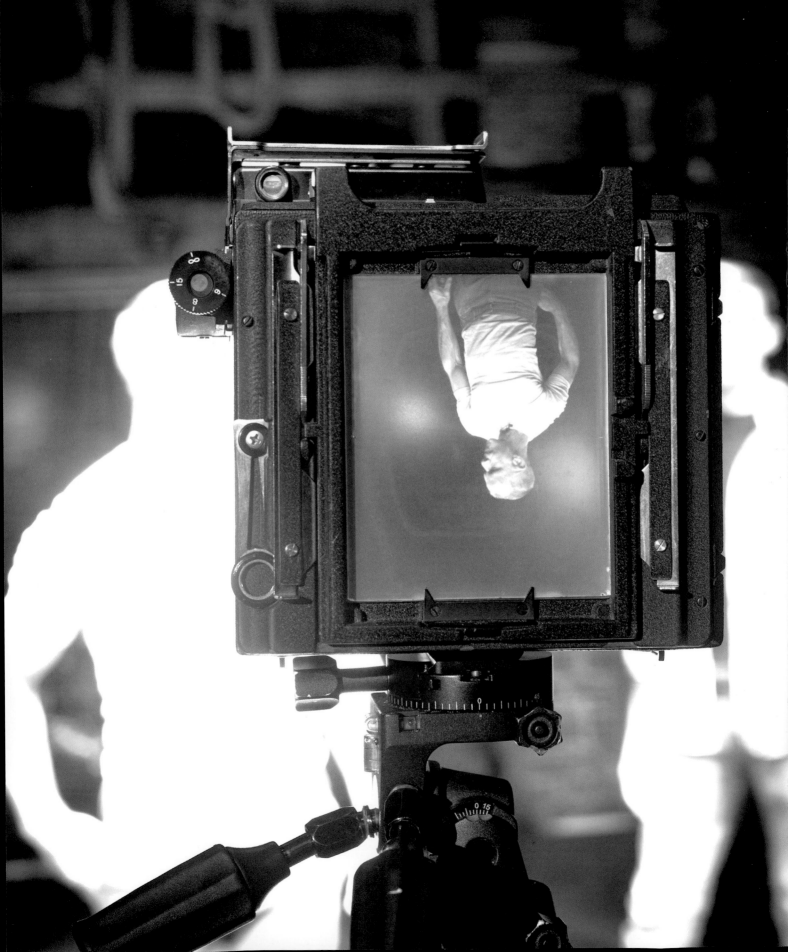

INTRODUCTION

—

JOSH LEHRER

It's foolish to think you could ever truly document the creation of something. Creation comes from inspiration, hope, collaboration, surrender, and the courage found deep within the creator's heart, gut, and mind. When I began to document the creation of *Hamilton*, I wondered how I could possibly photograph the creative part of a person if I couldn't see it. By that time I had been friends with its creators, Lin-Manuel Miranda, Tommy Kail, and Andy Blankenbuehler since 2007, when I documented their first show, *In the Heights*.

Everyone knew that something special was happening with *Hamilton*. It forces audiences to see the nation's development and the world from an unexpected, even subversive, perspective. I wanted to use a camera that could somehow reflect that unique perspective.

In 2008 I began to work on a series of photographs of homeless trans teenagers called *Becoming Visible*. There was such an historic depth to these young people and their experiences that I wanted to use an older photographic technique to express it. I intuitively knew that the mechanics of an antique camera would slow my pace and demand that I spend more time capturing the vulnerability that our mutual trust allowed. But I needed hands-on expertise so I enrolled in an antique lens class taught Geoffrey Berliner at the Penumbra Foundation.

Geoffrey gave me a 1944 Speed Graflex camera, retro-fitted with an 1840 Petzval lens, the first photographic lens specifically designed for portraiture. The camera is cumbersome. To use it, I had to mount it onto a heavy tripod, duck beneath a black cloth, focus it with a magnifying glass, load sheet film, and make lots of mistakes.

For *Hamilton*, which looked both backward and forward by using a traditional form by using a traditional form (musical theater) in a ground breaking way, I returned to my antique equipment and scheduled a series of formal portraits. These portraits were difficult to take: when I looked at each image on the ground glass at the back of my camera through a magnifying glass, it was both reversed and upside down; I had to scramble my brain yet be fully present in order to compose each image.

People tell me that they know every lyric and every note of *Hamilton*. They now have the chance discover many of the brave, vulnerable, desperate, determined, and beautiful faces of the talented people who embody those words and voices. And to stop time for a moment to see how they wore their splendid costumes on that surprisingly nuanced set.

There is cumulative value in finding stillness while the world turns upside down.

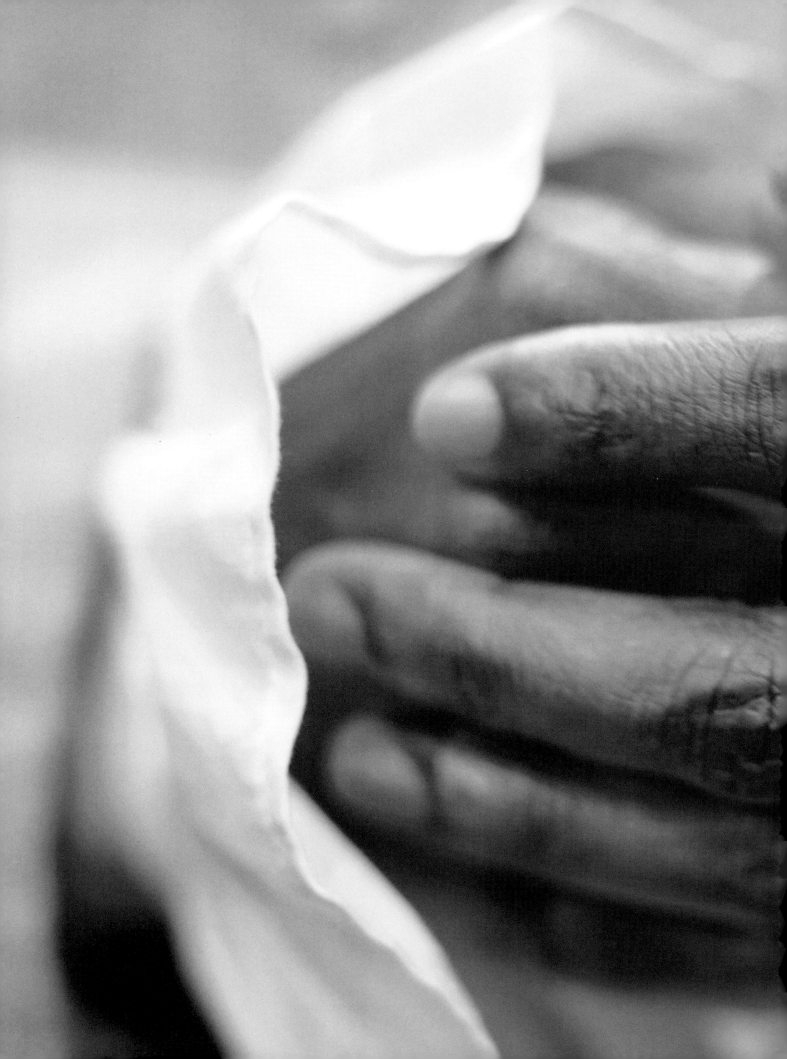

MORE THAN ANYTHING ELSE, "HAMILTON"
GAVE ME THE CHANCE TO SEE THE
FOUNDING FATHERS AS YOUNG MEN
OF ACTION, AS MEN OF DARING, VALOR,
AND COURAGE. IT'S A REMINDER OF JUST
HOW RADICAL THEY WERE. IT'S AS MUCH
IN WHAT LIN WROTE INTO EVERY LINE
AS IT IS IN THE ACTORS' FACES. SEEING
THEM IN FULL COLOR MAKES THE
CHARACTERS FEEL FRESH AND YOUNG.

—
JL

KEENAN WASHINGTON — *Ensemble*

TOUR

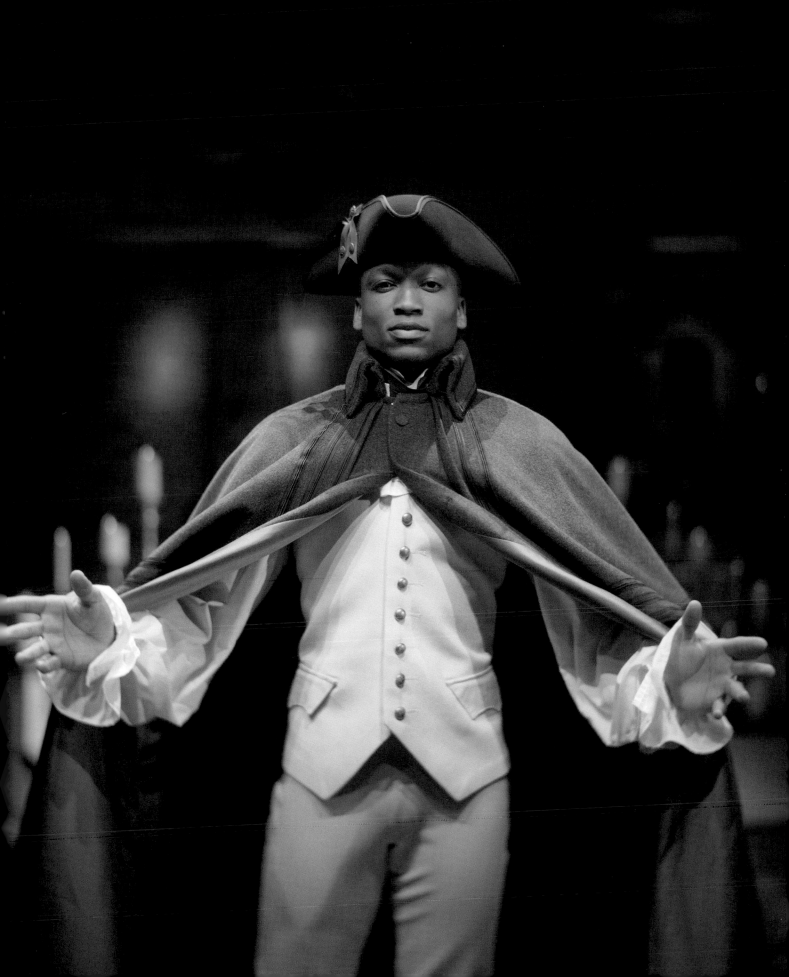

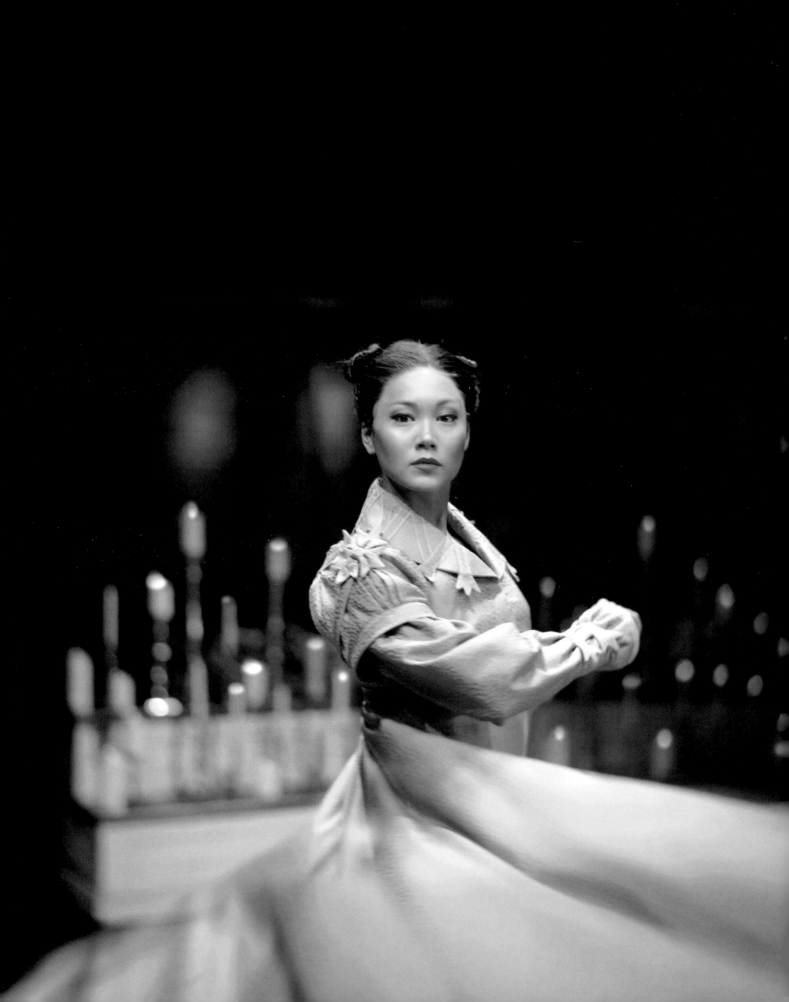

SABRINA IMAMURA — *Ensemble*

BROADWAY

MALLORY MICHAELLANN — *Ensemble*

CHICAGO

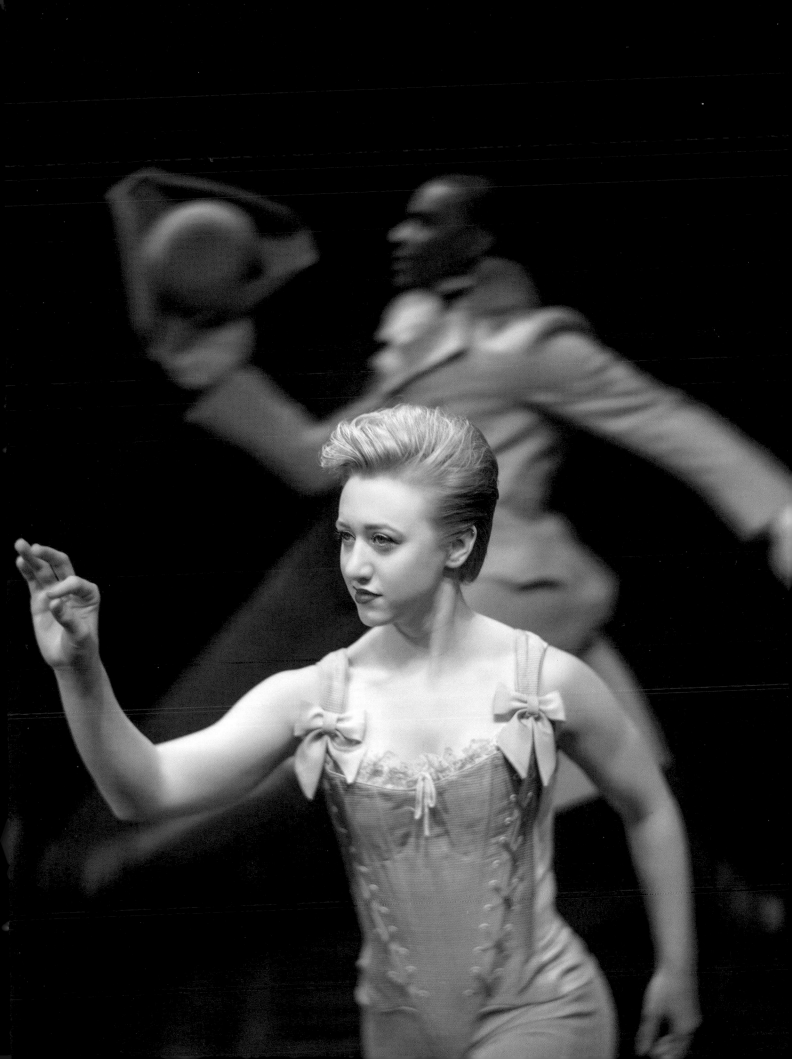

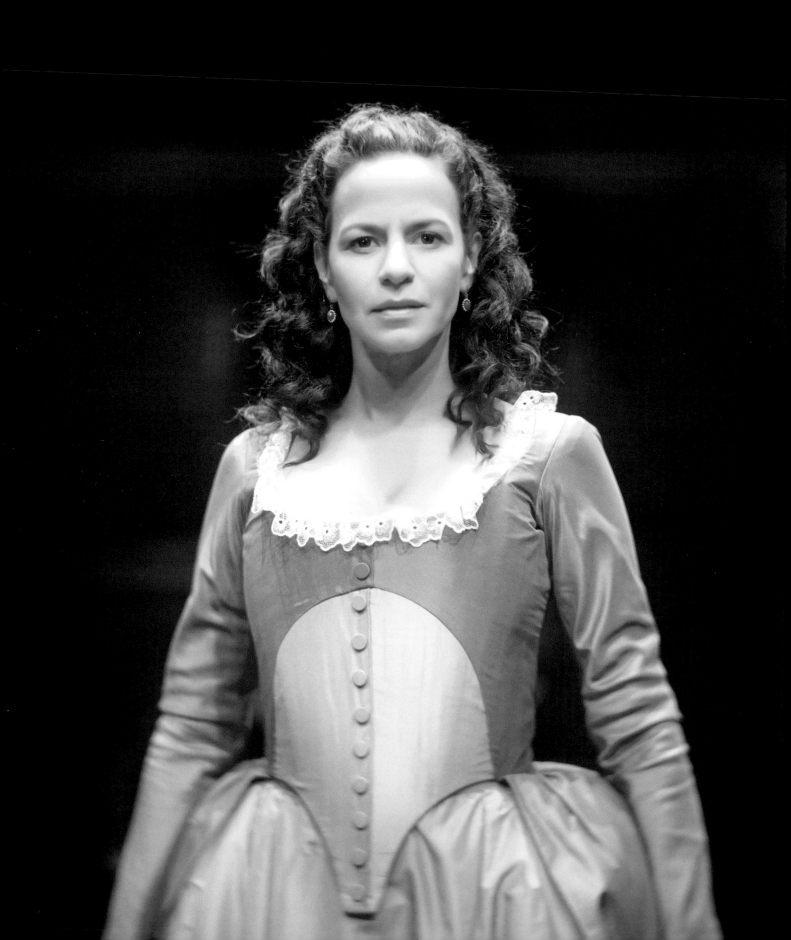

Angelica Schuyler, circa 1800 by Samuel Shelley

MANDY GONZALEZ – *Angelica Schuyler*

BROADWAY

KAREN OLIVO AND MANDY GONZALEZ
HAD DIFFERENT TAKES ON HOW THEY
PLAYED ANGELICA. I'D FIRST MET THEM
BOTH WHEN THEY WERE YOUNG ACTORS
IN "IN THE HEIGHTS". BOTH HAD BECOME
RICHER PERFORMERS. I WAS PARTICULARLY
STRUCK WITH HOW GROWN-UP THEY
SEEMED IN THE ROLE. JUST LIKE ANGELICA,
THEY KNEW THE JOB THEY HAD TO DO
AND, EVEN WHEN IT WAS NOT DONE
GLADLY, IT WAS DONE WITH INTEGRITY.

—
JL

KAREN OLIVO — *Angelica Schuyler*

CHICAGO

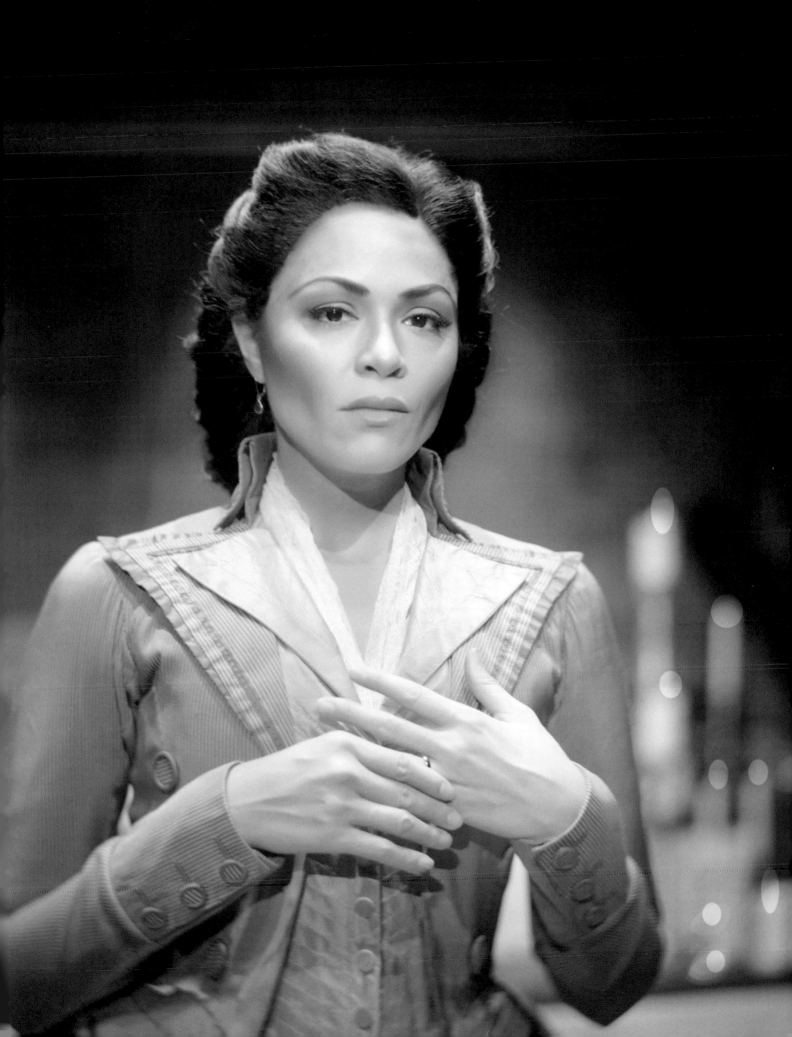

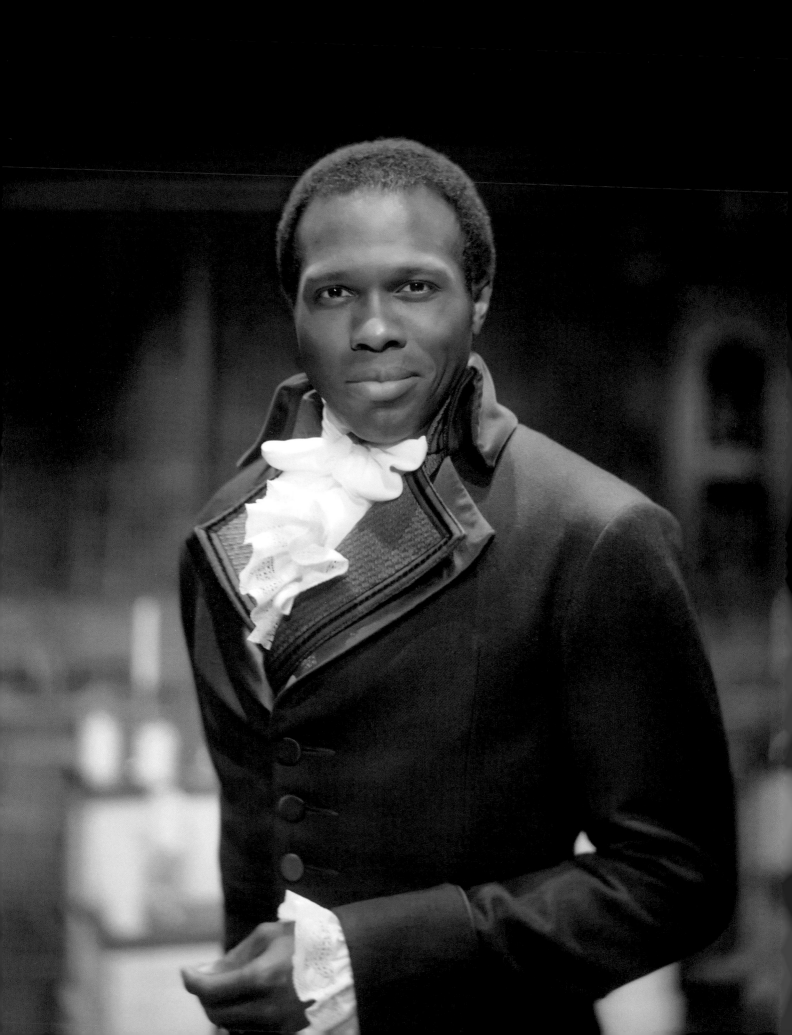

JOSHUA HENRY — *Aaron Burr*

TOUR

MICHAEL LUWOYE — *Alexander Hamilton*

BROADWAY

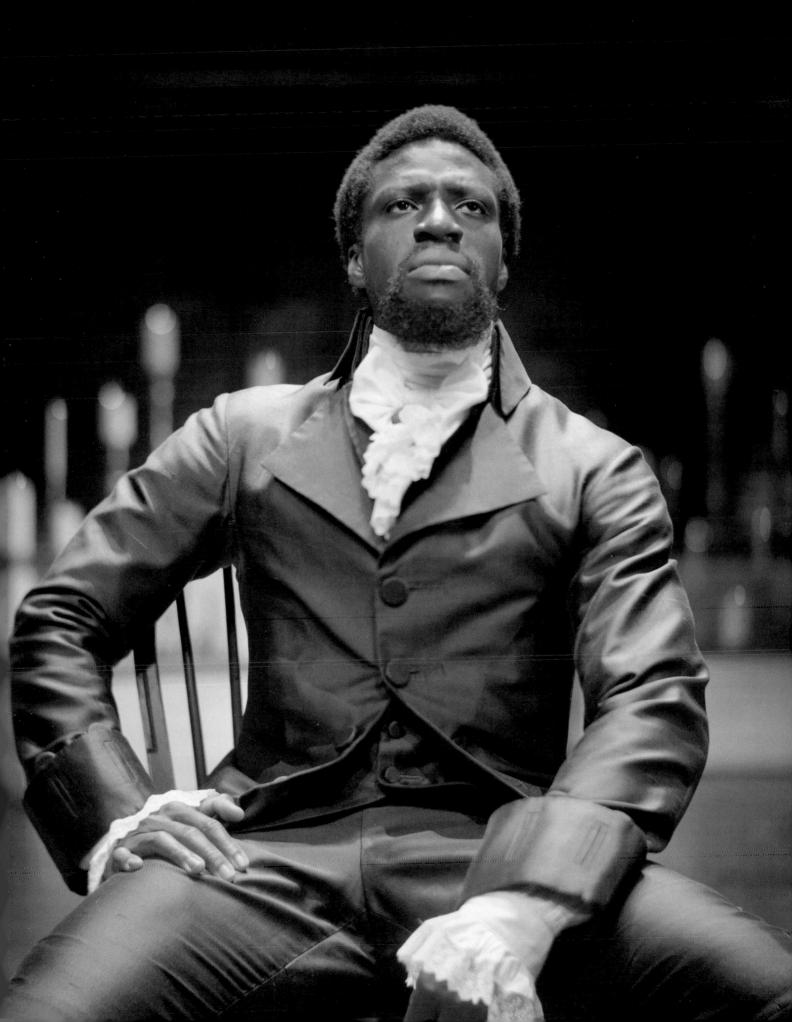

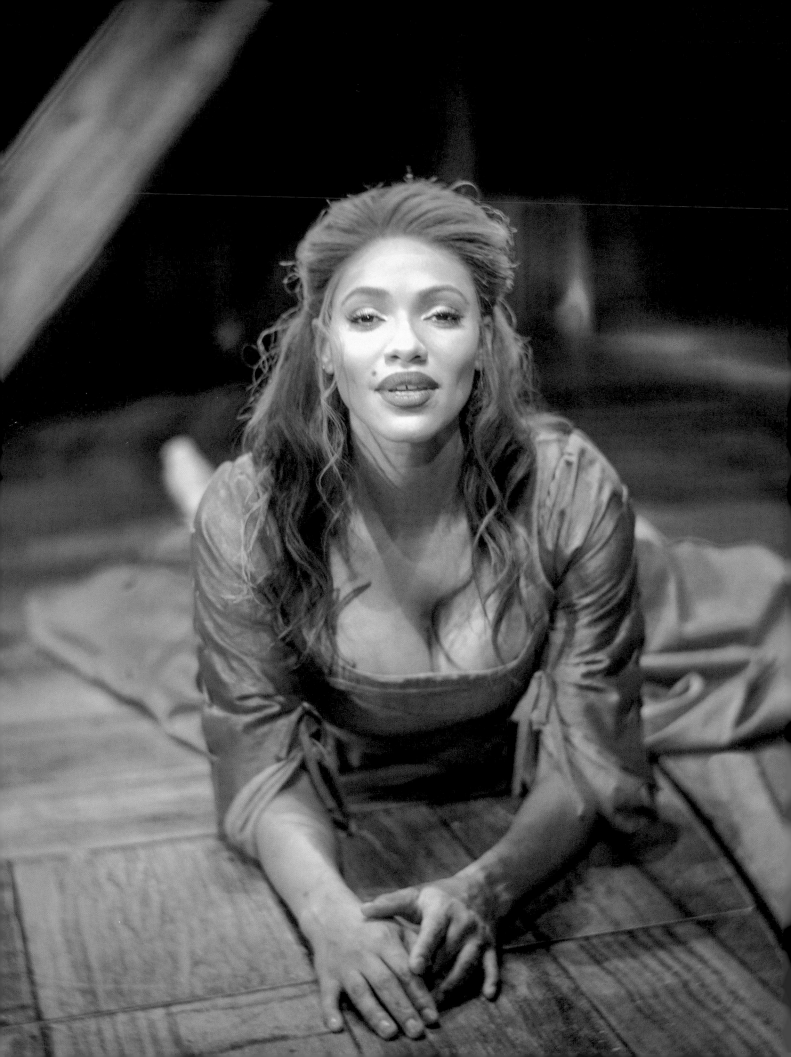

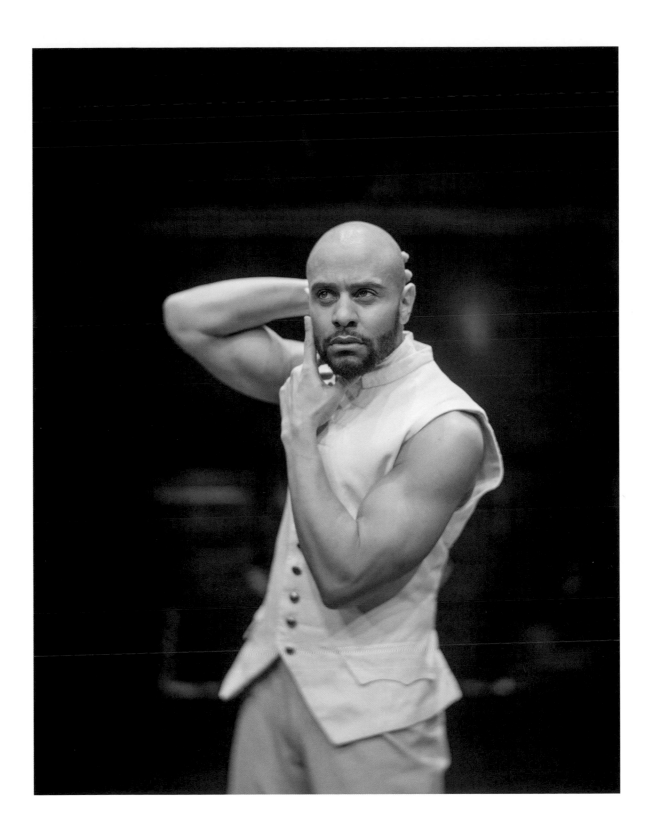

AUBIN WISE – *Maria Reynolds*

CHICAGO

TERRANCE SPENCER – *Ensemble*

BROADWAY

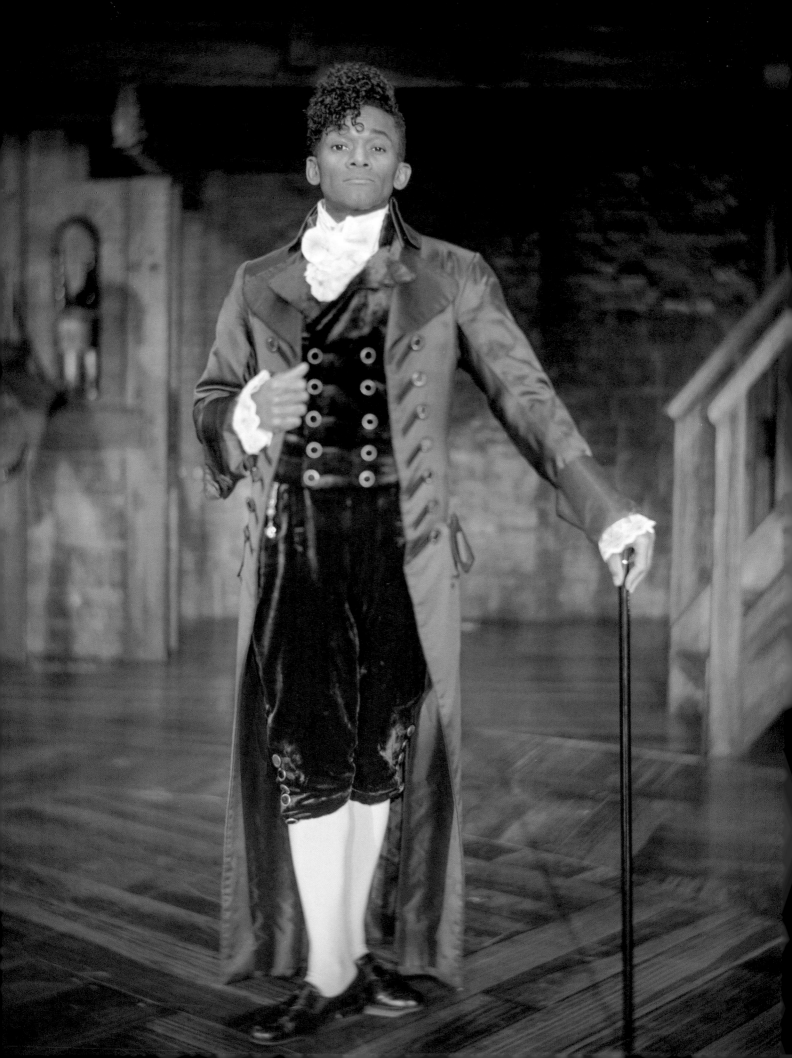

JASON PENNYCOOKE – *Marquis de Lafayette*

LONDON

SOLEA PFEIFFER — *Eliza Hamilton*

TOUR

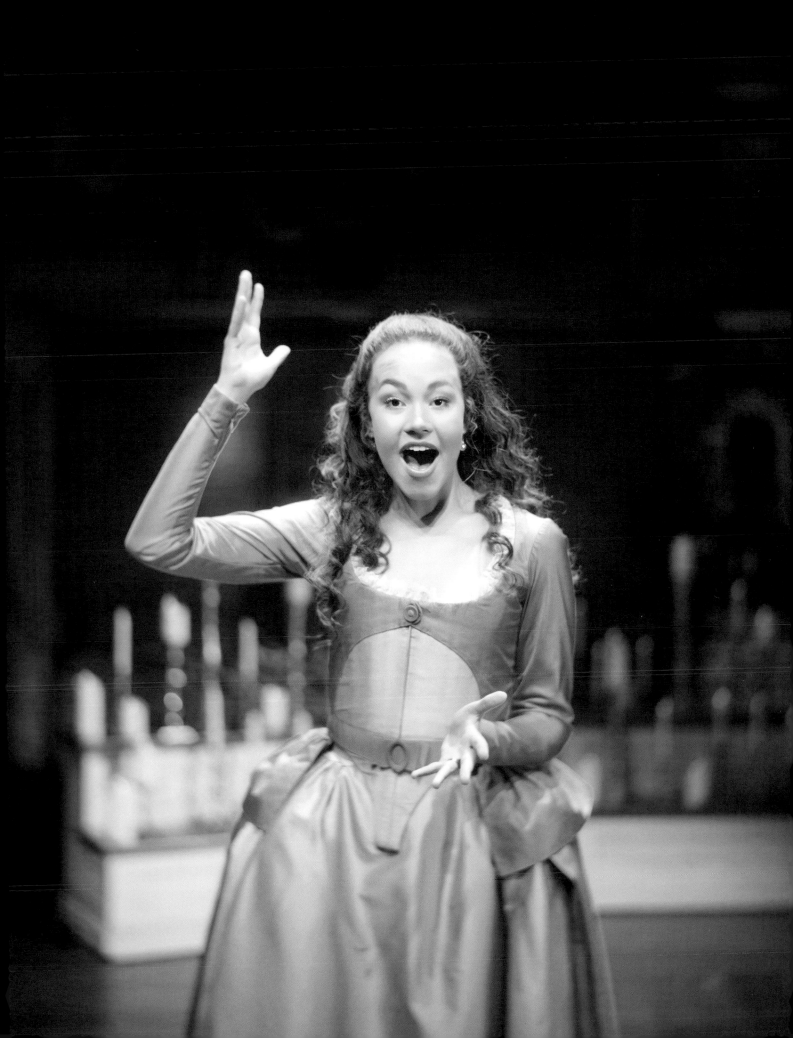

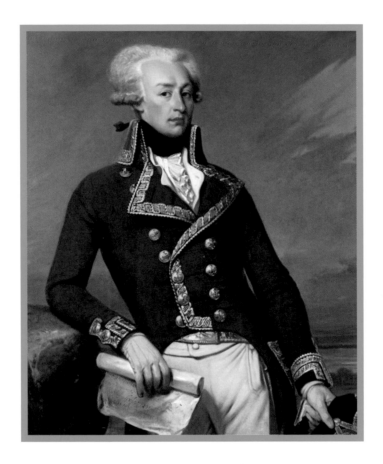

Marquis de Lafayette, 1834 by Joseph-Désiré Court

JAMES MONROE IGLEHART — *Marquis de Lafayette*

BROADWAY

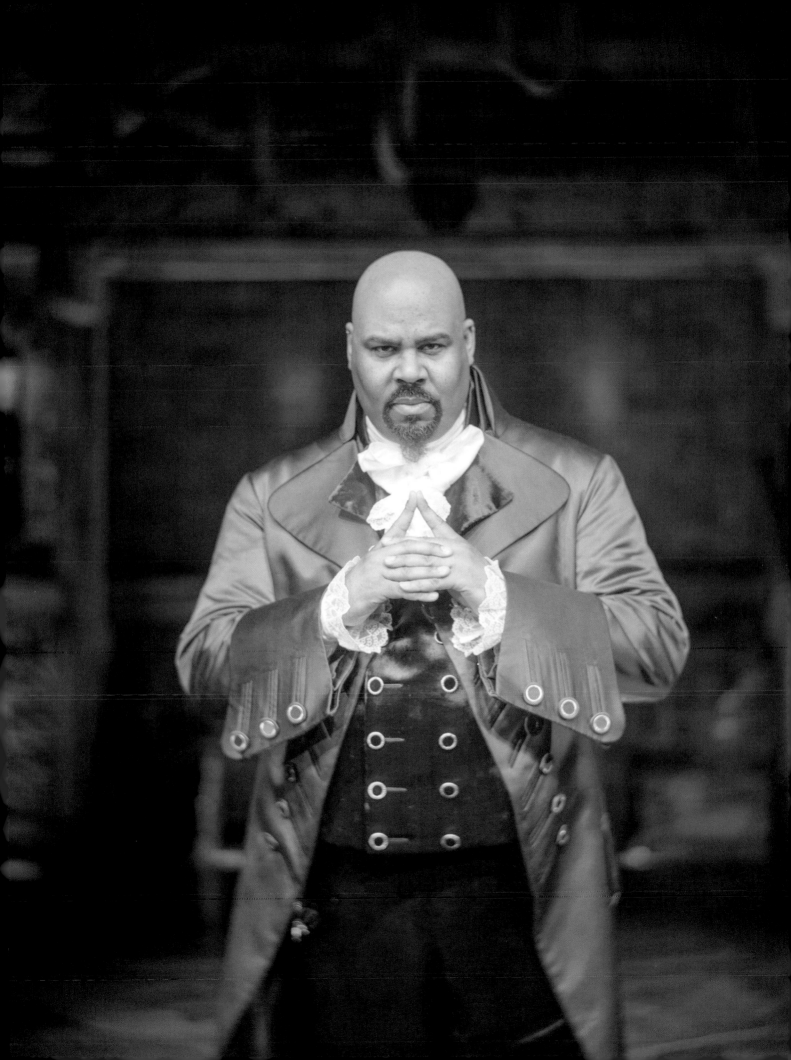

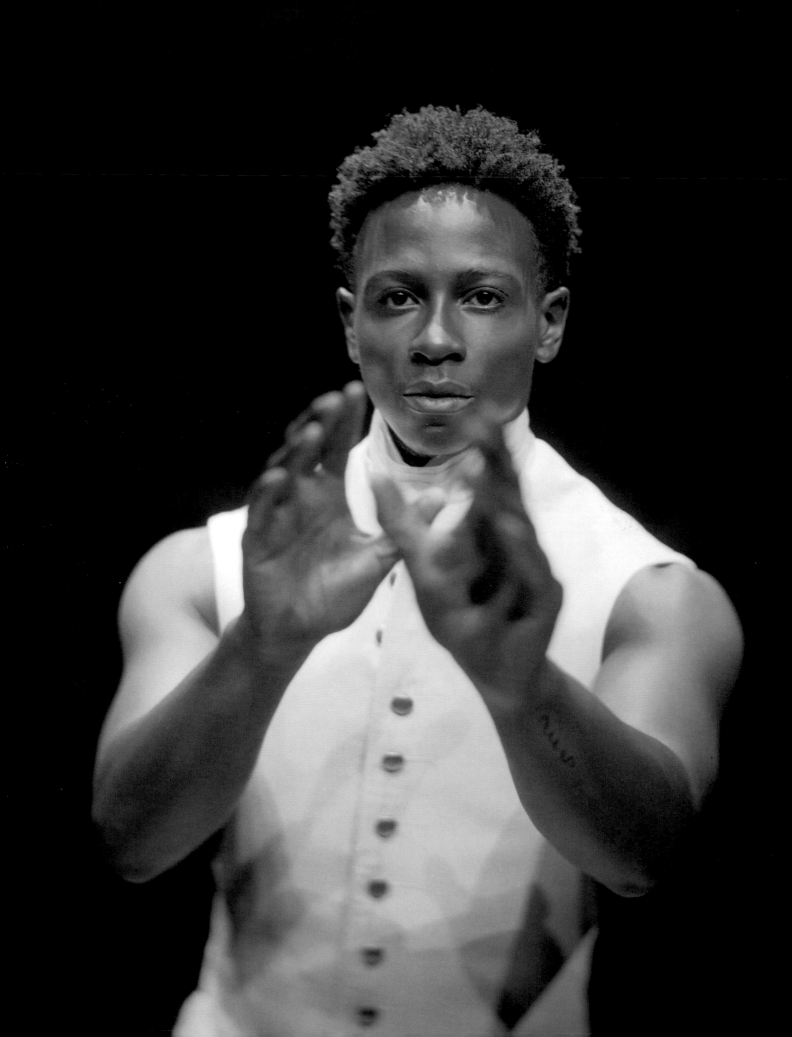

GREGORY HANEY — *Ensemble*

BROADWAY

AMBER IMAN – *Maria Reynolds*

TOUR

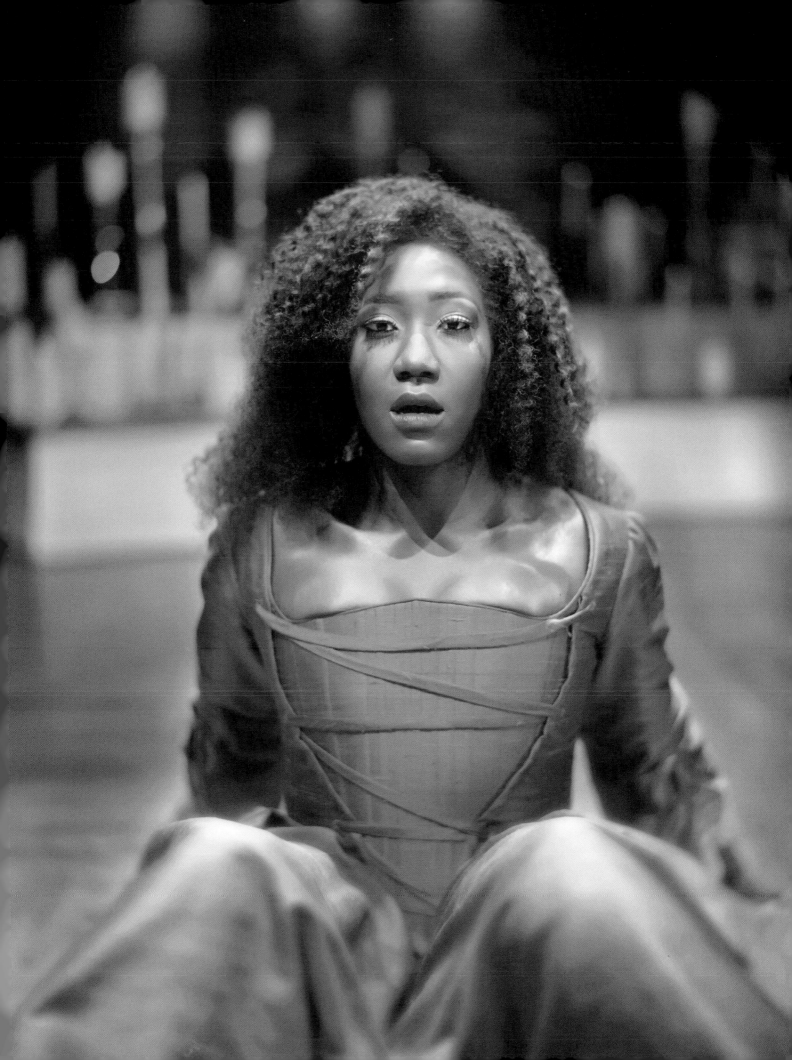

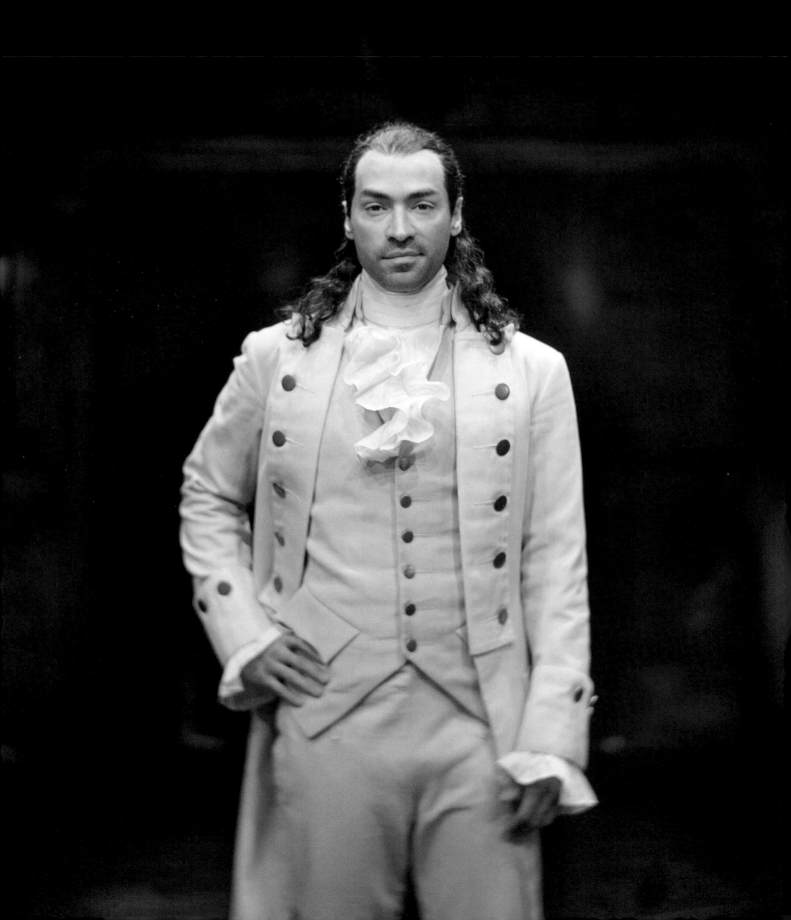

JEVON MCFERRIN — *Alexander Hamilton*

THIS PHOTO OF SAMANTHA MARIE WARE
IS PERHAPS MY FAVORITE. I DIDN'T
GIVE HER ANY DIRECTION AT ALL.
SHE KNEW WHERE THE LIGHT WAS,
AND POSED IN A VERY DIFFERENT WAY
THAN ALL THE OTHERS. IT ALL JUST
WORKED EFFORTLESSLY.

—
JL

SAMANTHA MARIE WARE — *Maria Reynolds*

CHICAGO

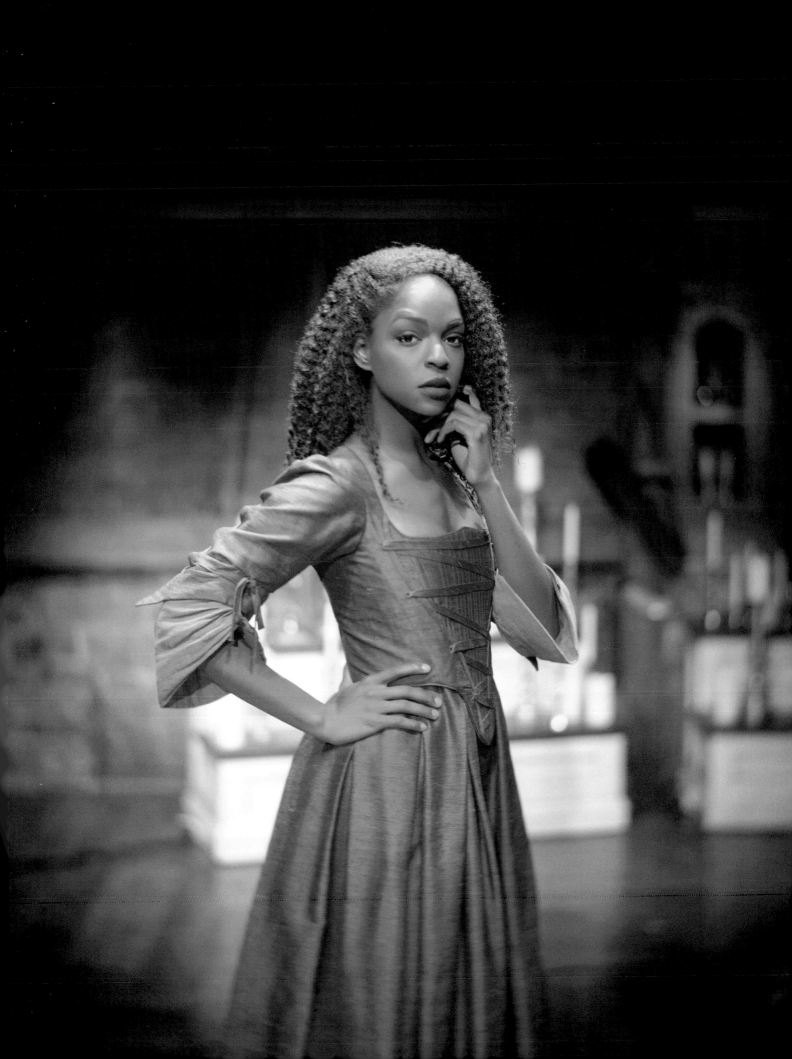

ROBERT WALTERS — *Ensemble*

BROADWAY

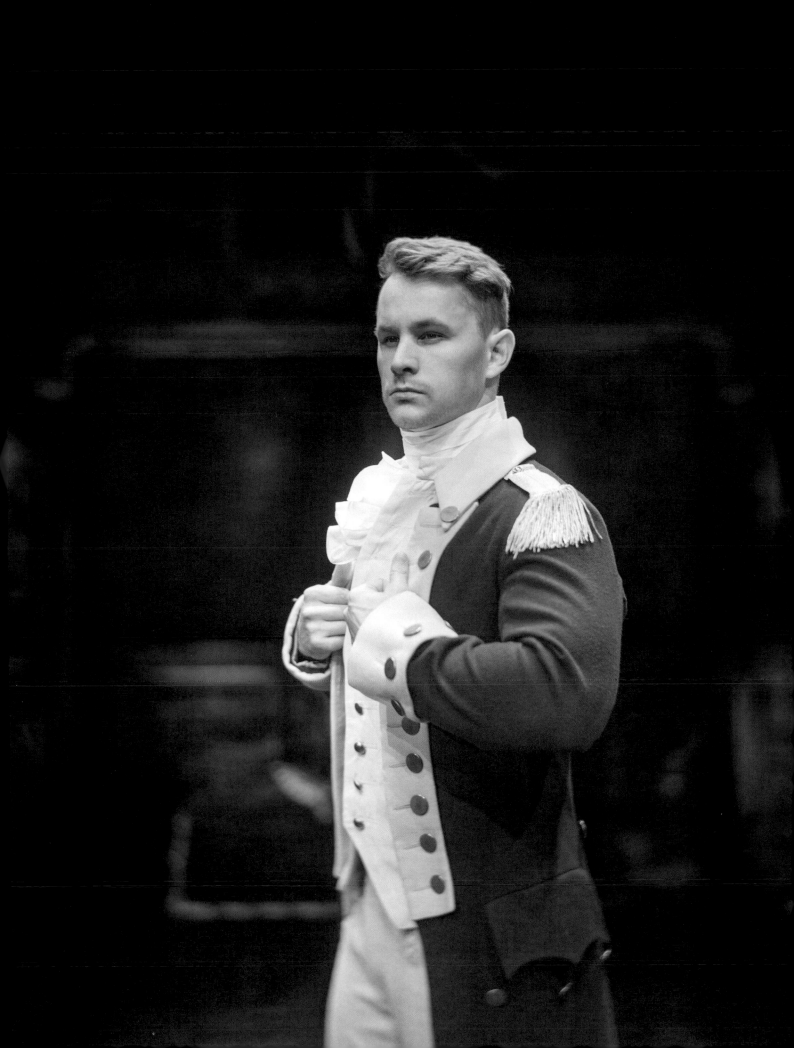

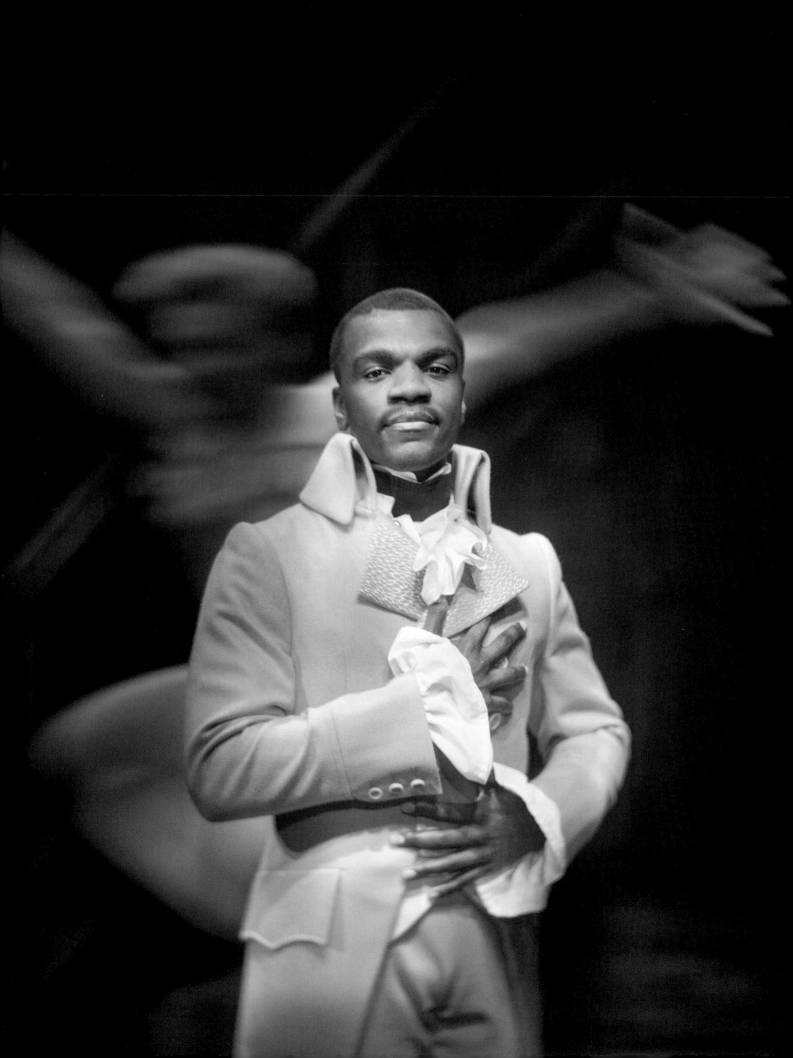

SHARROD, LIKE ALL OF THE ACTORS,
CAME ONTO THE STAGE EXPRESSING
GENUINE GRATITUDE FOR THE
OPPORTUNITY TO BE IN THE SHOW.
I FELT HONORED TO BE ABLE TO
MEMORIALIZE THE MOMENT.

—

JL

SHARROD WILLIAMS — *Ensemble*

CHICAGO

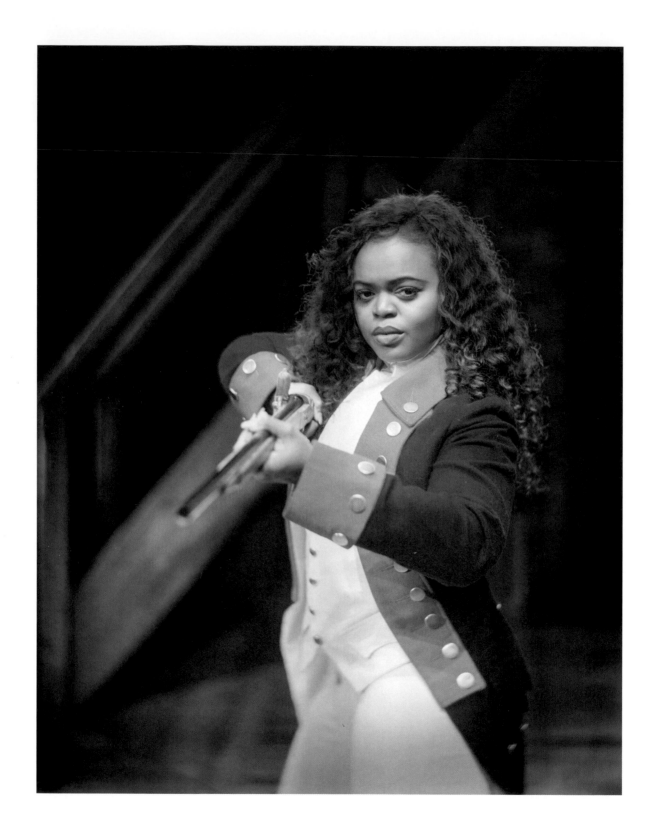

SANDRA OKUBOYEJO — *Ensemble*

CHICAGO

SETH STEWART — *Ensemble*

BROADWAY

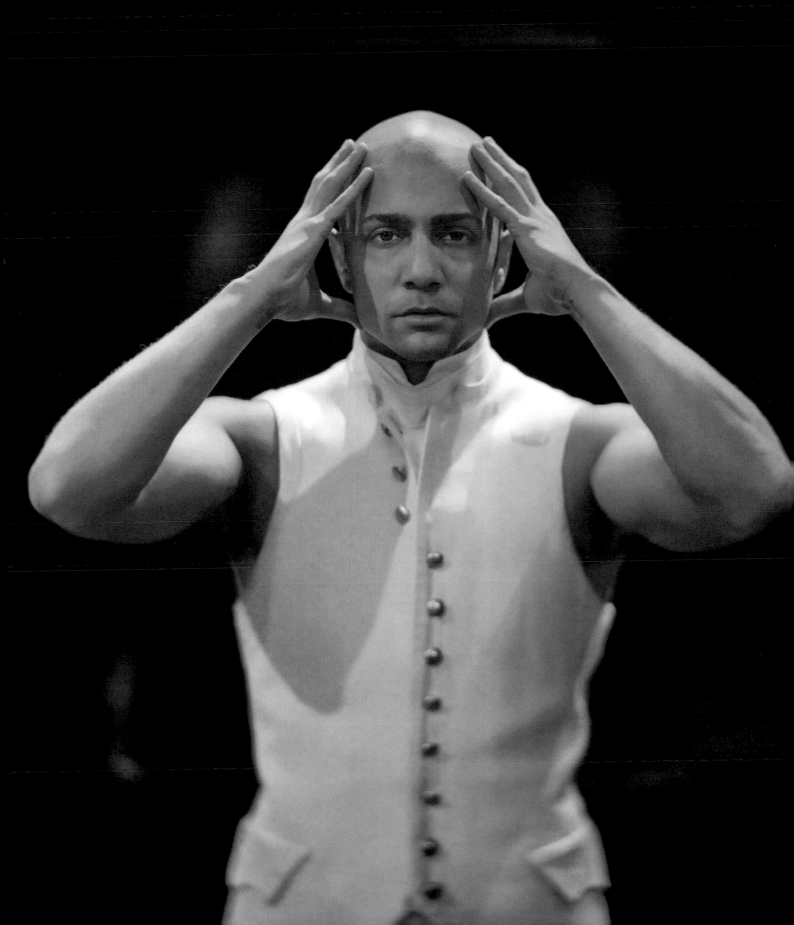

CARL CLEMONS-HOPKINS – *Aaron Burr*

CHICAGO

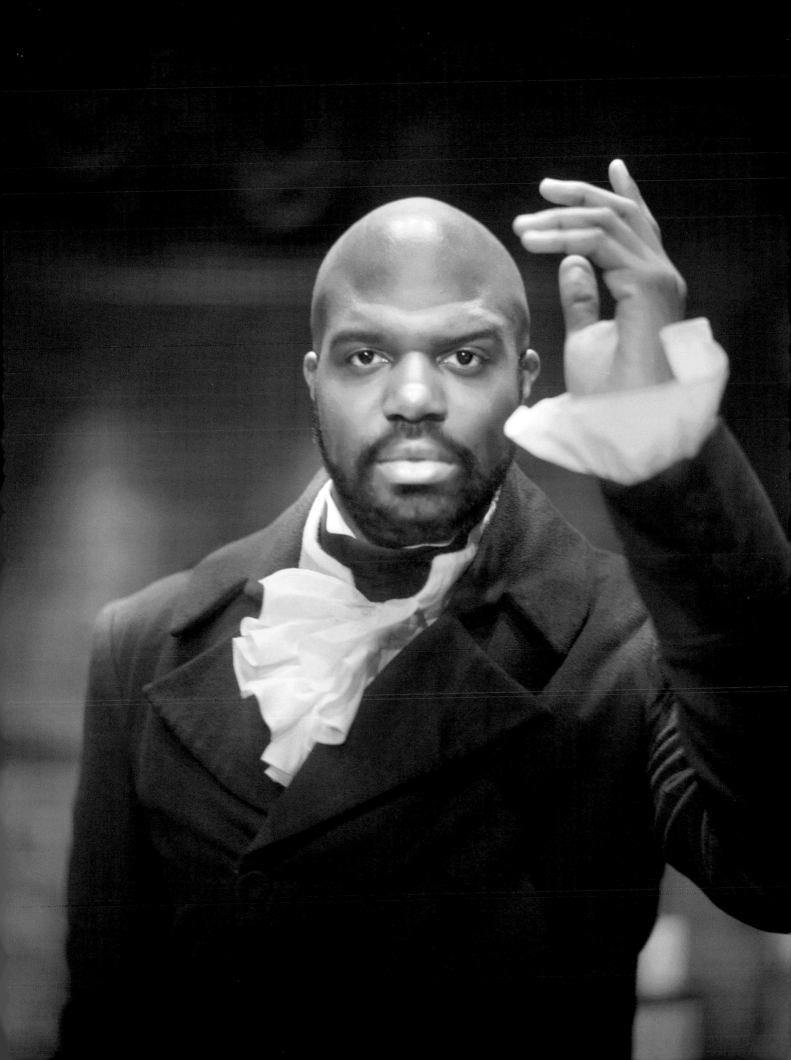

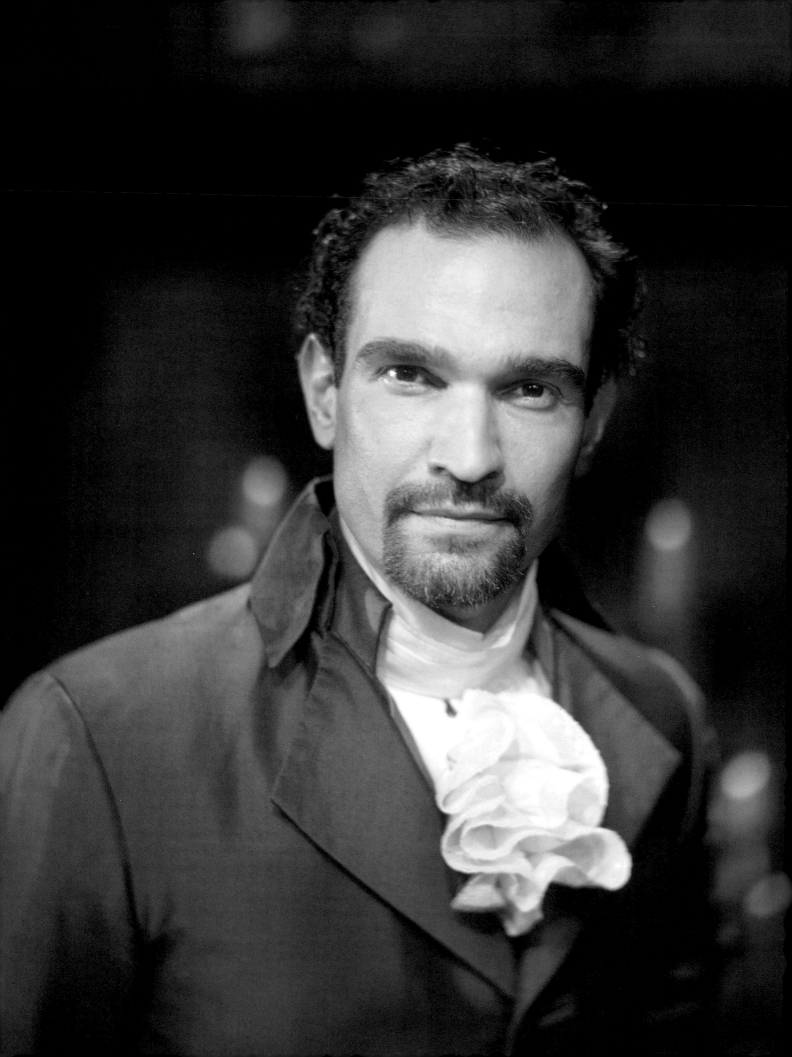

JAVIER WAS THE UNDERSTUDY FOR
LIN IN "IN THE HEIGHTS", AND PLAYED
THE ROLE OF HAMILTON ONE SHOW A
WEEK DURING LIN'S RUN. HE FOCUSED
HIS, AND THE AUDIENCE'S, ATTENTION
TO THE SUBTLETIES AND SUBTEXT OF
THE CHARACTER AND THE SHOW.
HIS OFFSTAGE ACTIVISM, ESPECIALLY
FOR HIV/AIDS, ADDS A DIMENSION TO
HIS ONSTAGE PERFORMANCE THAT IS
NON-PERFORMATIVE. IT'S JUST HIM.
WHO HE IS SPEAKS VOLUMES.

—
JL

JAVIER MUÑOZ — *Alexander Hamilton*

BROADWAY

JARED HOWELTON – *Thomas Jefferson*

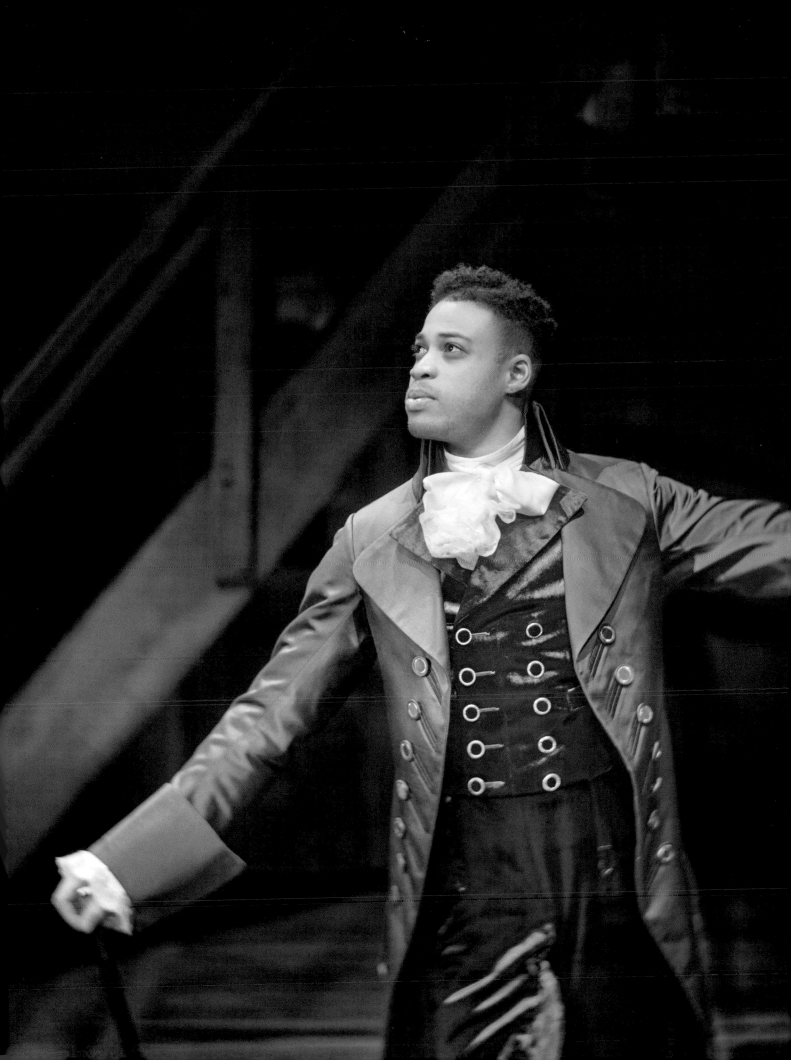

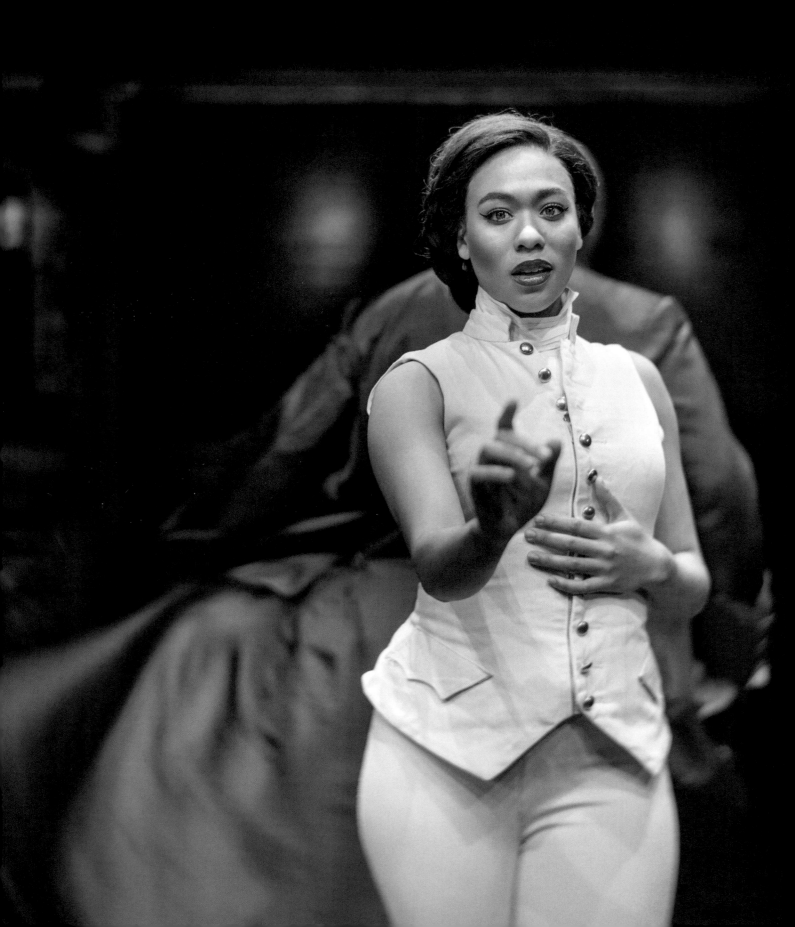

RAVEN THOMAS — *Ensemble*

BROADWAY

GABRIELLA SORRENTINO — *Ensemble*

BROADWAY

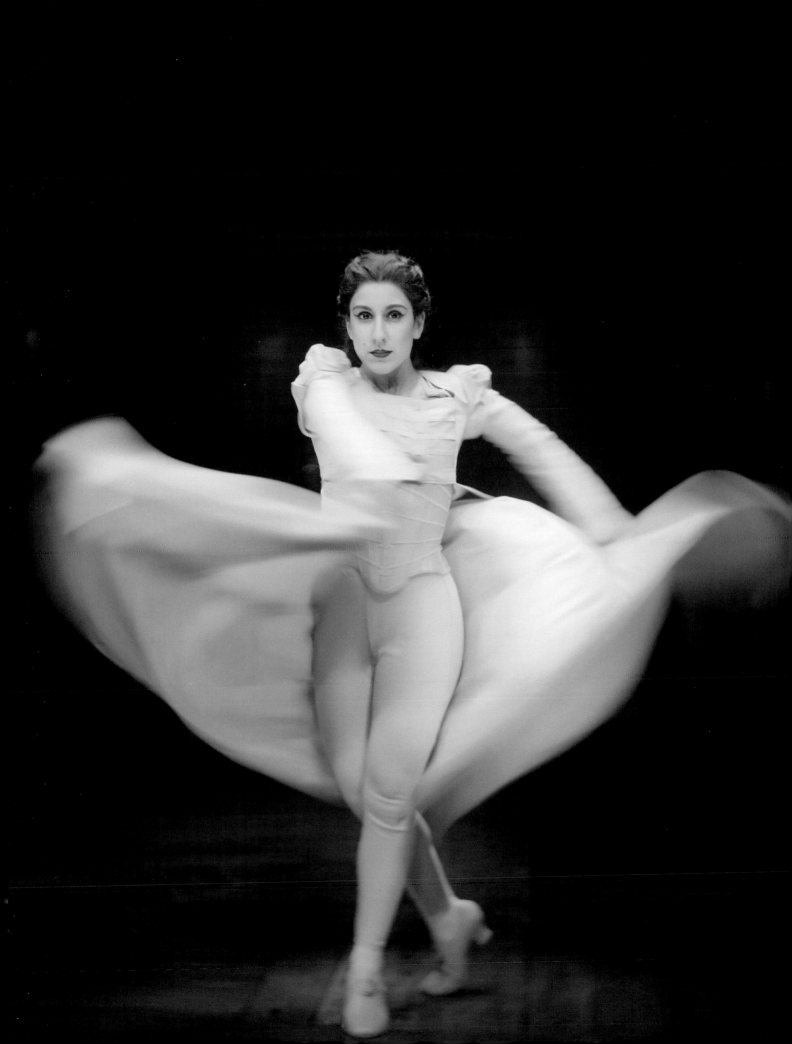

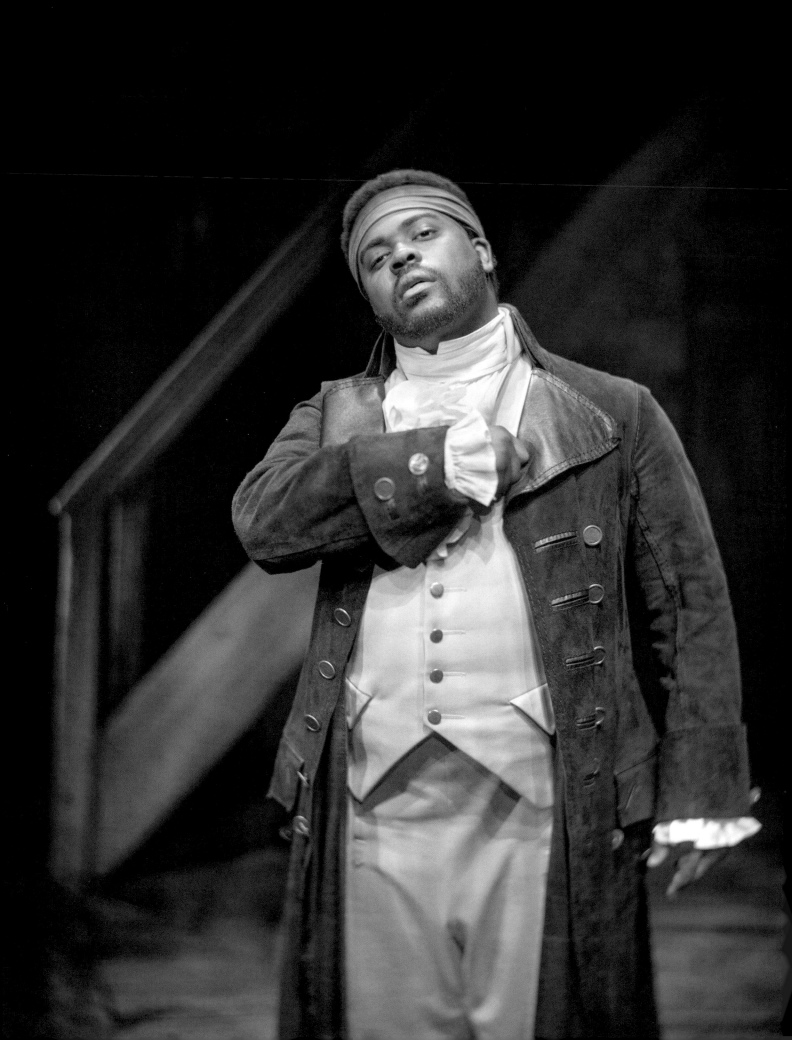

EBRIN STANLEY — *Hercules Mulligan*

CHICAGO

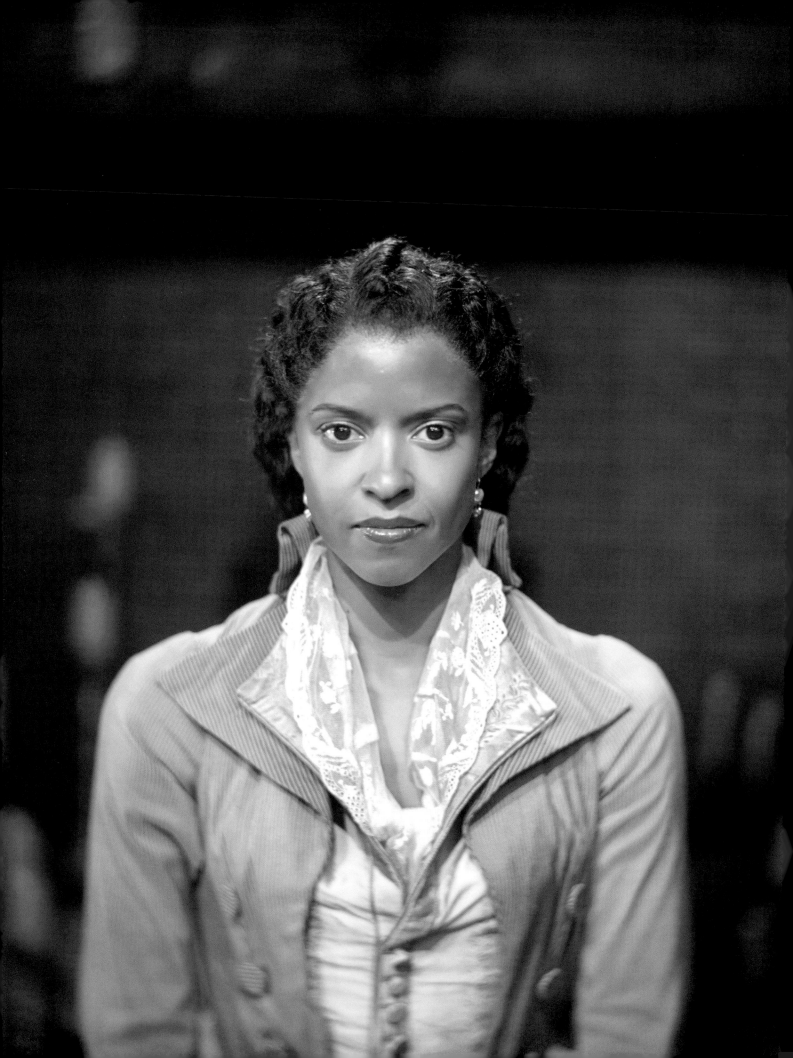

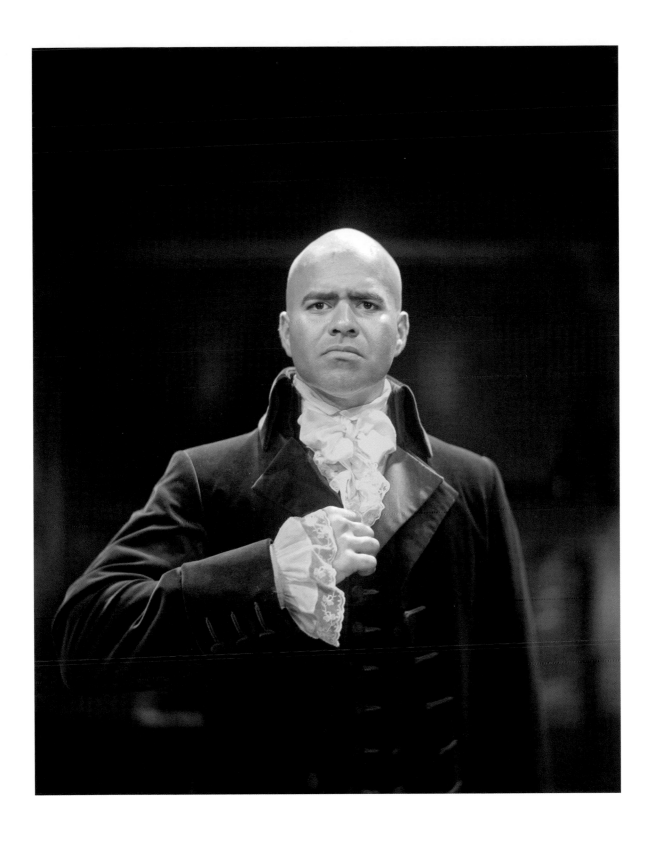

RENÉE ELISE GOLDSBERRY — *Angelica Schuyler*

BROADWAY

CHRISTOPHER JACKSON — *George Washington*

BROADWAY

DAVEED DIGGS — *Thomas Jefferson*

BROADWAY

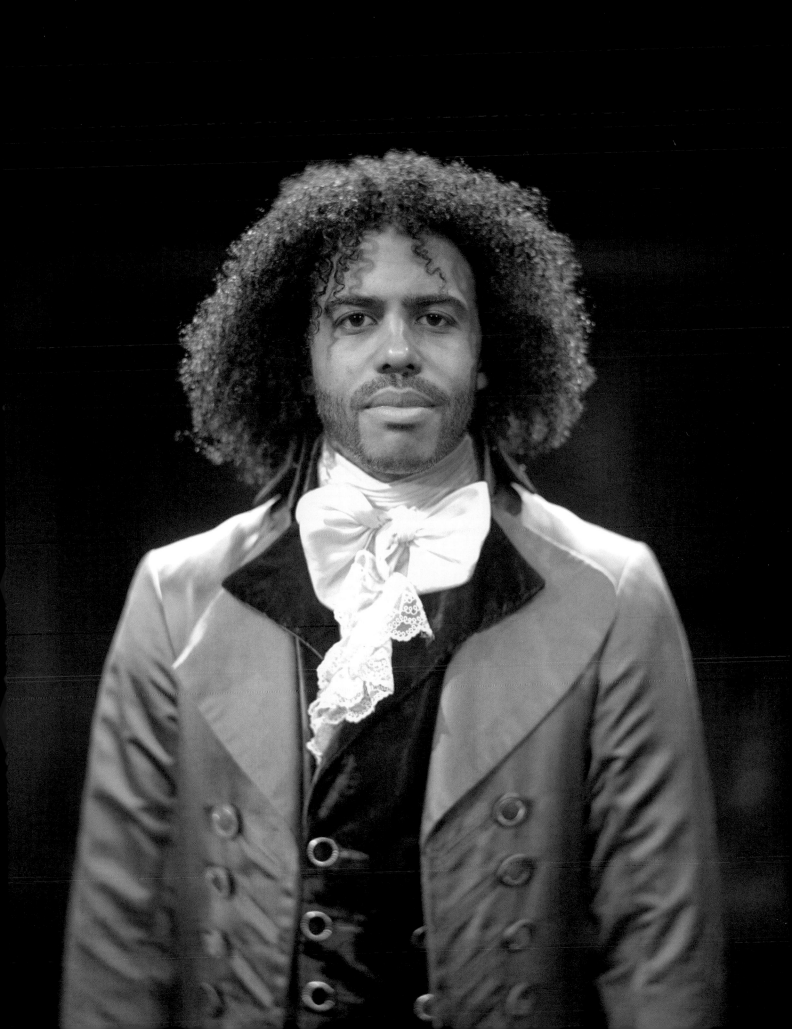

PHILLIPA HAS ONE OF THE CLEAREST
AND PUREST VOICES OF ANYONE I'VE
EVER HEARD ON A BROADWAY STAGE.
I WANTED TO MAKE SURE THAT HER
BRIGHTNESS TRANSFERRED ONTO FILM.
SHE STEPPED INTO THE BRIGHT LIGHT
AND GAVE IT TO ME.

—
JL

PHILLIPA SOO — *Eliza Hamilton*

BROADWAY

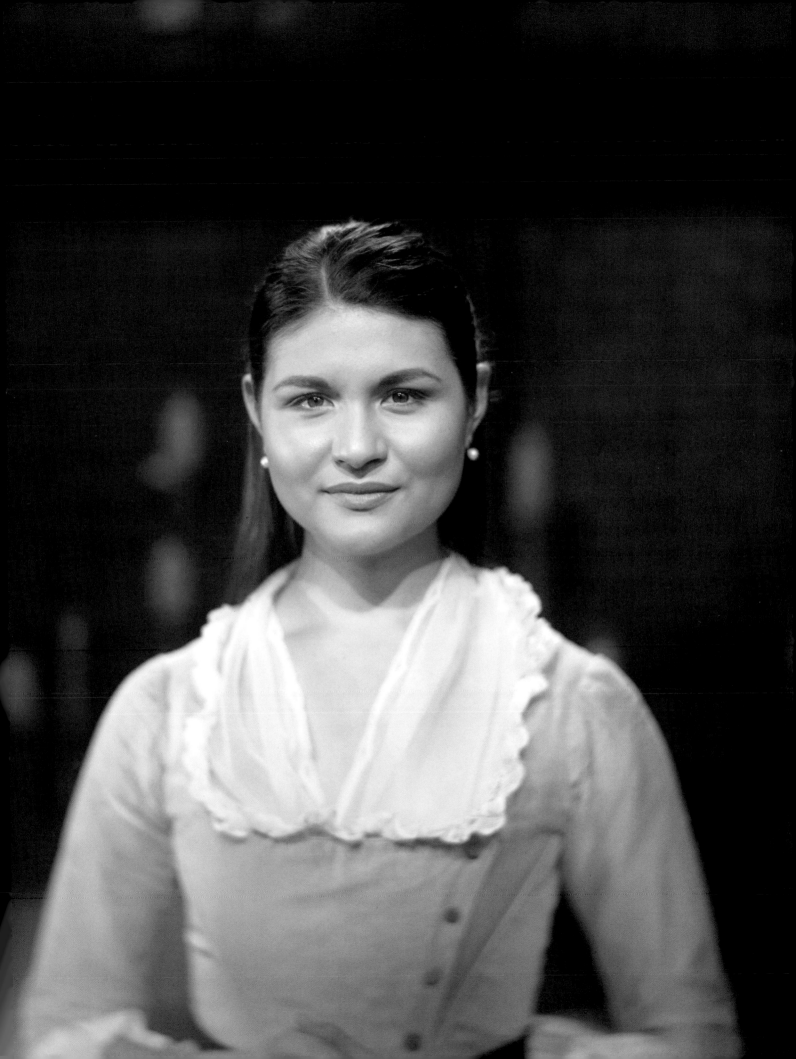

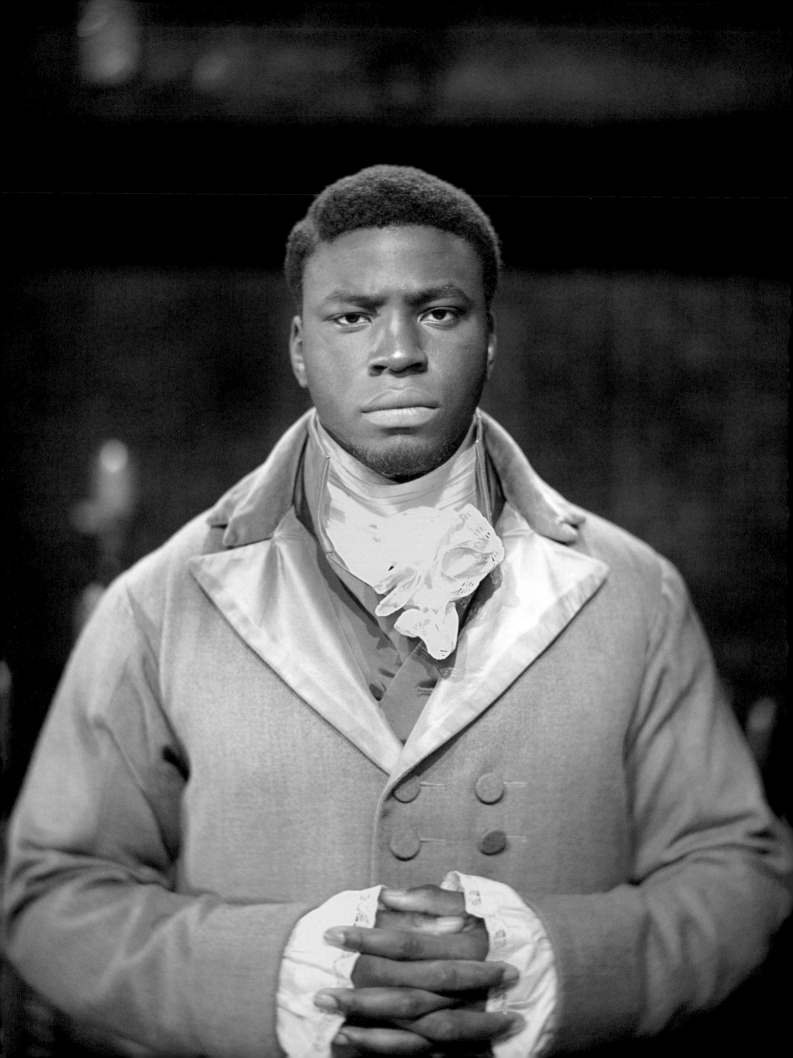

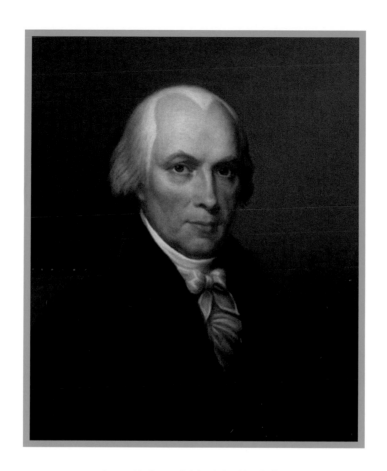

James Madison, 1816 by John Vanderlyn

OKIERIETE ONAODOWAN — *James Madison*

BROADWAY

LESLIE ODOM JR. — *Aaron Burr*

BROADWAY

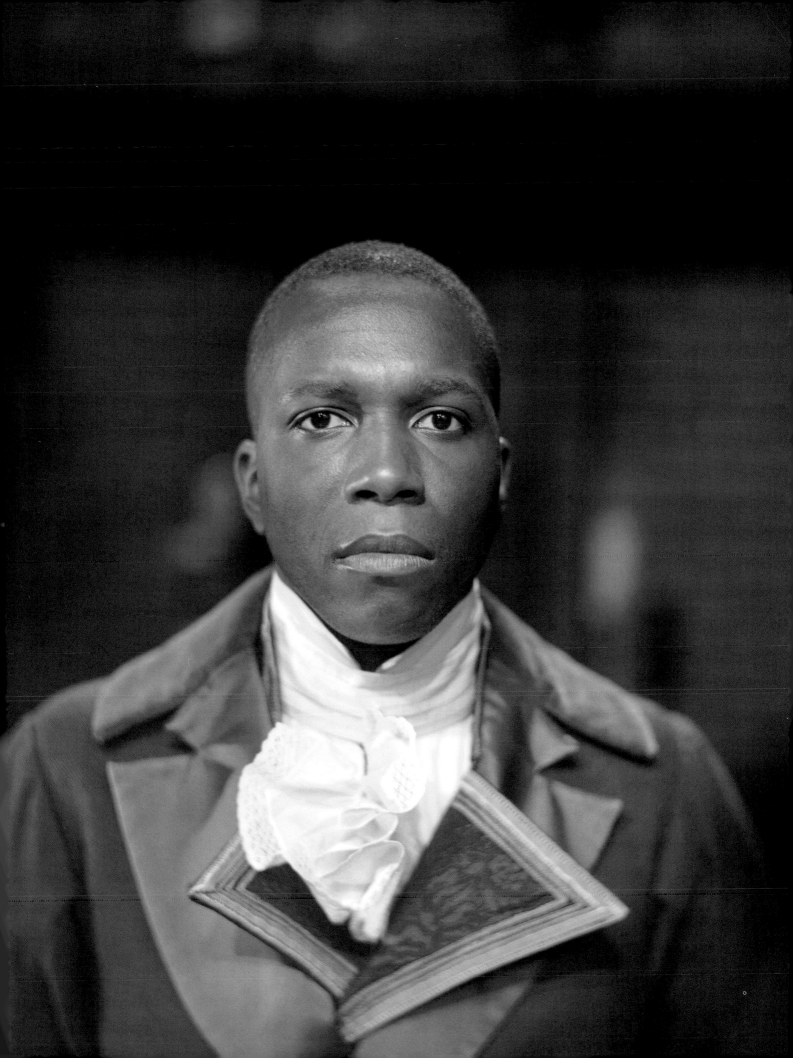

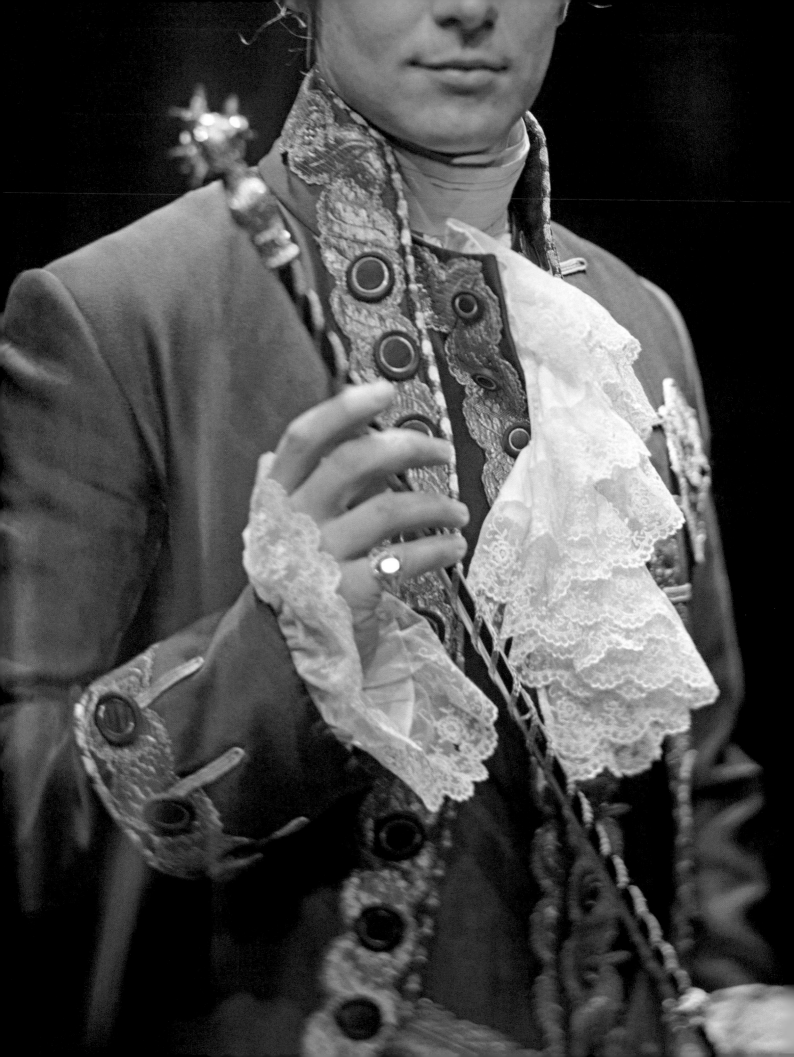

JONATHAN GROFF – *King George*

BROADWAY

MANY OF THE POSES IN THESE
PHOTOGRAPHS, ESPECIALLY THOSE
IN WHICH HANDS WERE BROUGHT
CLOSE TO THE ACTORS' FACES OR
BODIES, WERE ADAPTED BY THE ACTORS
FROM ANDY BLANKENBUEHLER'S
ORIGINAL CHOREOGRAPHY.

—
JL

CARLEIGH BETTIOL — *Ensemble*

BROADWAY

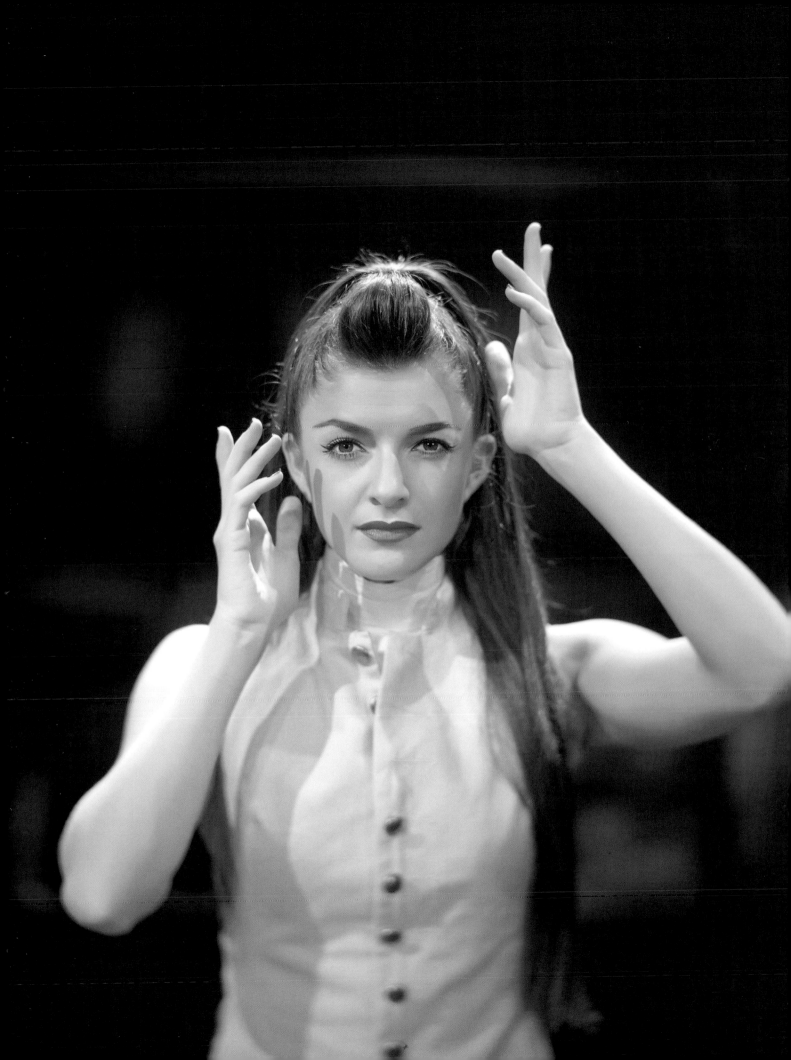

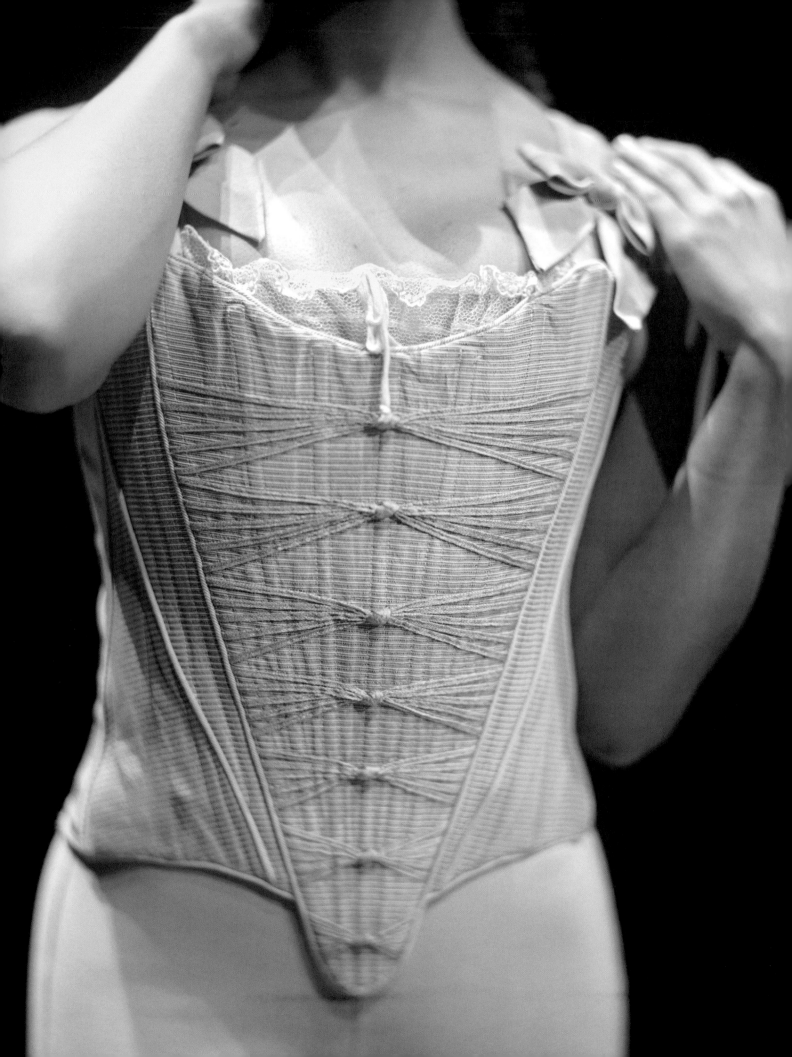

PAUL TAZEWELL PUT DETAILS INTO
THE COSTUMES THAT THE AUDIENCE
WILL NEVER SEE, YET THEY SOMEHOW
FEEL THEM—INCREDIBLY INTRICATE
DETAILS THAT MAY BE ON STAGE FOR
SECONDS SUCH AS HAND WOVEN
LACE AND TIED THREADED KNOTS.
THIS PIPING WAS NOT EASY TO CREATE
OR MAINTAIN BUT THAT'S WHAT THE
COSTUME DESIGNERS AND WARDROBE
SUPERVISORS DO EVERY DAY.

—
JL

JASMINE WAS ONE OF THE YOUNGEST
MEMBERS OF THE ENSEMBLE WHEN
HAMILTON OPENED OFF-BROADWAY.
SHE BROUGHT A NATURAL YOUTH
AND BEAUTY AND INNOCENCE TO
THE ROLE OF PEGGY. BUT THE BURDEN
THAT SHE HAD TO CARRY AS MARIA
REYNOLDS LANDED PARTICULARLY
HEAVILY ON HER. IT WAS SUCH A BIG
TRANSITION GOING FROM PEGGY TO
MARIA EVERY NIGHT, BUT SHE HANDLED
IT FLAWLESSLY. BOTH SHE AND HER
PARTNER, ANTHONY RAMOS, CANNOT
BE ANYTHING BUT AUTHENTIC.

—
JL

JASMINE CEPHAS JONES — *Maria Reynolds*

BROADWAY

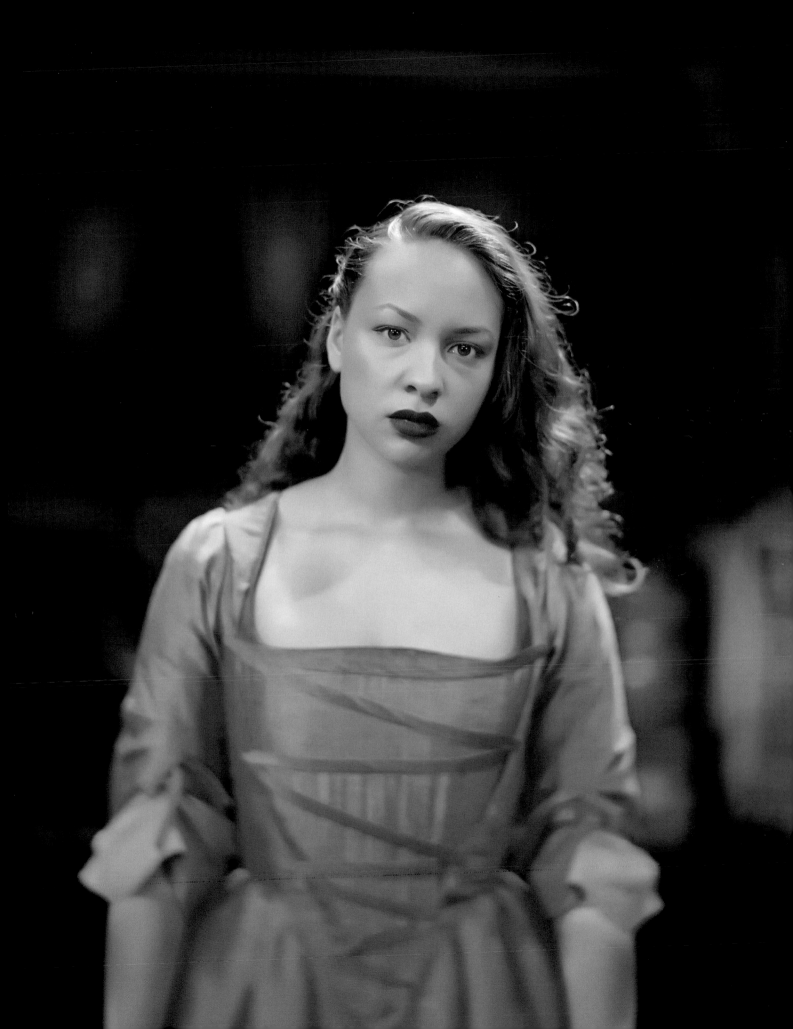

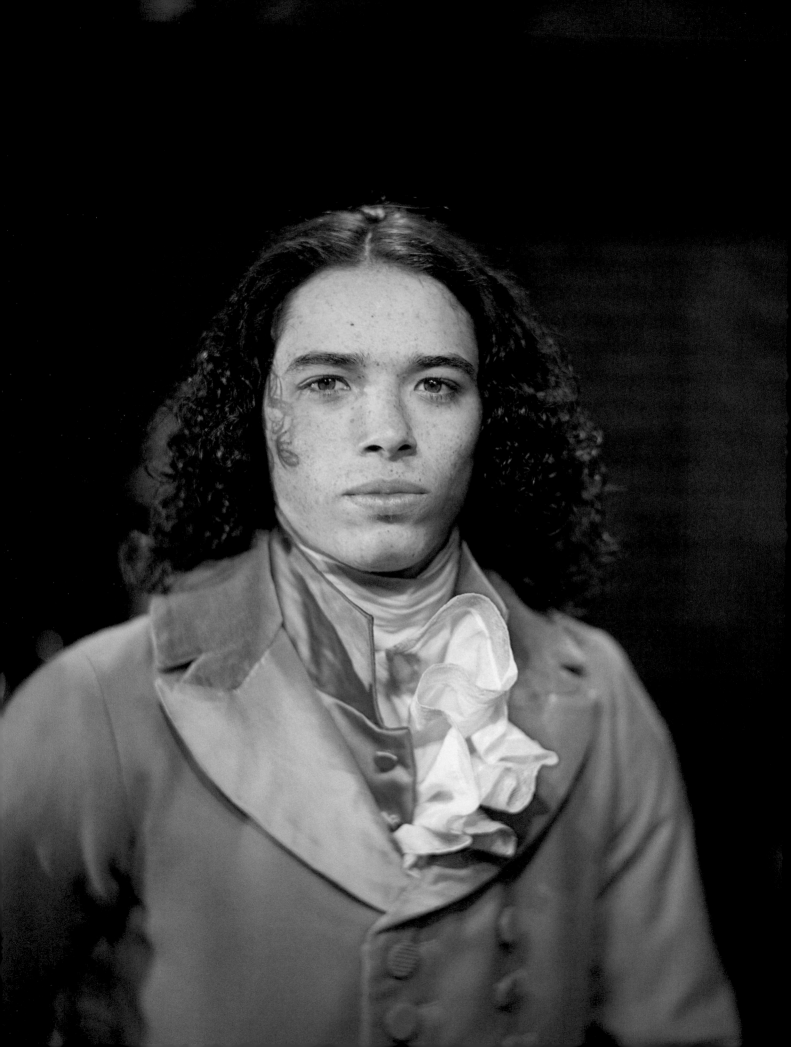

ANTHONY RAMOS – *Philip Hamilton*

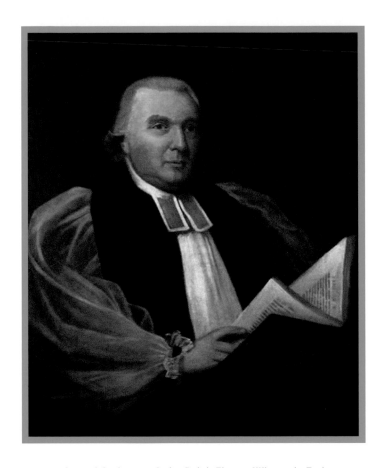

Samuel Seabury, 1785 by Ralph Eleaser Whiteside Earl

THAYNE JASPERSON – *Samuel Seabury*

BROADWAY

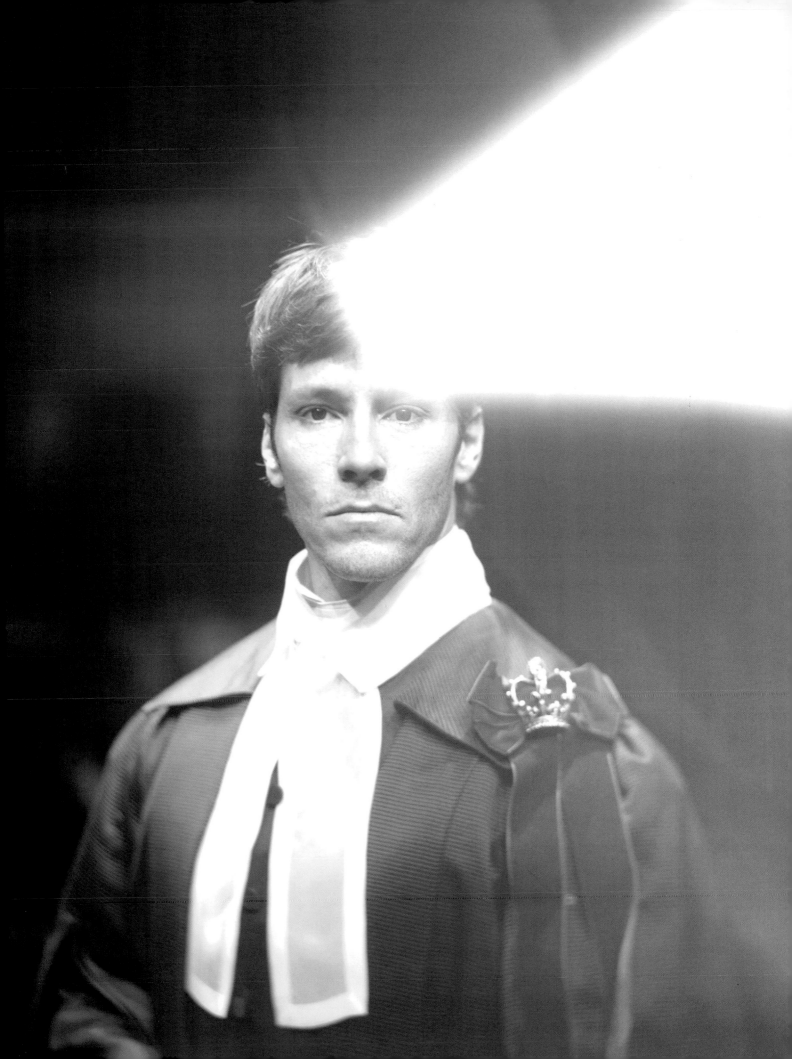

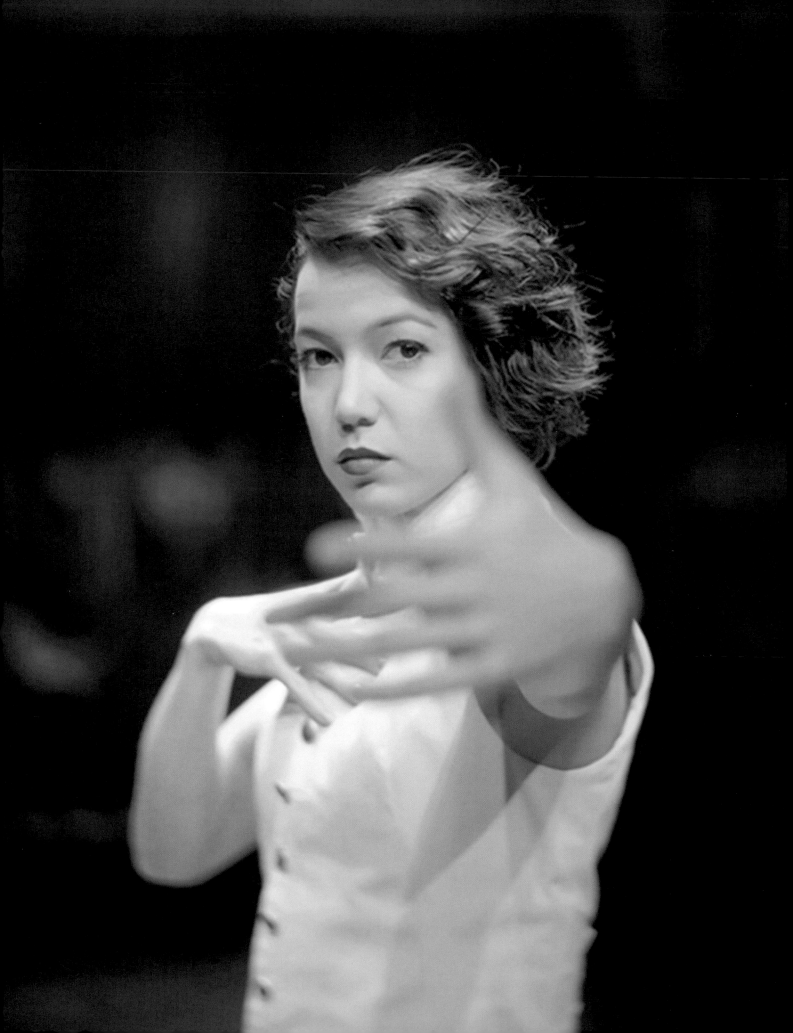

MORGAN MARCELL — *Ensemble*

BROADWAY

BRANDON HUDSON & THAYNE JASPERSON – *Ensemble and Samuel Seabury*

BROADWAY

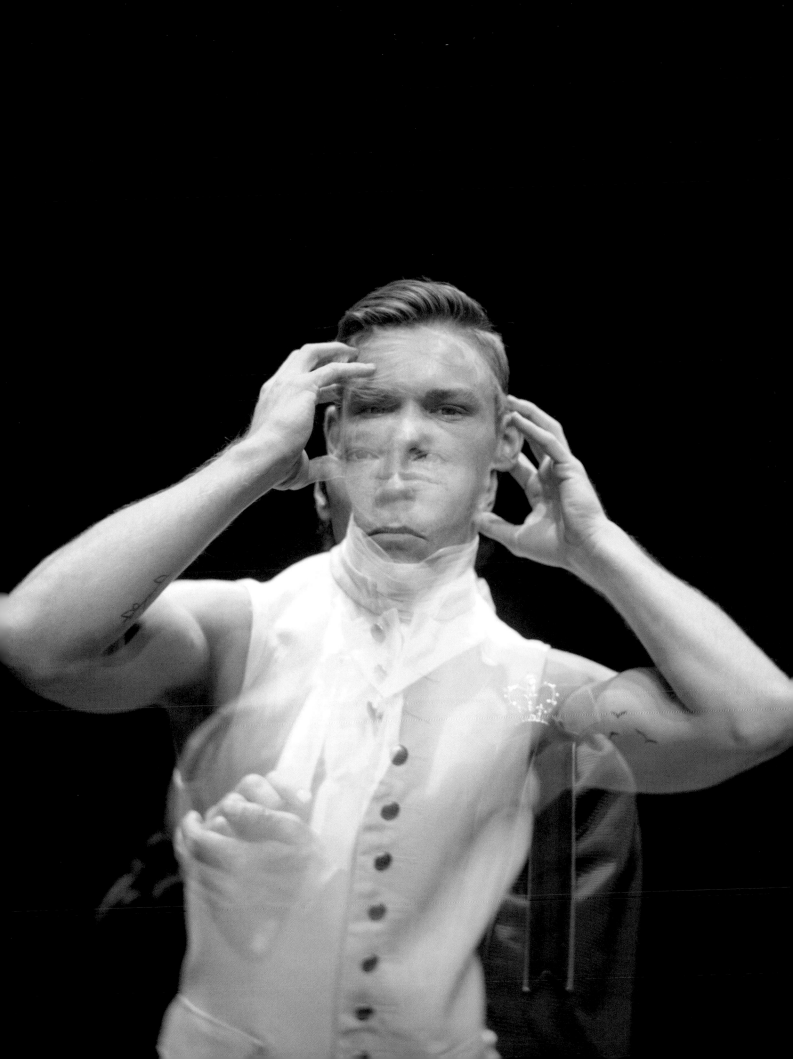

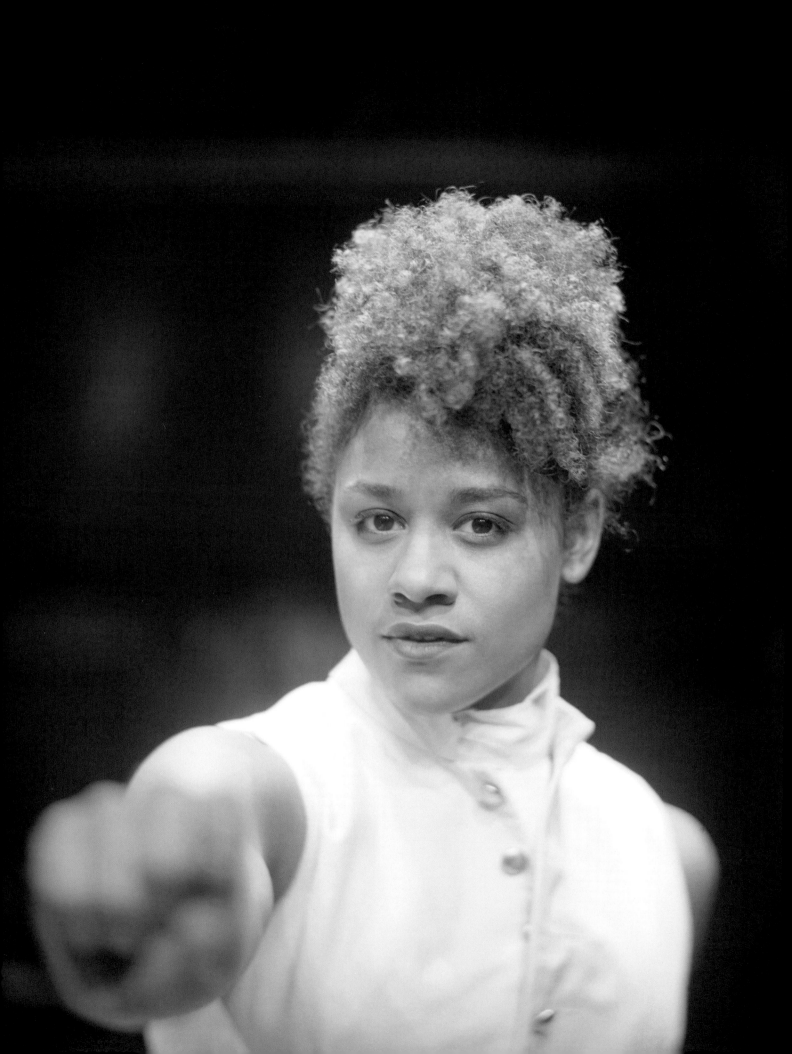

ARIANA WAS THE ORIGINAL BULLET.
SO MUCH OF THE STORY IS TOLD,
INTENTIONALLY OR OTHERWISE,
BY THE ACTOR'S FACE AND WHERE THEY
PLACE THEIR GAZE. ARIANA WAS ALWAYS
SO COMMITTED AND HYPERFOCUSED
ON WHERE HER FINGERS WERE ON
STAGE THAT I WANTED HER TO BREAK
CHARACTER AND LOOK AT THE LENS JUST
FOR A SECOND, SO WE COULD SEE HER.

—
JL

ARIANA DEBOSE — *Ensemble*

BROADWAY

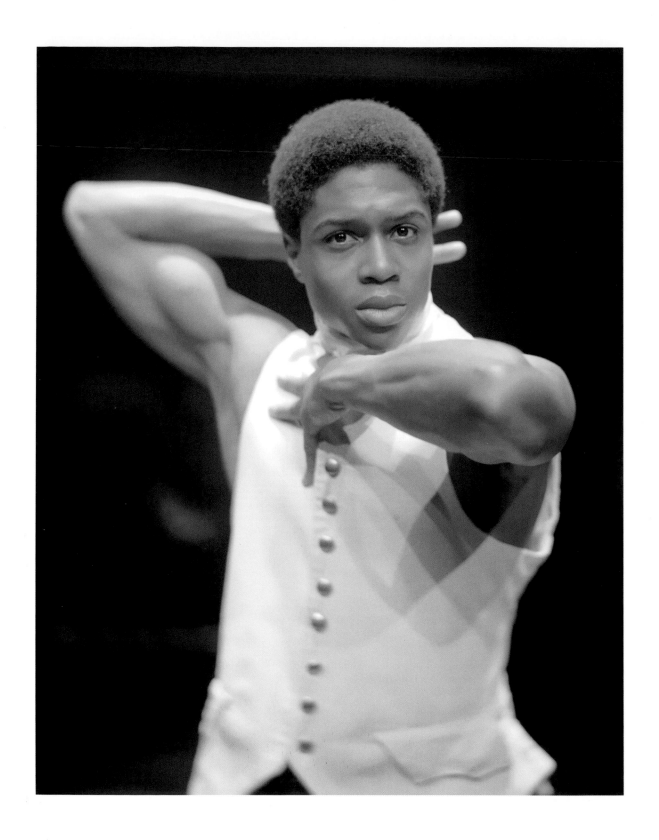

EPHRAIM SYKES — *Ensemble*

BROADWAY

SYDNEY JAMES HARCOURT — *James Reynolds*

BROADWAY

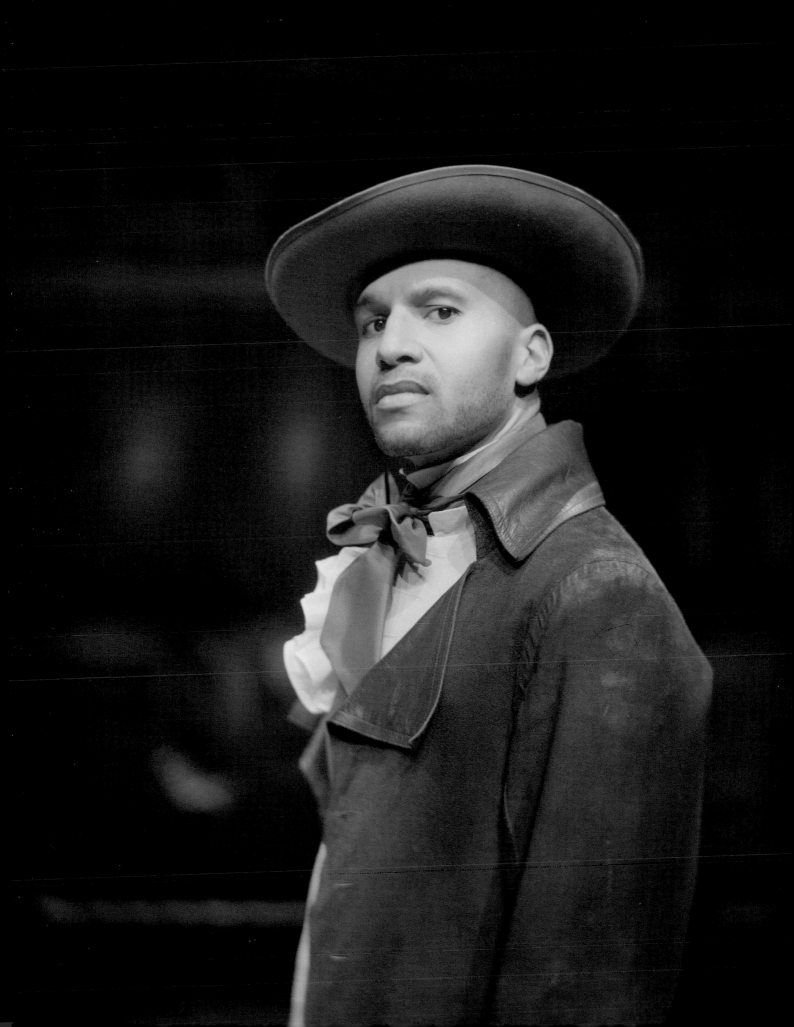

EMMY RAVER-LAMPMAN — *Ensemble*

BROADWAY

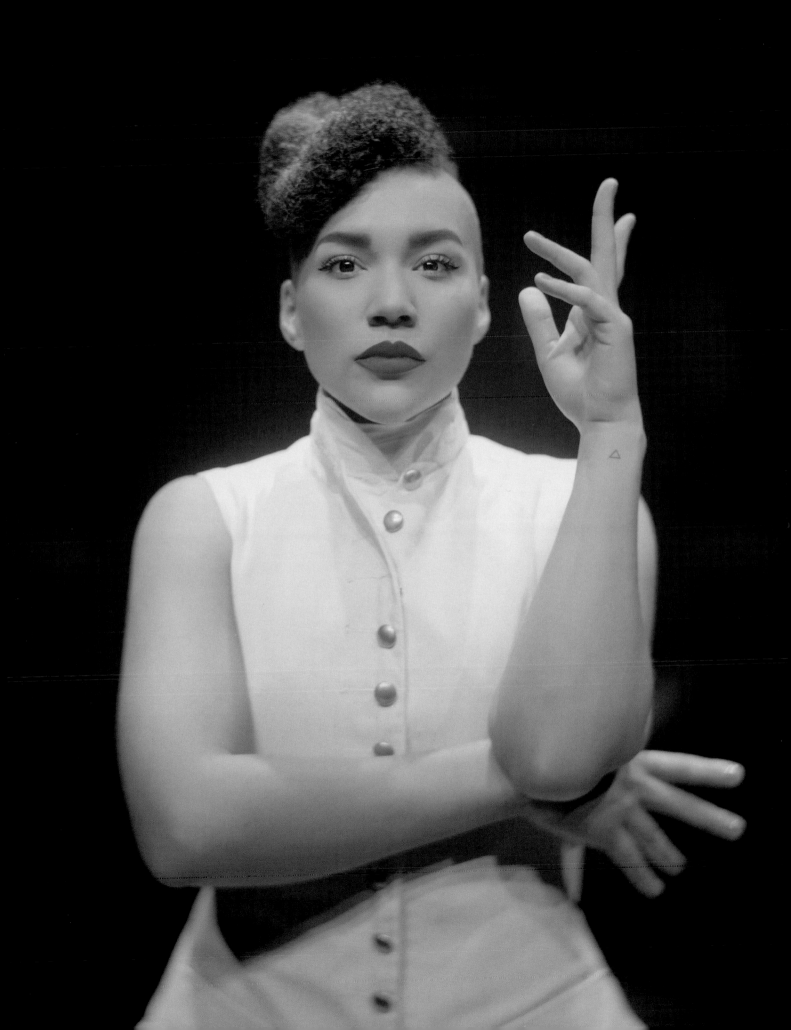

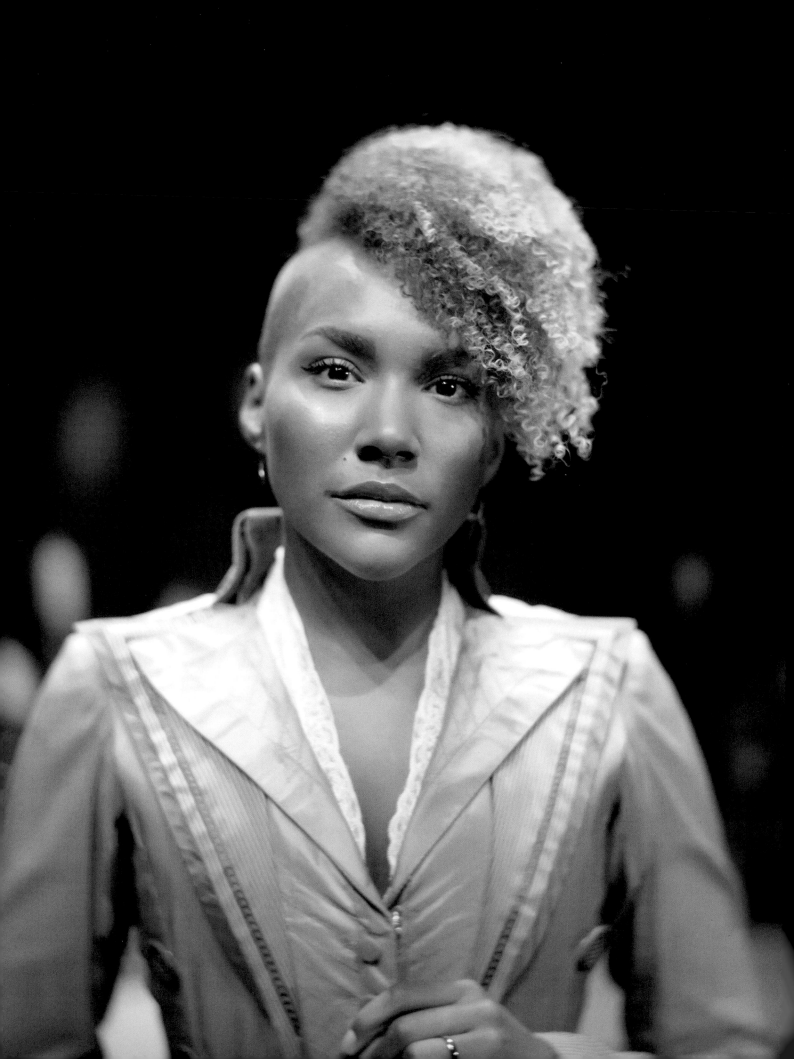

EMMY RAVER-LAMPMAN – *Angelica Schuyler*

TOUR

LEAH HILL — *Ensemble*

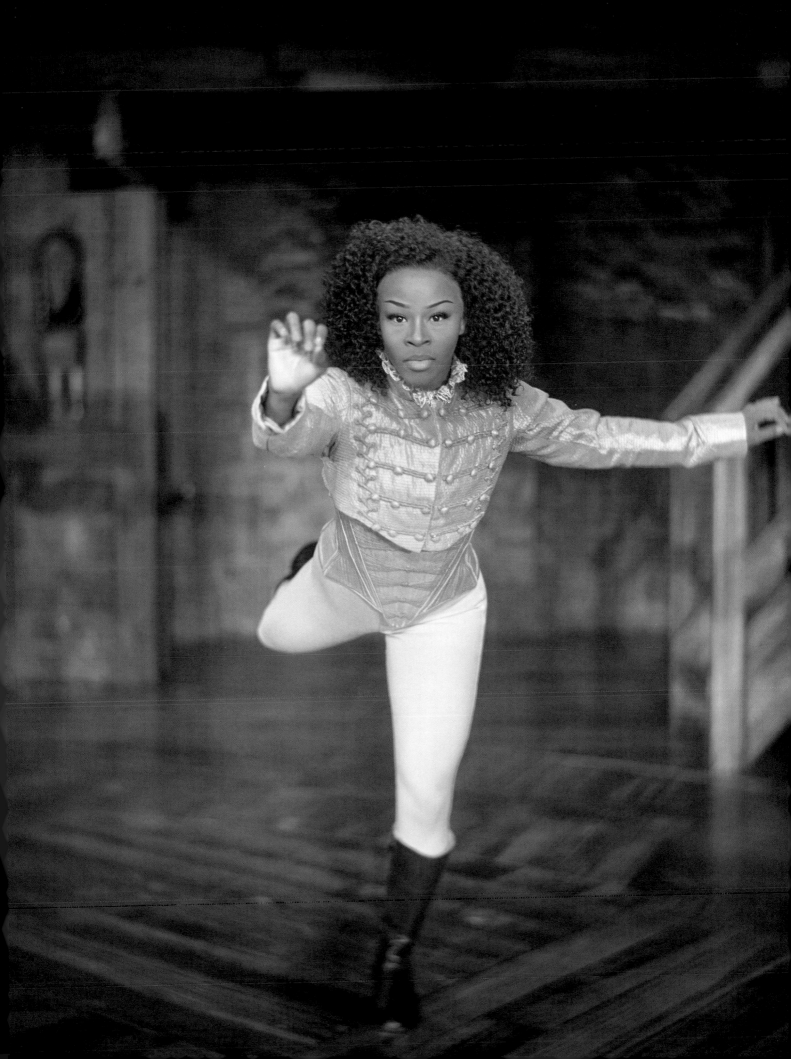

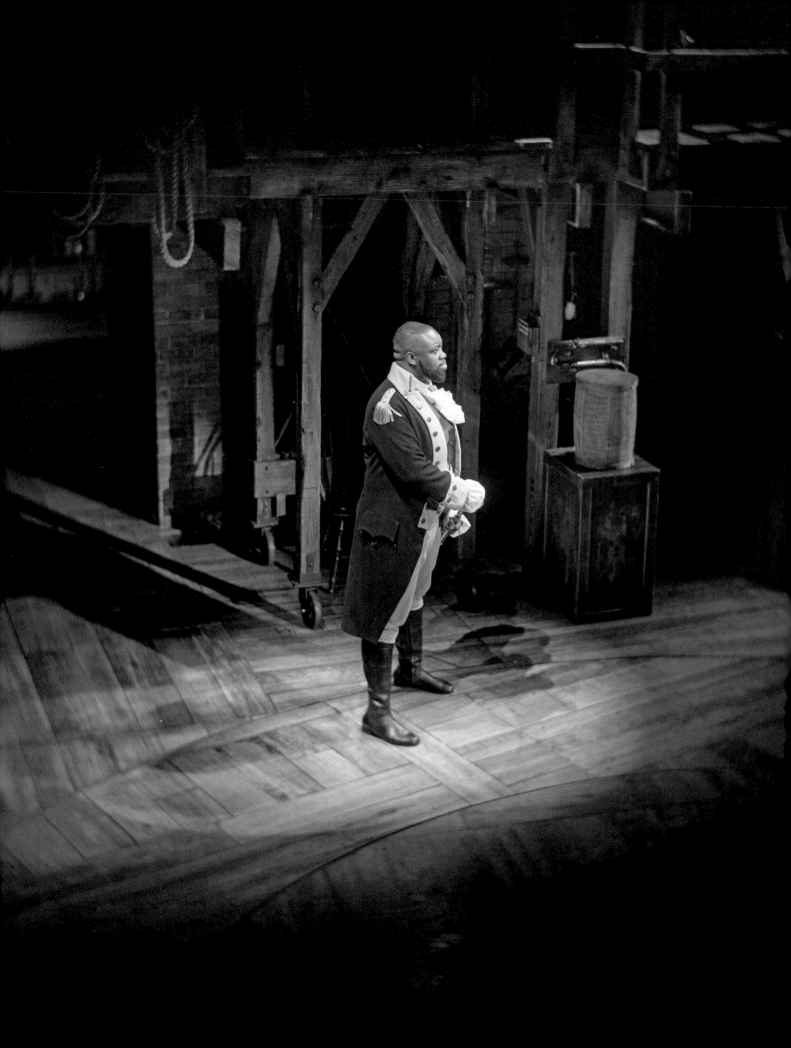

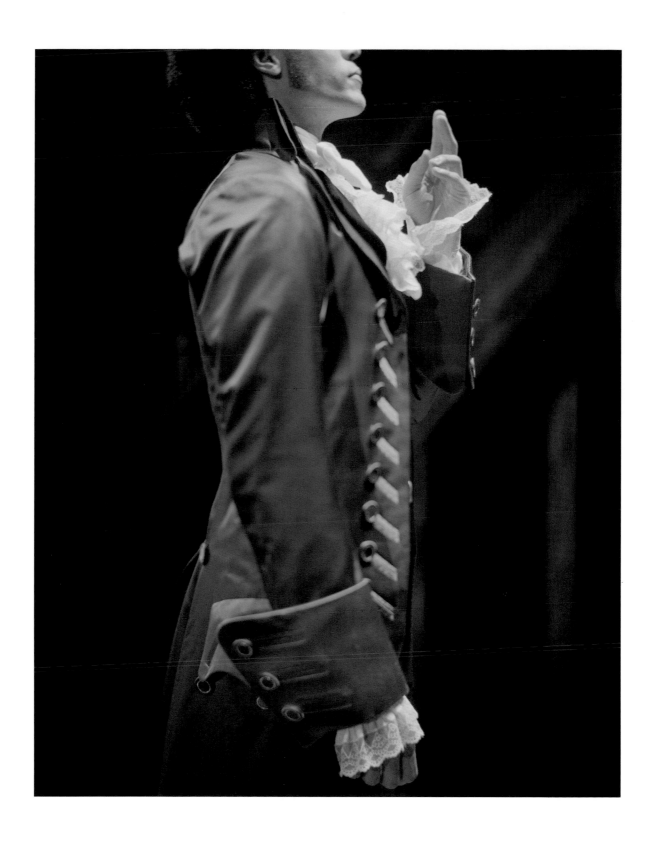

TAMAR GREENE – *George Washington*

CHICAGO

JORDAN DONICA – *Lorem*

LONDON

JONATHAN KIRKLAND – *George Washington*

CHICAGO

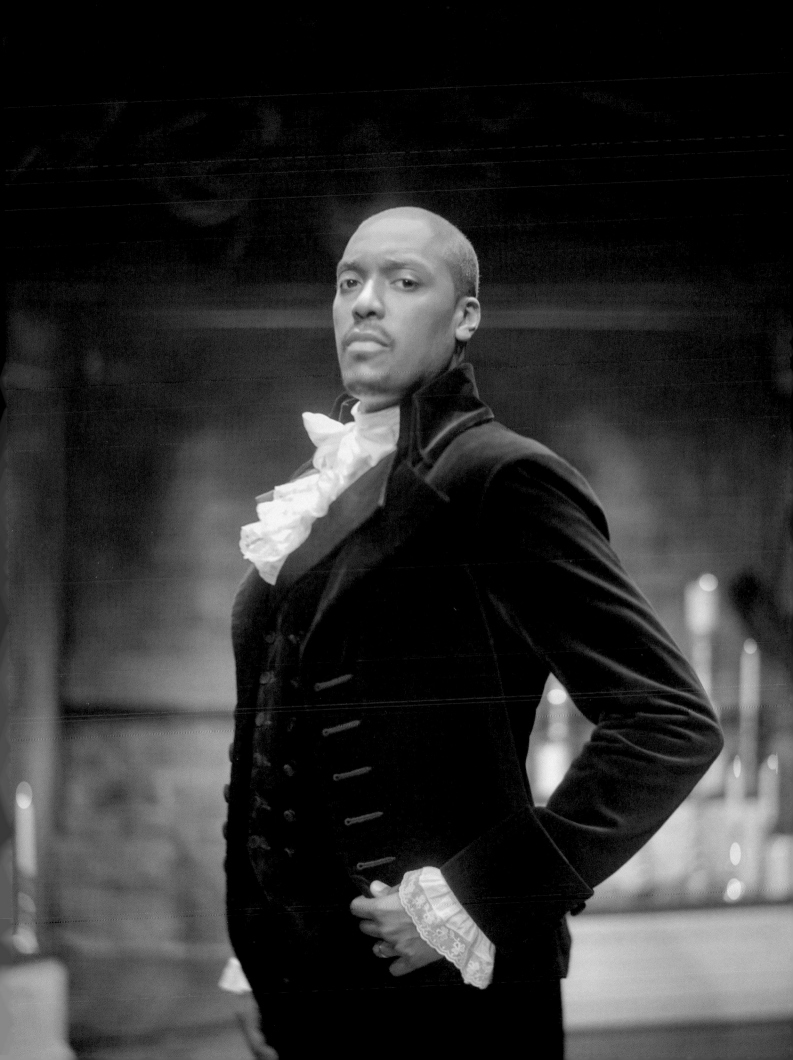

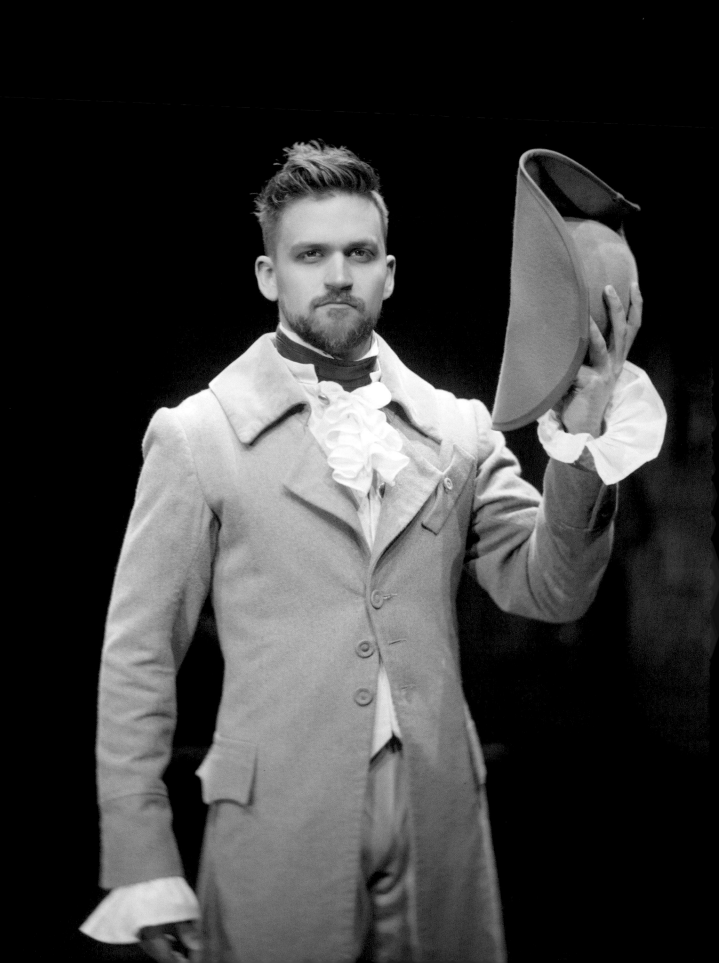

NEIL HASKELL — *Ensemble*

BROADWAY

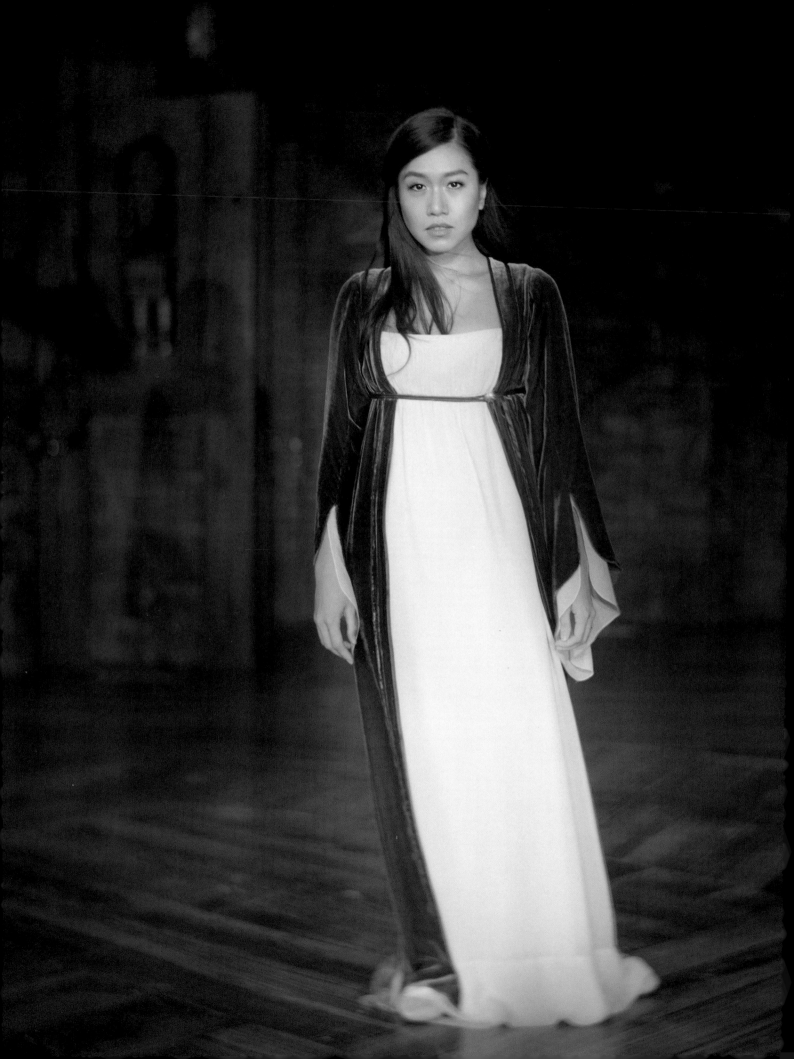

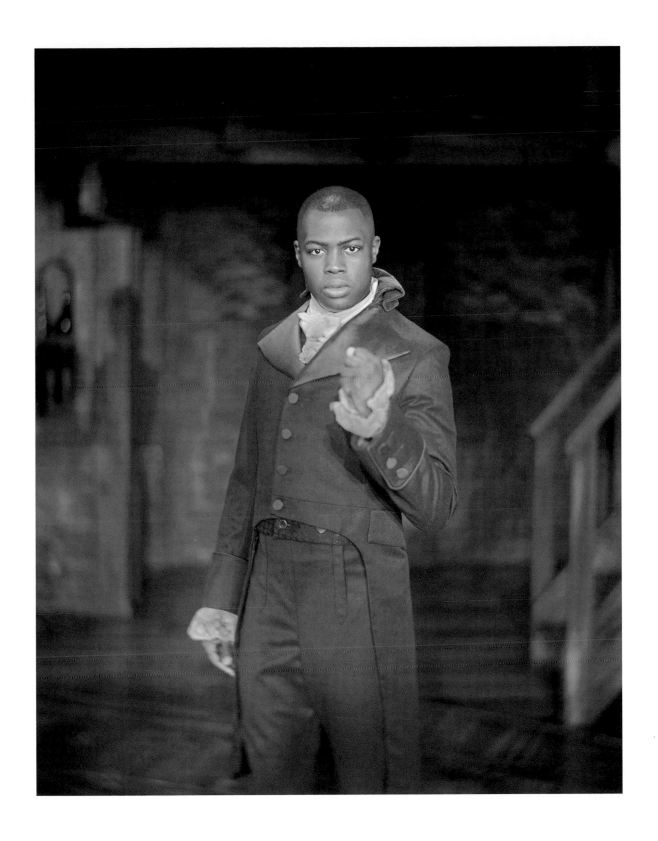

RACHELLE ANN GO – *Eliza Hamilton*

LONDON

SAM OLADEINDE – *Aaron Burr*

LONDON

ONE OF THE THINGS THAT'S SO
COMPELLING ABOUT BURR AND
HAMILTON'S RELATIONSHIP WAS THAT
THEY WERE FRIENDS AND, WERE IT
NOT FOR AMBITION, CIRCUMSTANCES,
AND TIMING, PROBABLY WOULD HAVE
REMAINED SO. GREGORY TRECO
HAD THE ABILITY TO PHYSICALLY
AND EMOTIONALLY MANIFEST THE
HEARTBREAK AND LOSS OF BURR IN A WAY
THAT WAS AT ONCE TOTALLY THEATRICAL
AND TRUE TO THE CHARACTER.

—
JL

GREGORY TRECO — *Aaron Burr*

BROADWAY

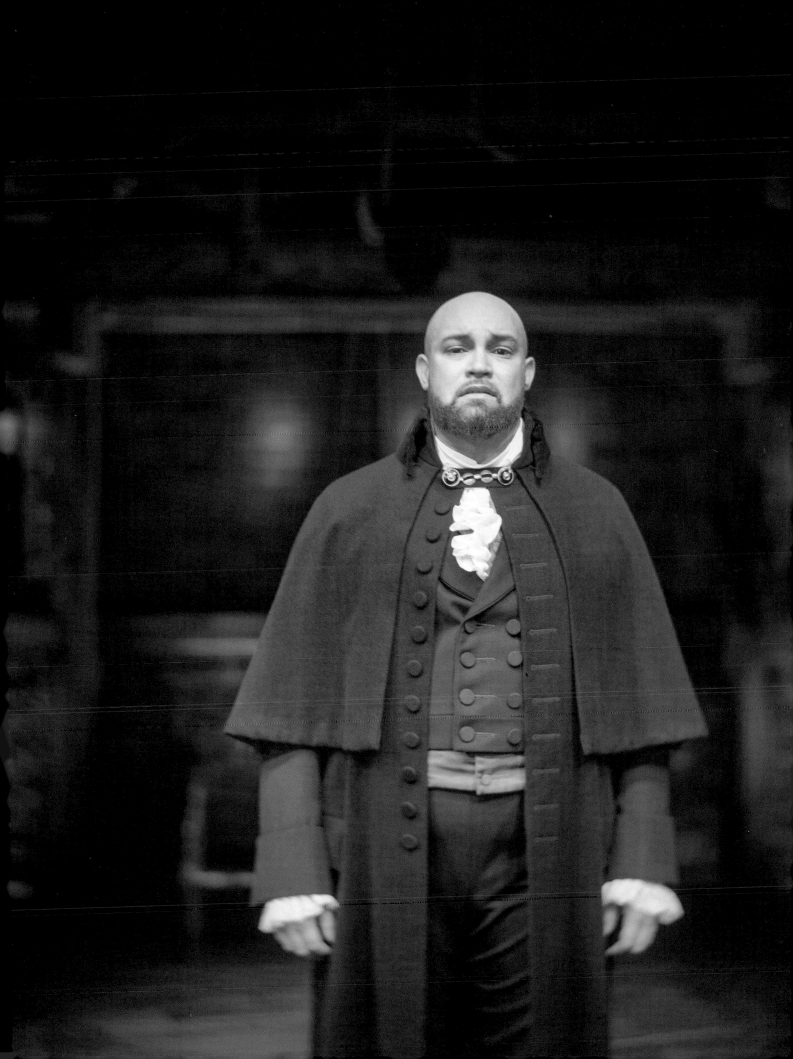

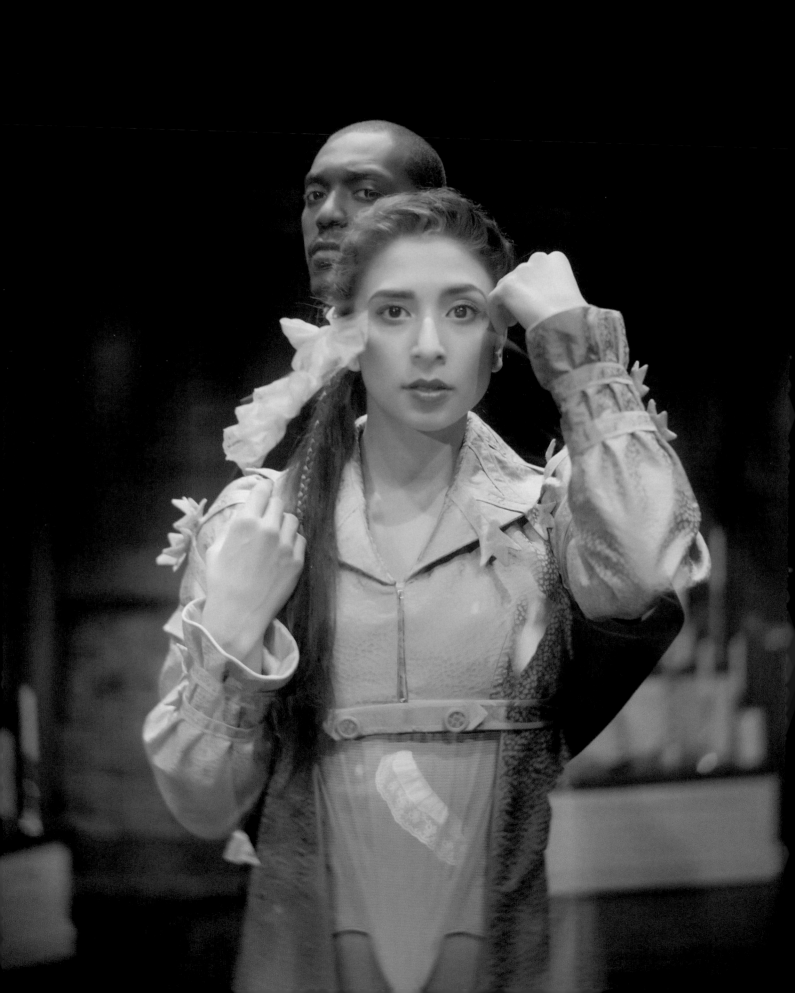

LAUREN BOYD & JONATHAN KIRKLAND — *Ensemble and George Washington*

JENNIE HARNEY-FLEMING — *Angelica Schuyler*

BROADWAY

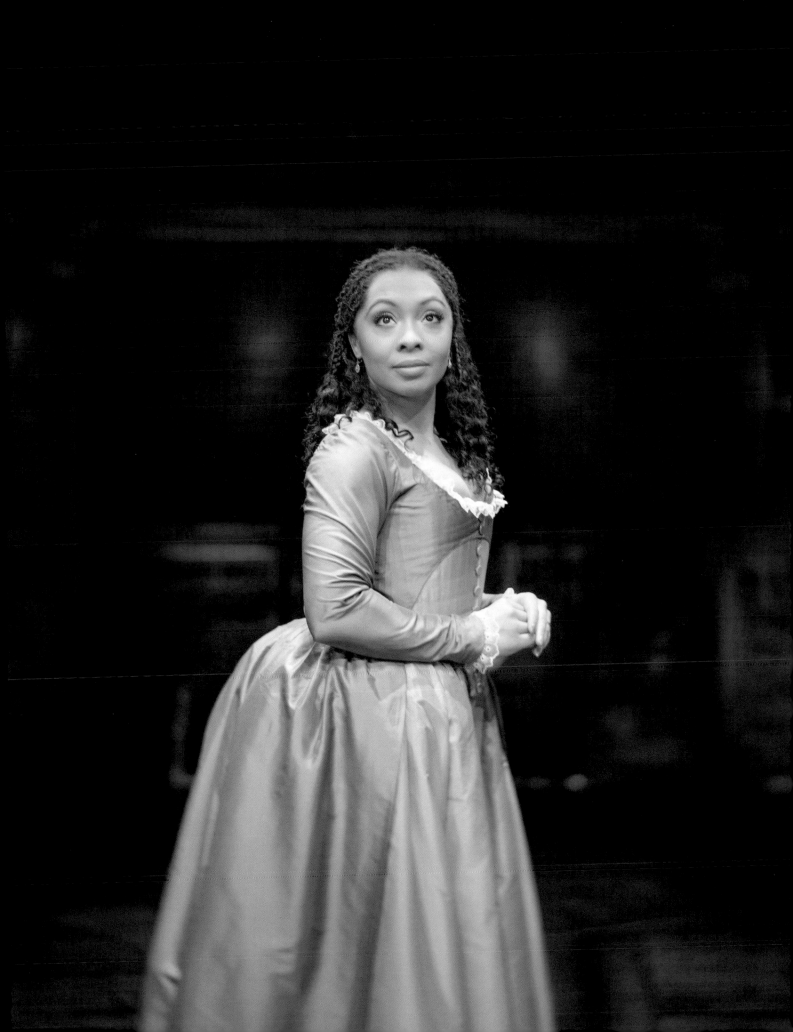

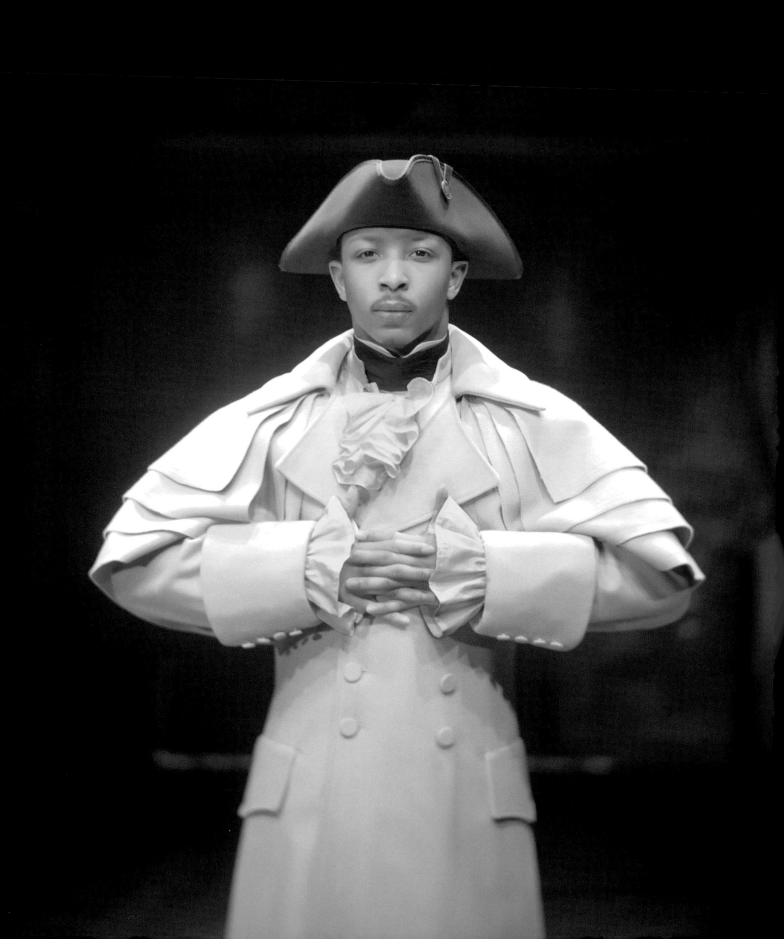

ZELIG WILLIAMS – *Ensemble*

BROADWAY

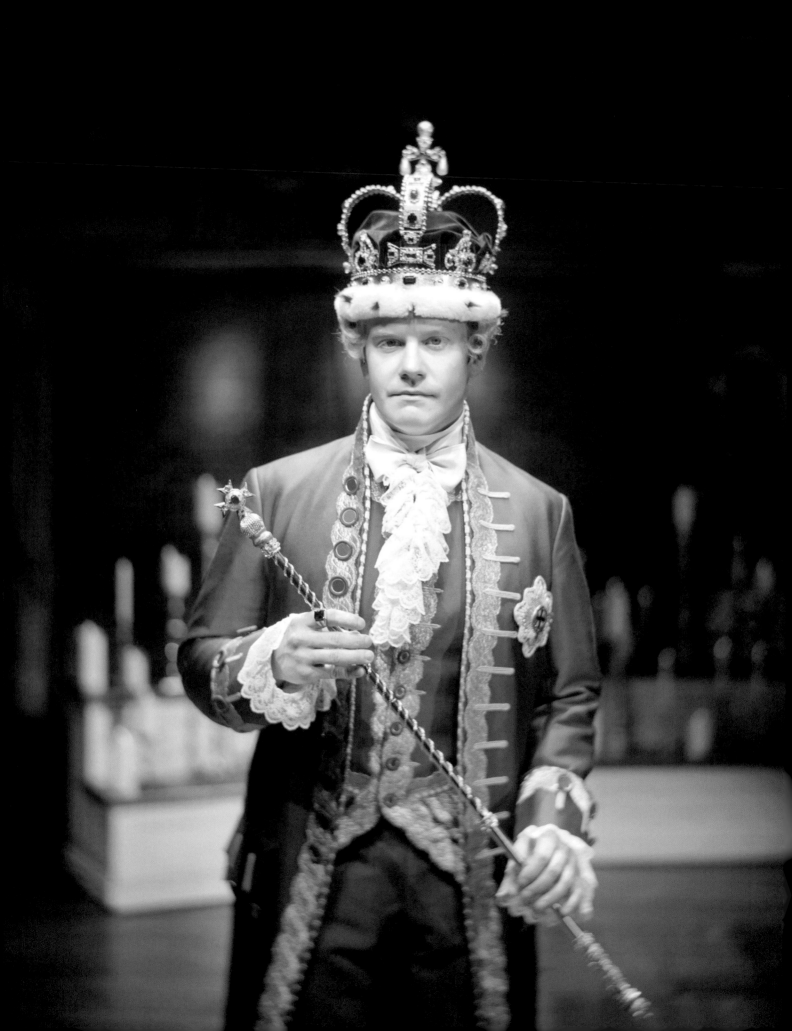

RORY O'MALLEY – *King George*

BROADWAY

RACHEL JOHN – *Angelica Schuyler*

LONDON

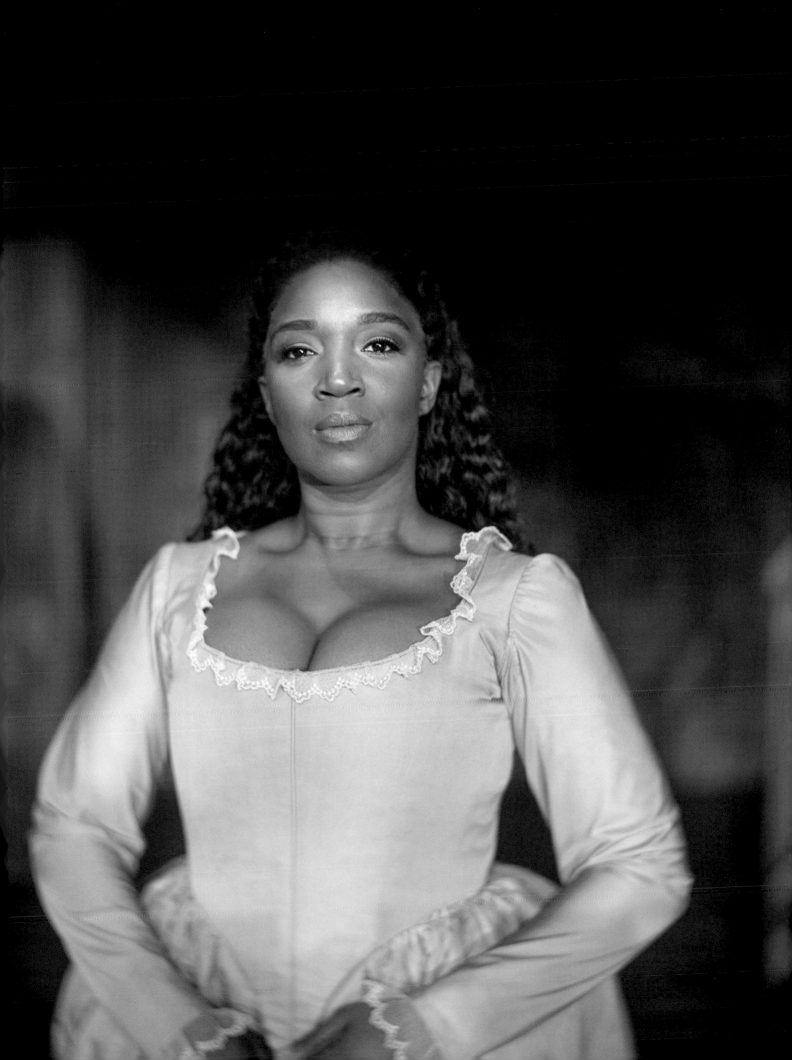

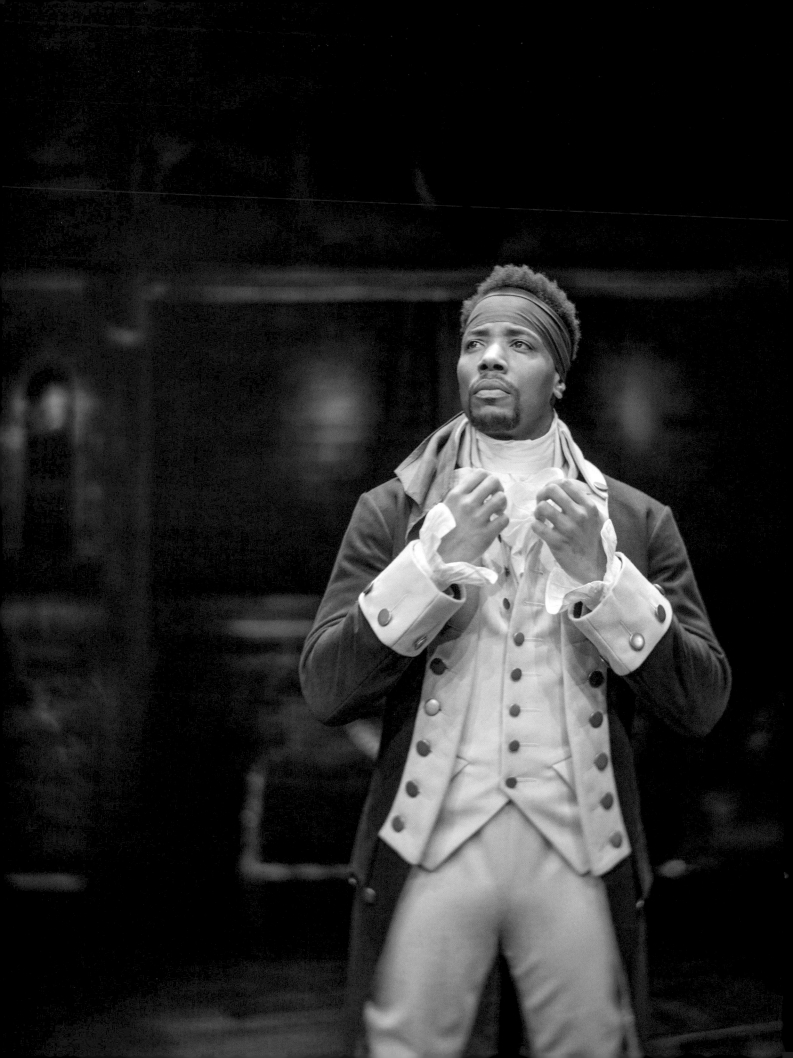

WALLACE SMITH – *Hercules Mulligan*

BROADWAY

JUSTICE MOORE – *Ensemble*

BROADWAY

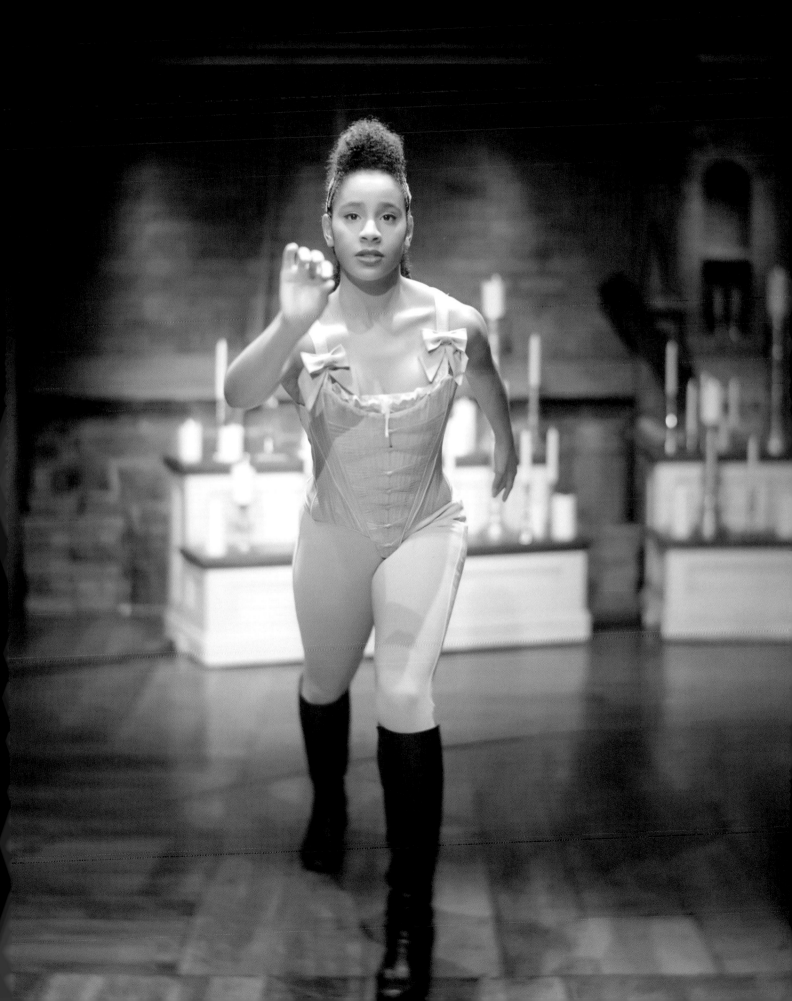

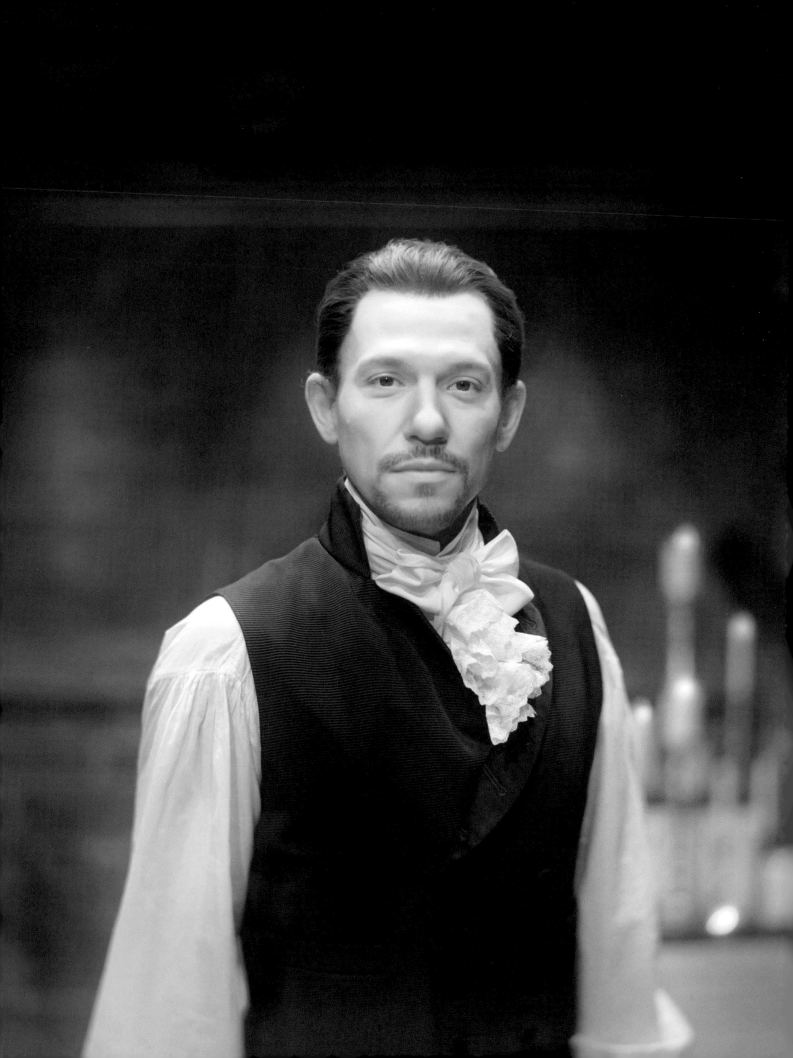

MIGUEL CERVANTES – *Alexander Hamilton*

BROADWAY

I NORMALLY DISCOURAGE THE PEOPLE
I'M PHOTOGRAPHING FROM HOLDING
THEIR HANDS THIS WAY; IT MAKES THEM
LOOK LIKE THEY HAVE SOMETHING TO
HIDE. BUT GILES TERERA PLAYED BURR AS
IF HE HAD A SECRET, SO IT SEEMED RIGHT.

—
JL

GILES TERERA — *Aaron Burr*

LONDON

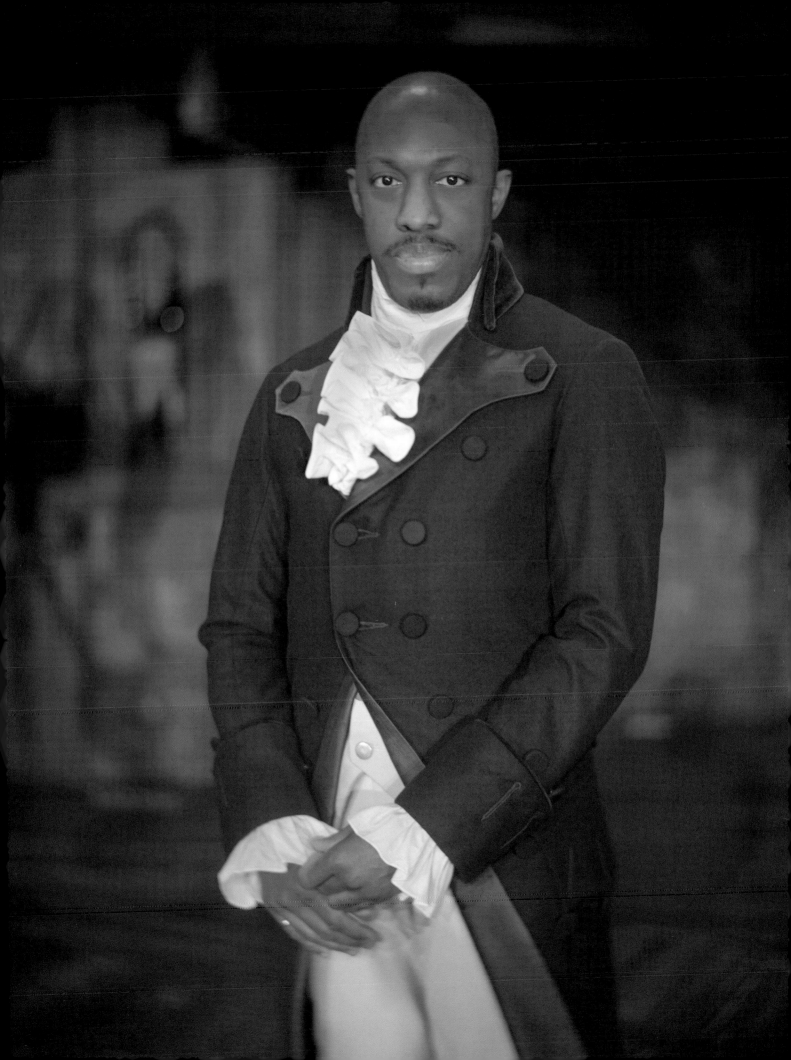

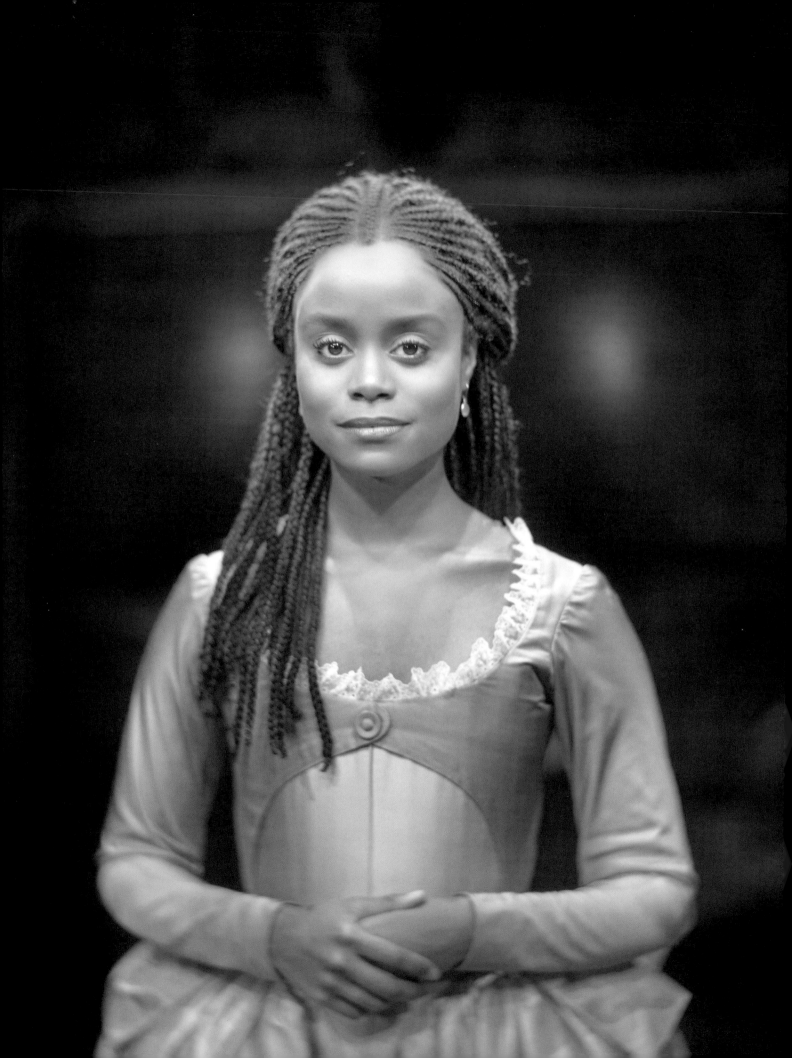

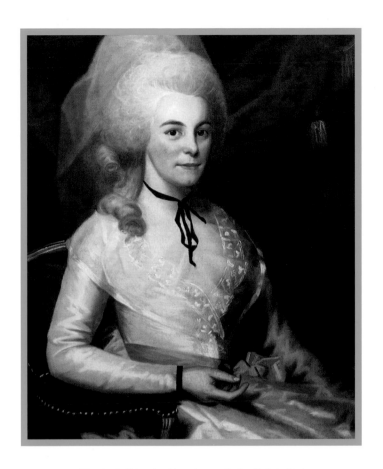

Elizabeth Schuyler Hamilton, 1787 by Ralph Earl

DENÉE BENTON – *Eliza Hamilton*

BROADWAY

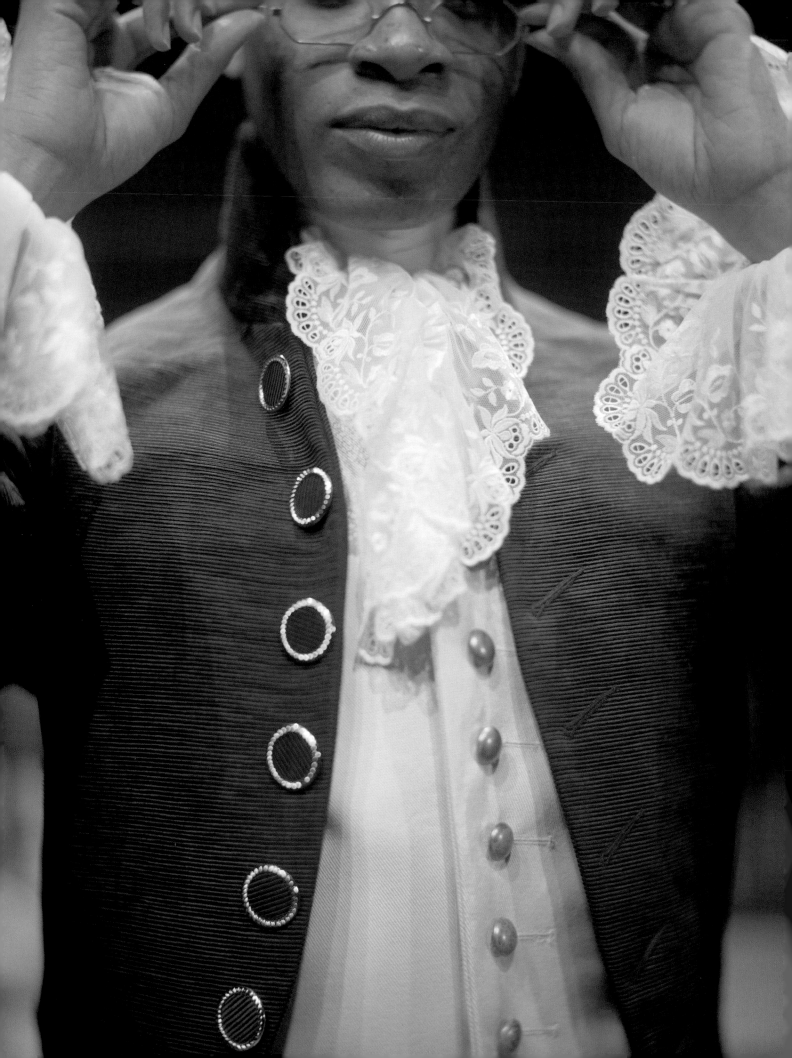

DESMOND NEWSON – *Ensemble*

TOUR

MANY OF THE CAST TOLD ME THAT
TOMMY DIDN'T CAST THEM BECAUSE OF
WHAT THEY DID OR DID NOT LOOK LIKE,
BUT RATHER BECAUSE OF THEIR TALENT
AND THEIR SOULS.

—
JL

JOSH ANDRÉS RIVERA, JORDAN DONICA, RUBÉN J. CARBAJAL
Hercules Mulligan, Marquis de Lafayette, John Laurens

TOUR

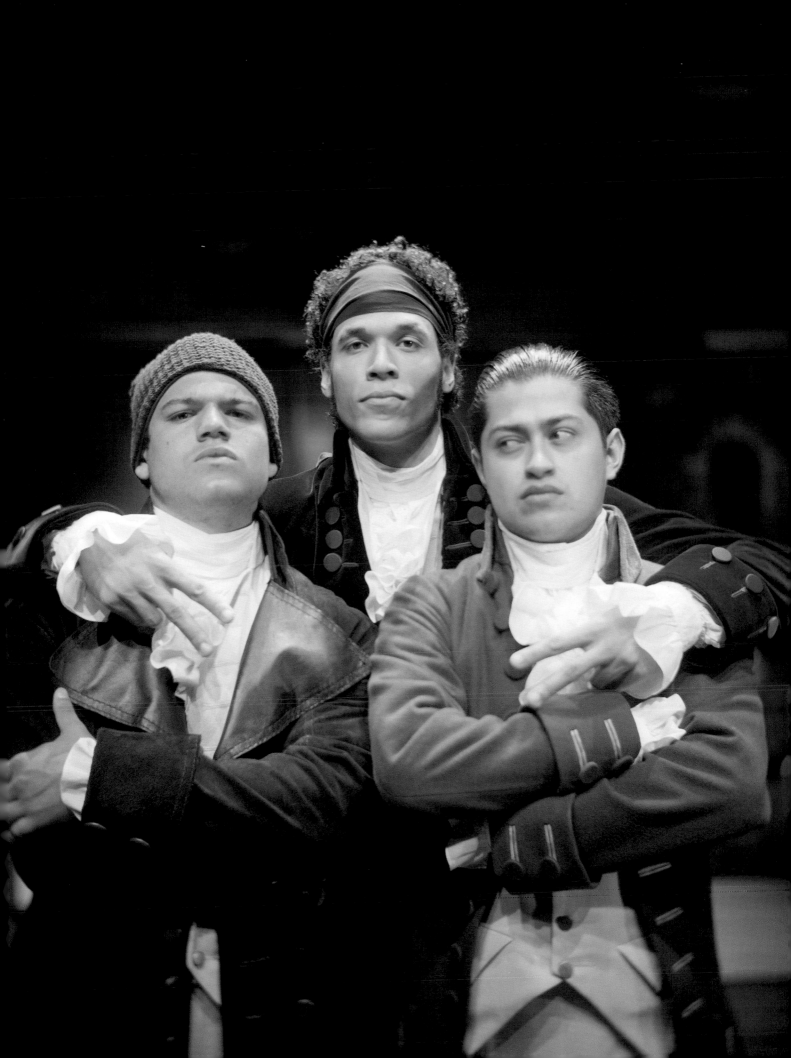

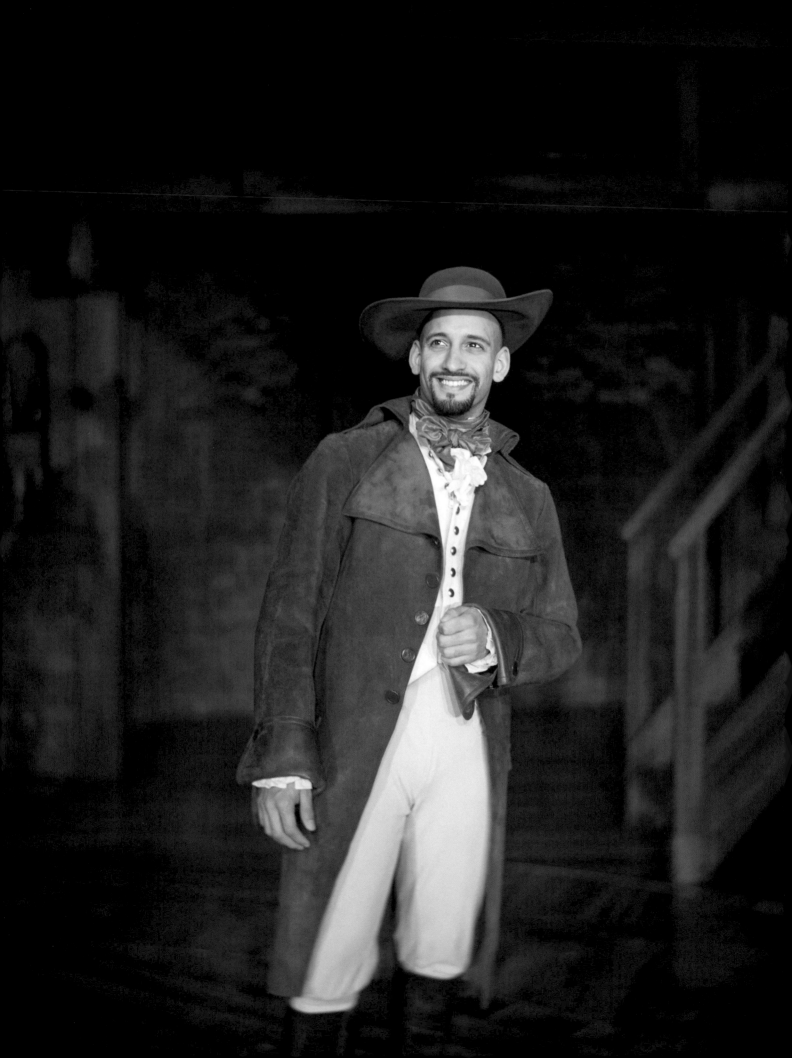

WAYLON JACOBS – *James Reynolds*

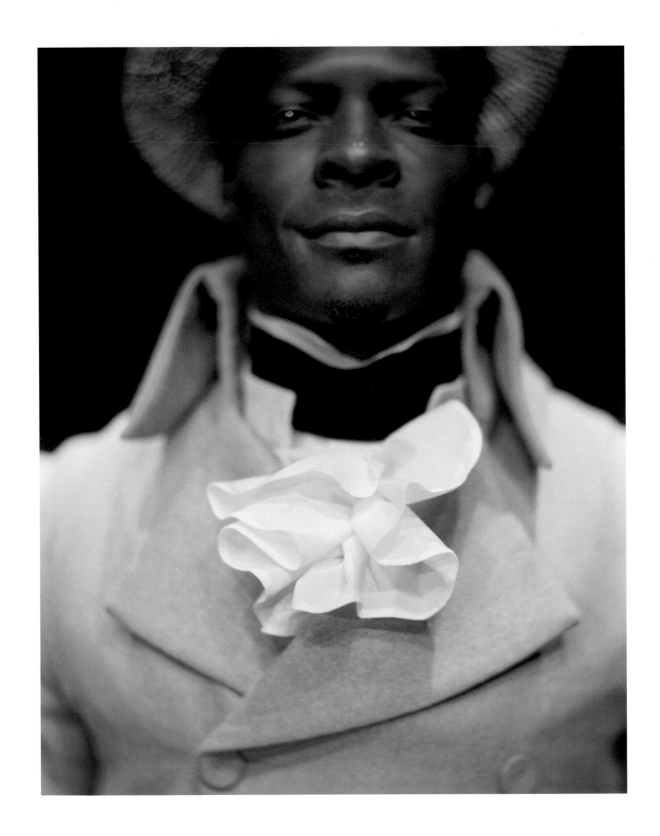

RICKEY TRIPP – *Ensemble*

BROADWAY

TANAIRI SADE VAZQUEZ – *Ensemble*

BROADWAY

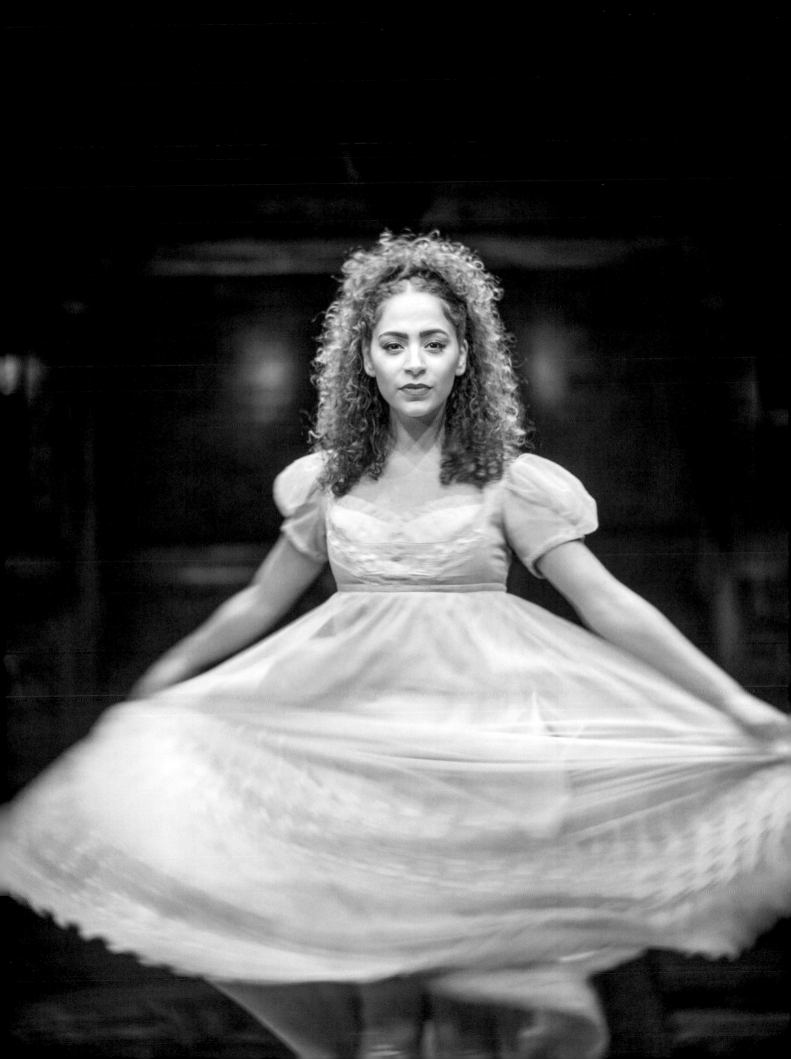

JOSEPH MORALES — *Alexander Hamilton*

TOUR

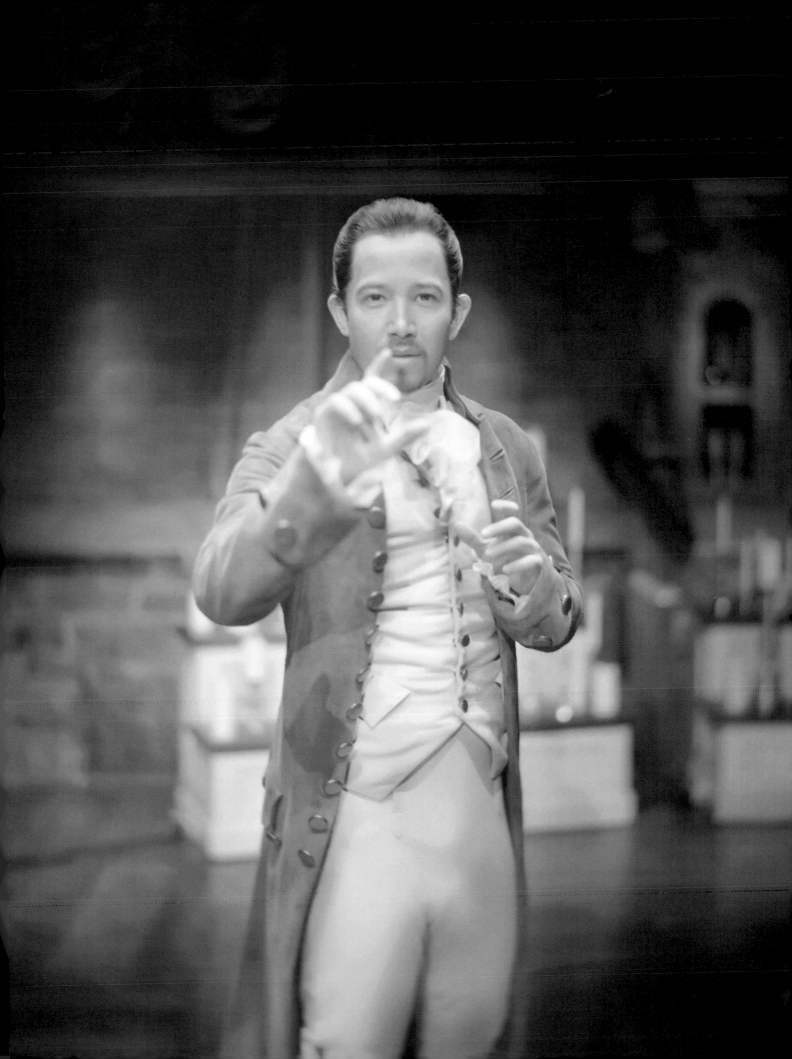

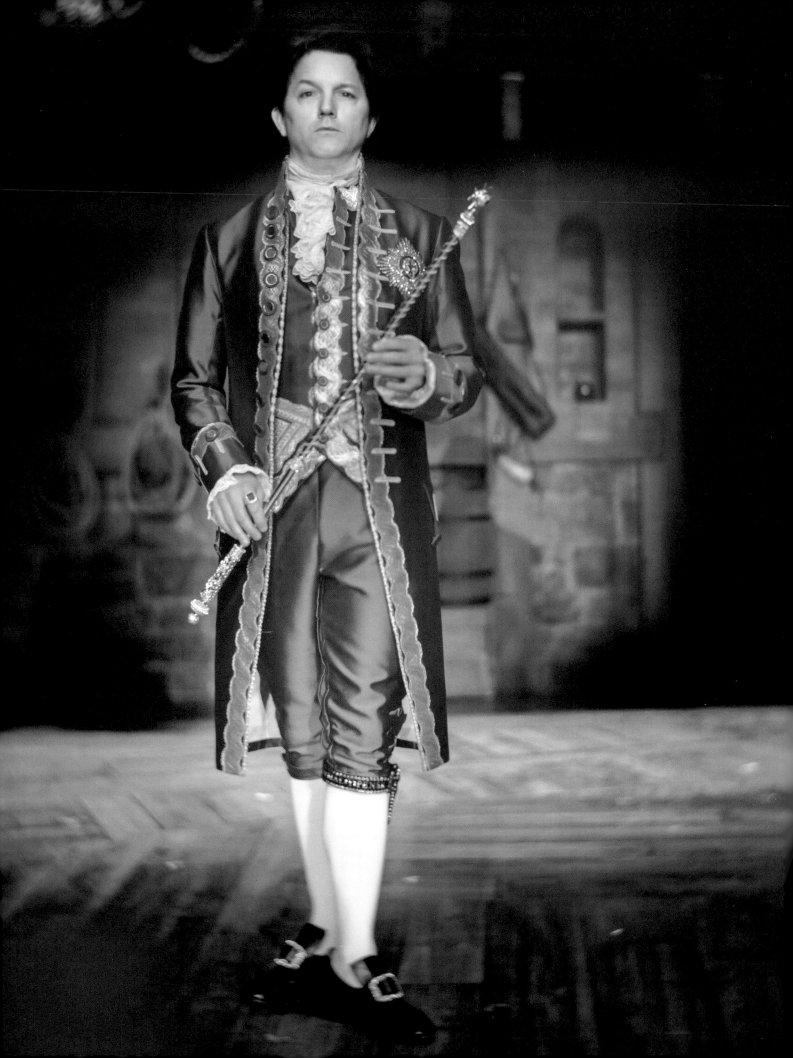

JON PATRICK WALKER – *King George*

TOUR

REMMIE BOURGEOIS – *Ensemble*

CHICAGO

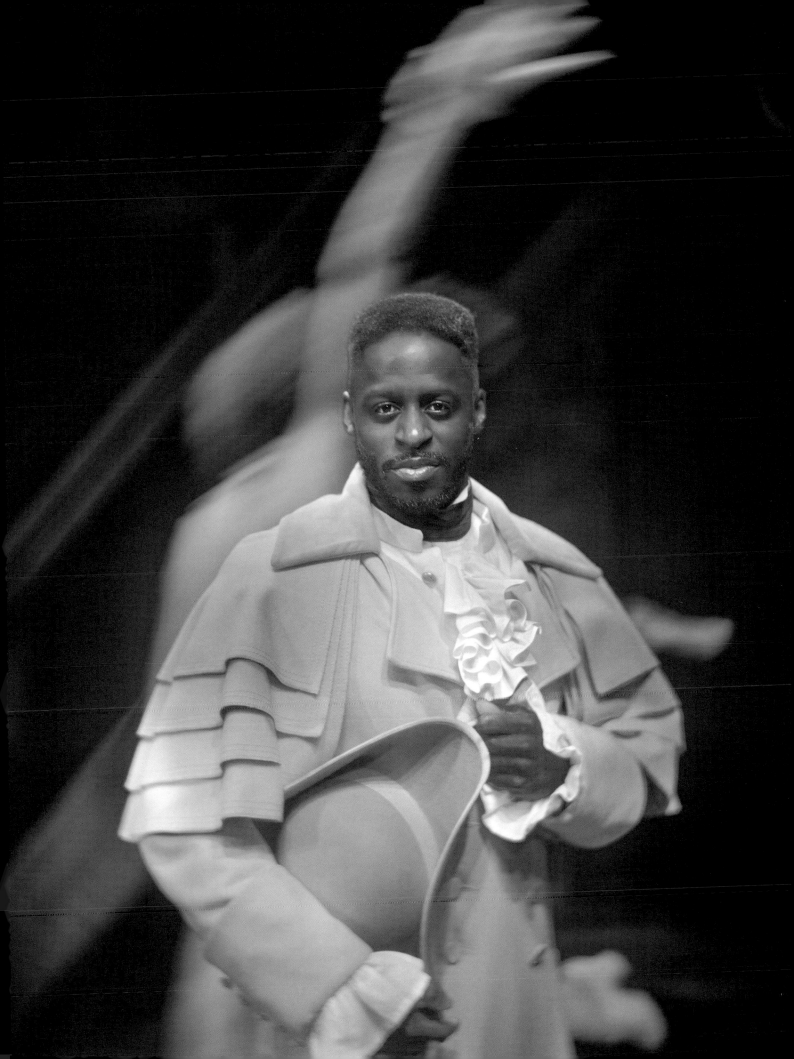

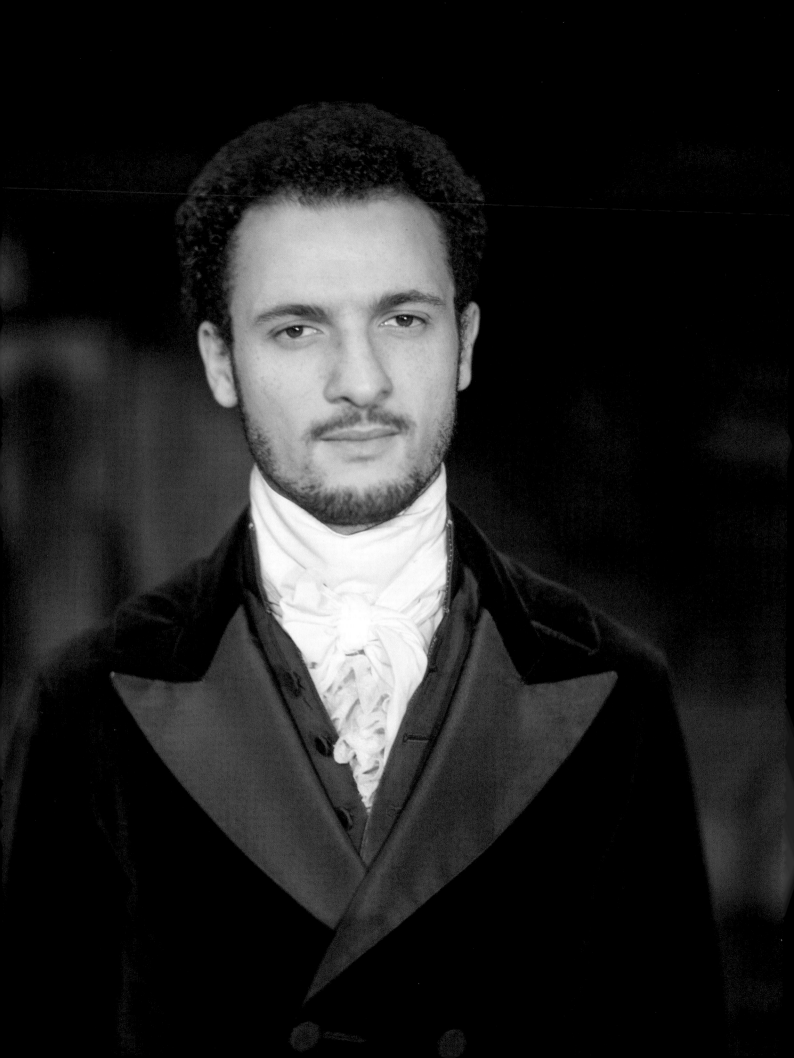

BECAUSE THE LONDON COMPANY
ISN'T NECESSARILY BURDENED BY
HISTORY, THEY PLAY "HAMILTON" AS A
LIGHTER AND EASIER-TO-UNDERSTAND
SHOW. THEY EVEN PLAY IT WITH
AMERICAN ACCENTS, EVEN THOUGH
IN THE PERIOD PEOPLE PROBABLY
SPOKE WITH BRITISH ACCENTS.

—
JL

JAMAEL WESTMAN — *Alexander Hamilton*

LONDON

PHIL COLGAN – *Ensemble*

TOUR

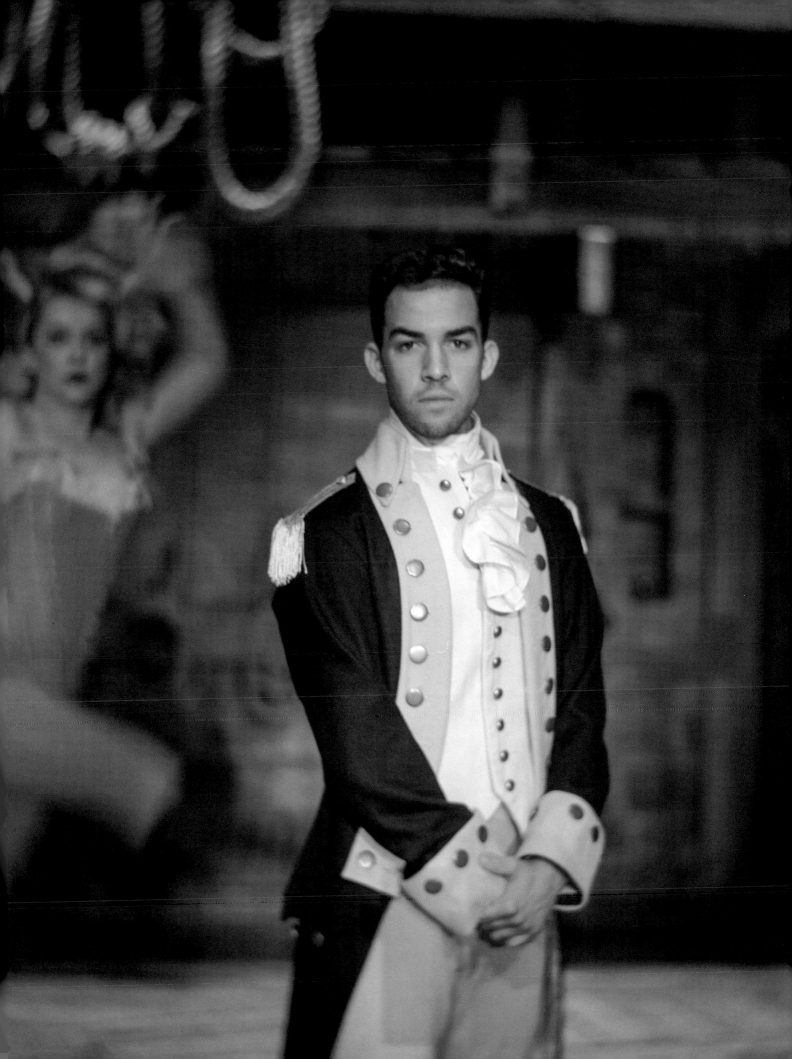

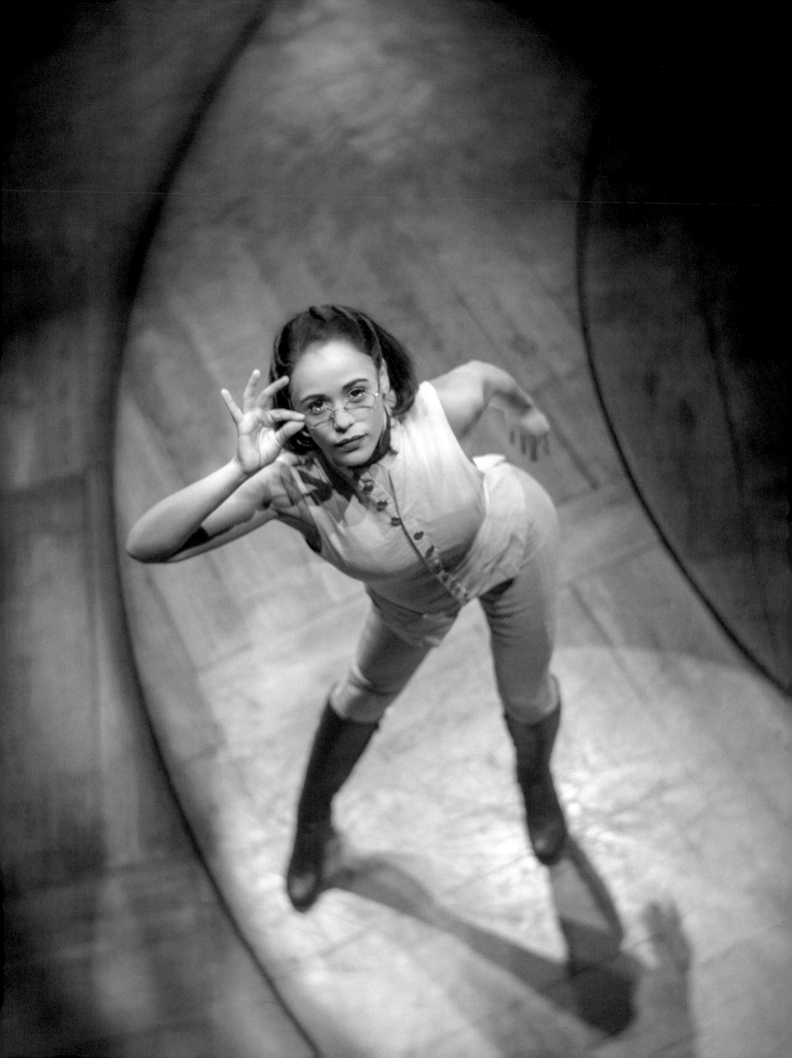

ALEXIA SKY COLON – *Ensemble*

CHICAGO

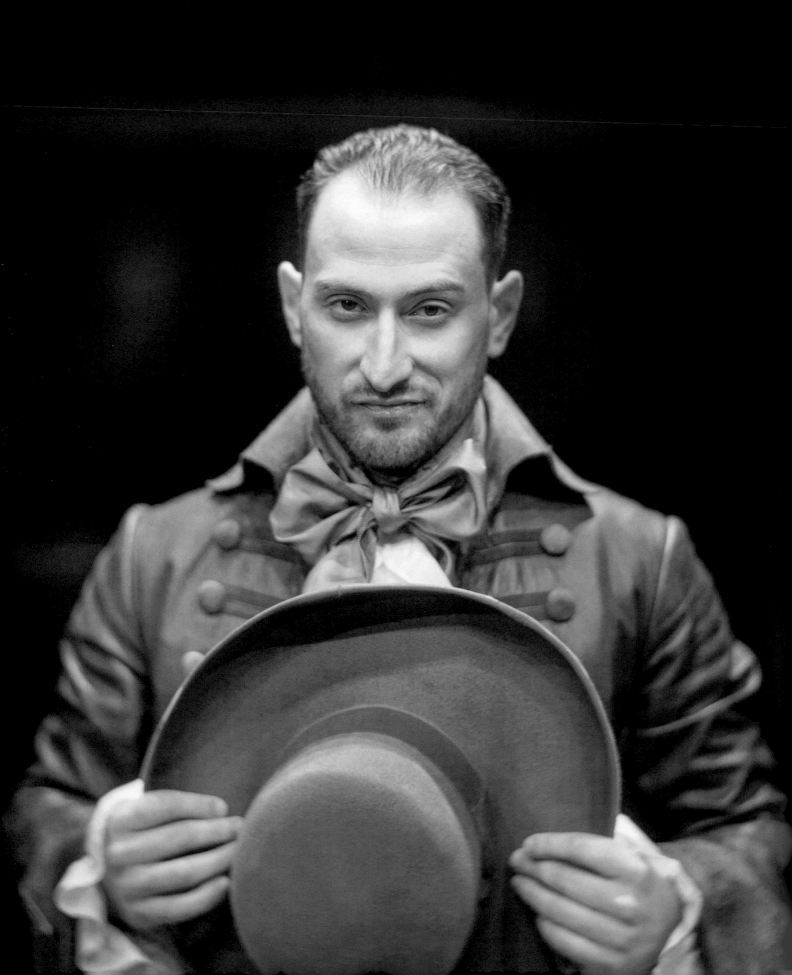

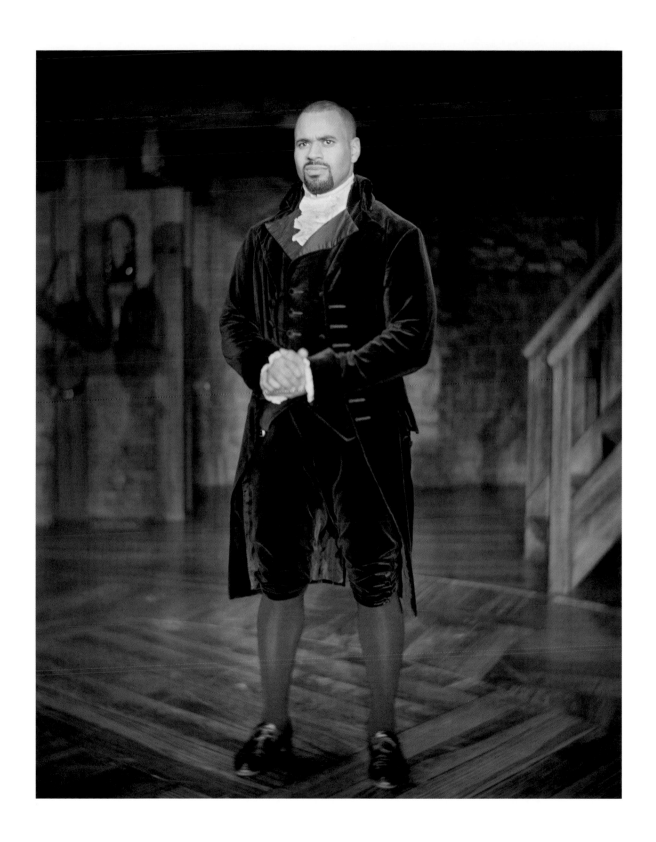

RODDY KENNEDY — *Ensemble*

BROADWAY

OBIOMA UGOALA — *George Washington*

LONDON

LESLIE GARCIA BOWMAN – *Charles Lee*

LONDON

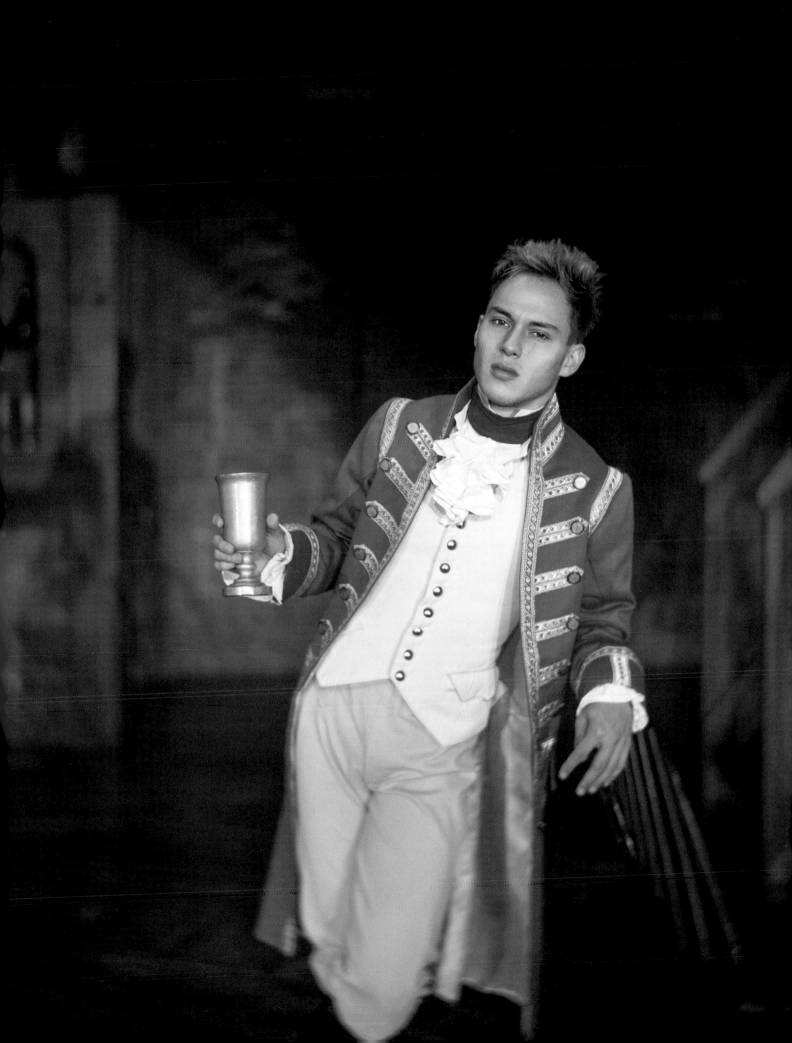

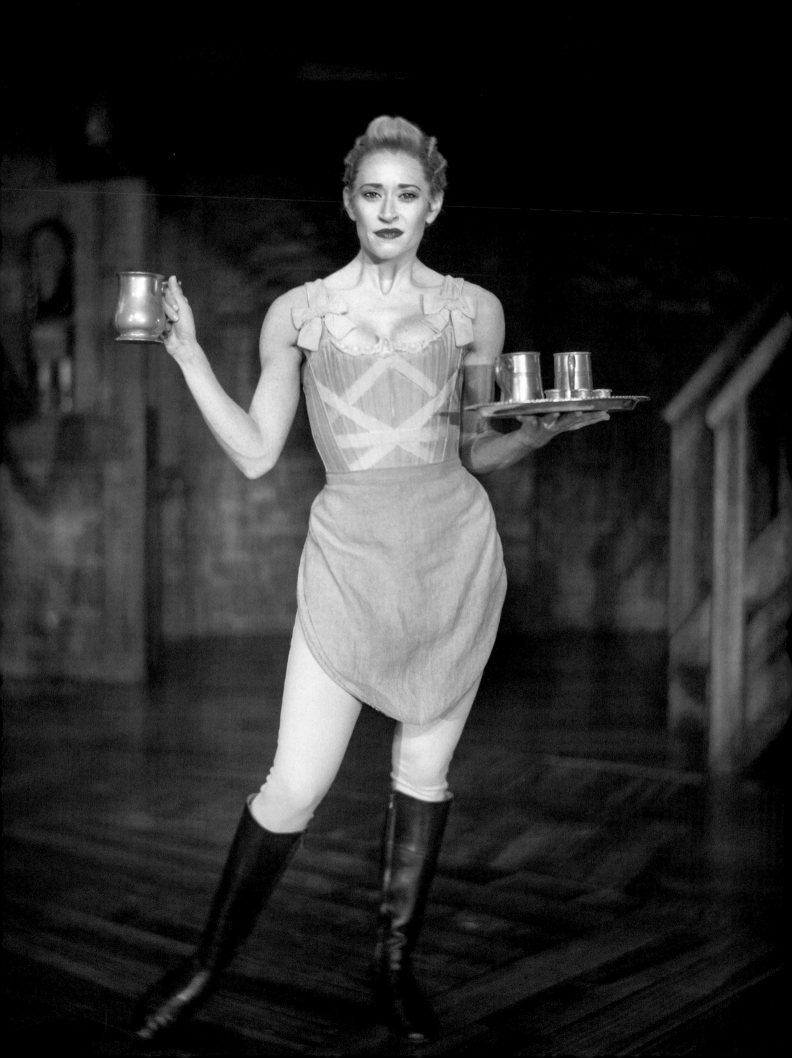

IT'S OVERWHELMING TO THINK OF ALL
OF THE THINGS A BARMAID WOULD HAVE
SEEN AND HEARD IN THE TAVERNS AND
MEETING HALLS OF THAT TIME.

—
JL

KELLY DOWNING — *Ensemble*

LONDON

ANDREW CALL – *King George*

CHICAGO

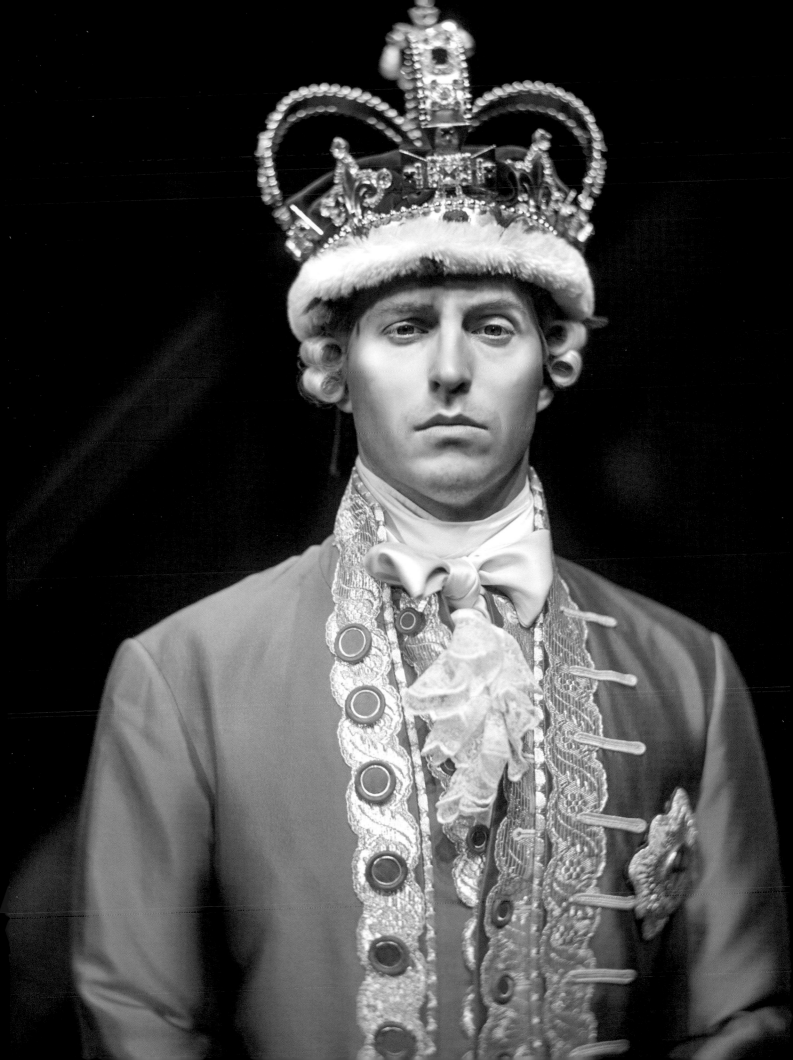

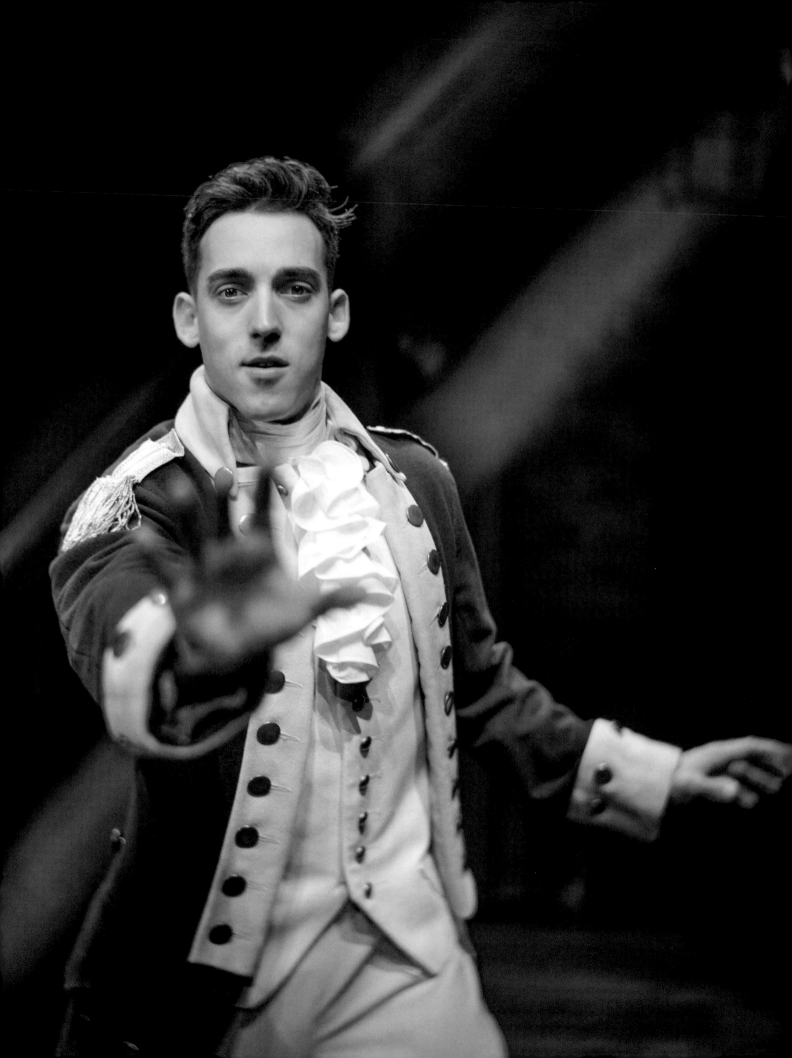

JOHN MICHAEL FIUMARA — *Ensemble*

CHICAGO

AKRON WATSON – *Aaron Burr*

CHICAGO

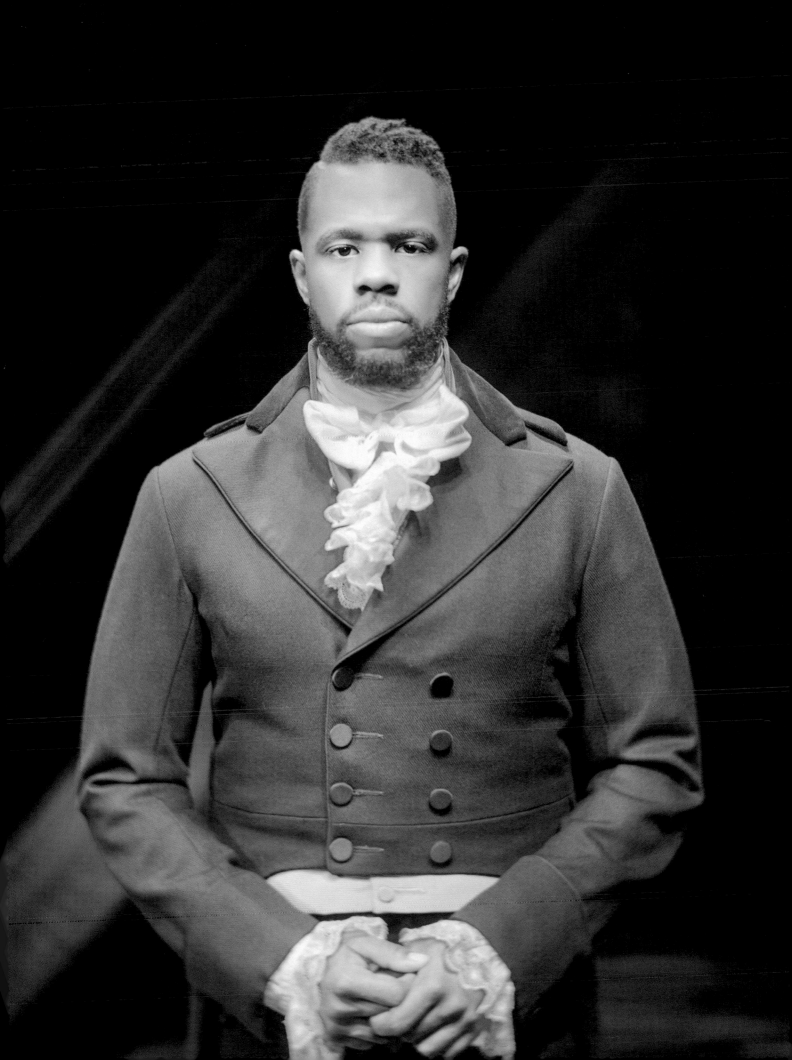

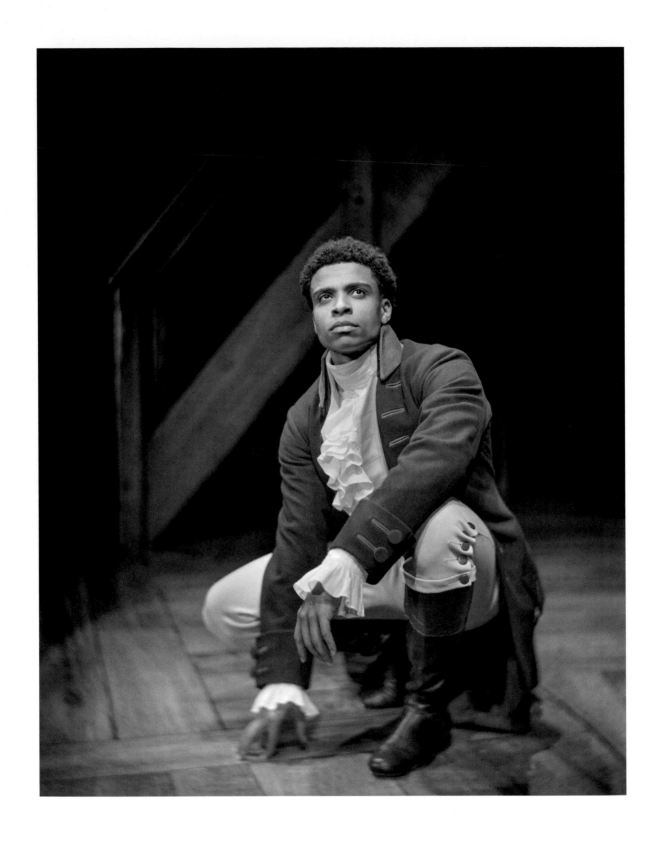

JAMAAL FIELDS-GREEN – *Philip Hamilton*

CHICAGO

JENNIFER GELLER – *Ensemble*

TOUR

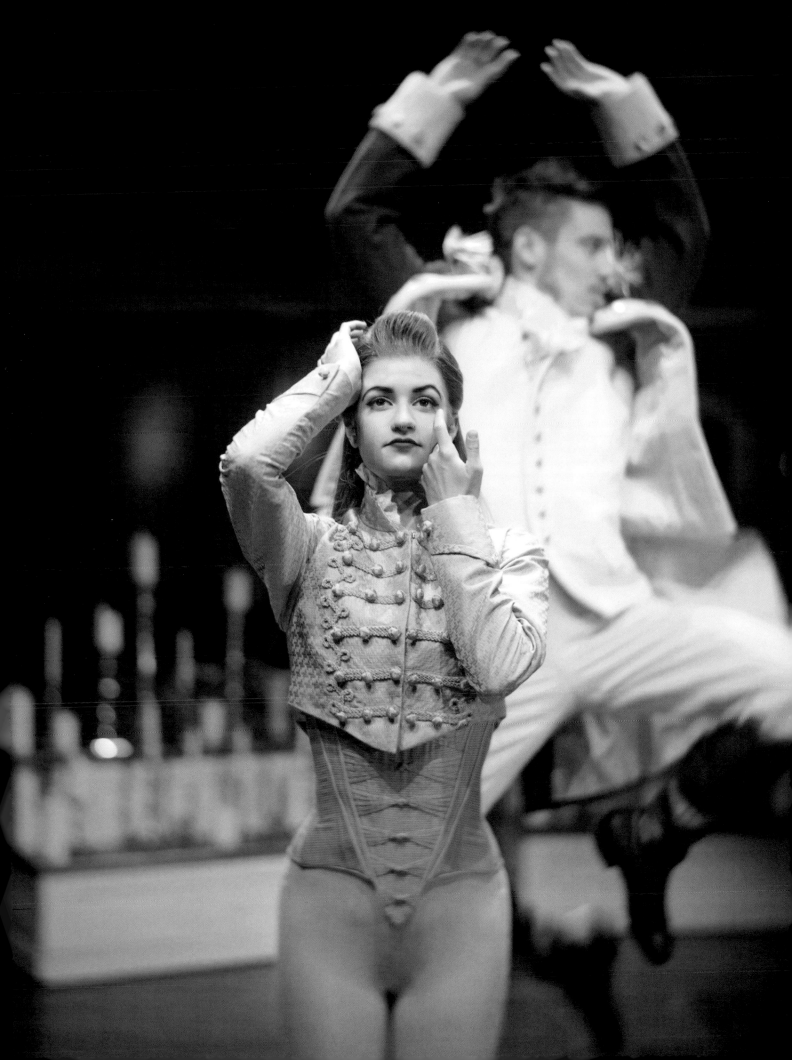

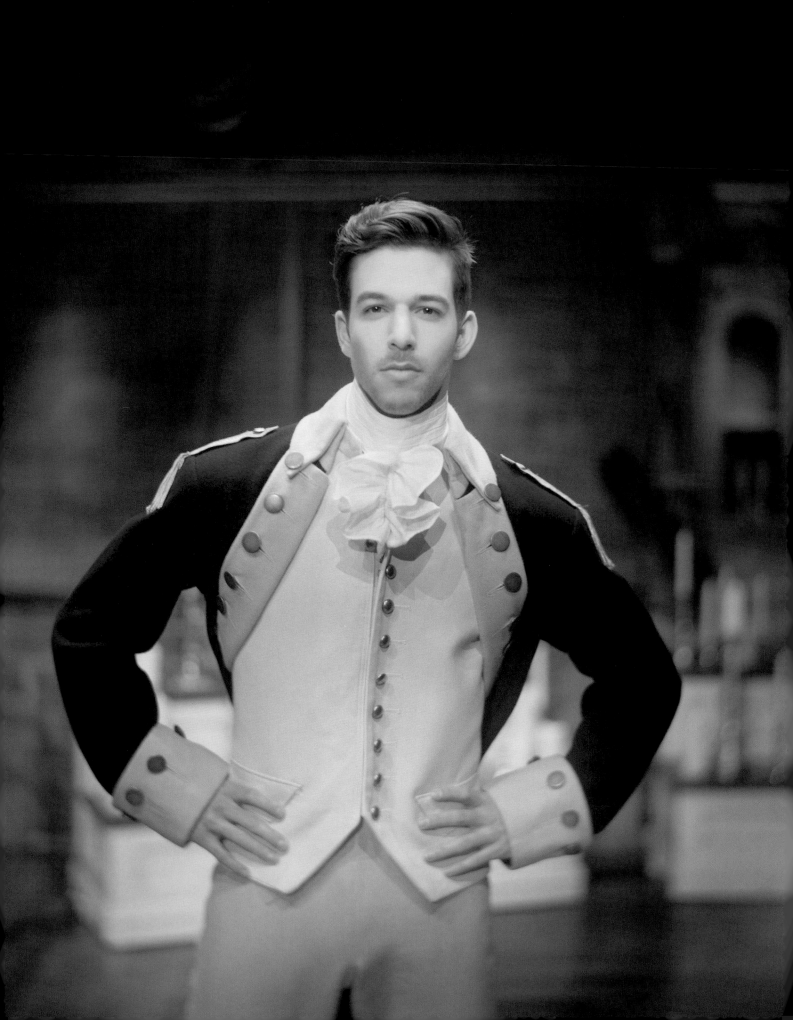

AARON GORDON – *Charles E. Lee*

CHICAGO

JORDAN FISHER — *Philip Hamilton*

BROADWAY

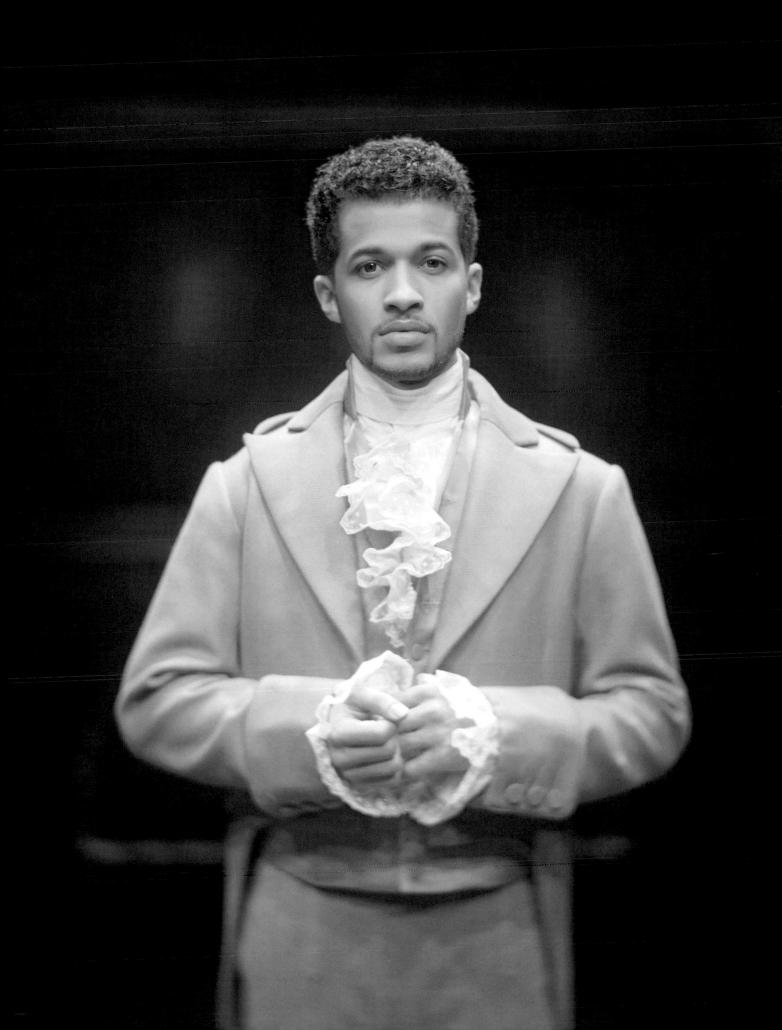

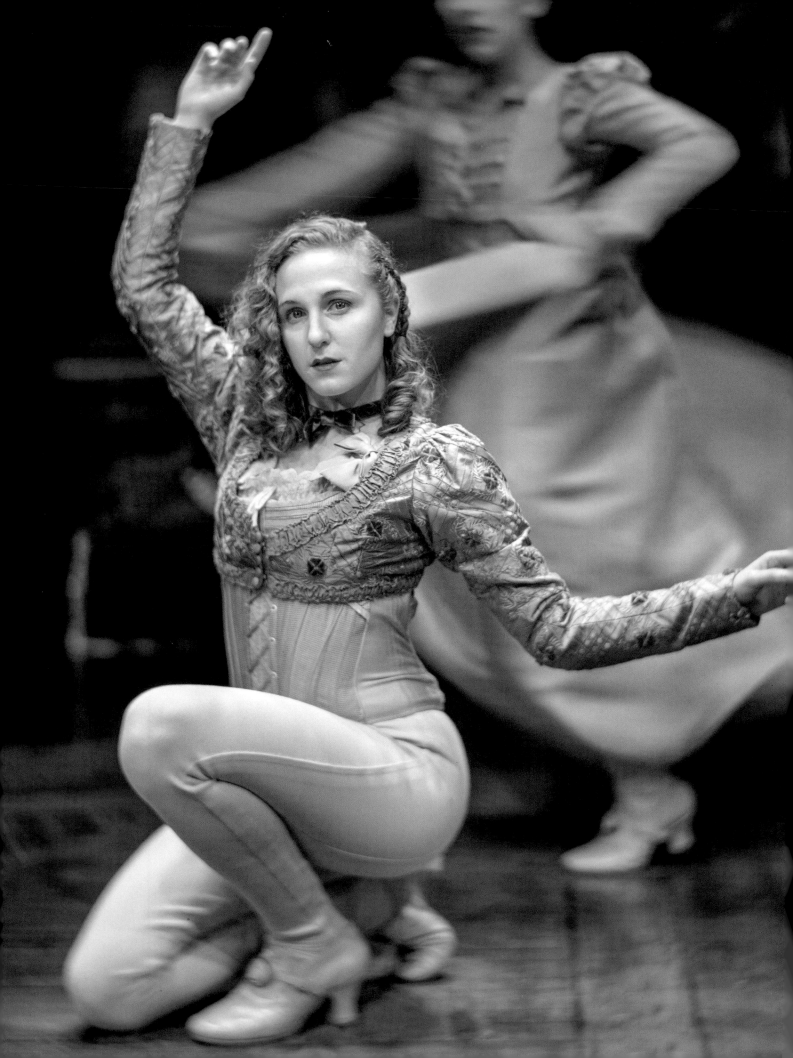

HOPE ENDRENYI — *Ensemble*

BROADWAY

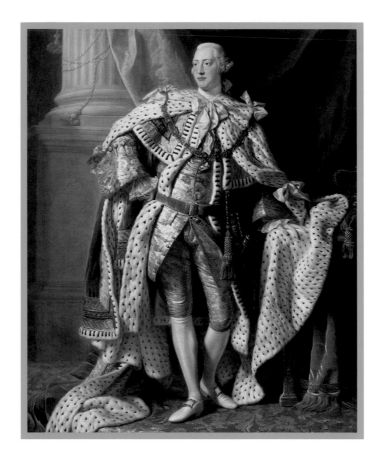

King George. 1765 by Allan Ramsay

MICHAEL JIBSON – *King George*

LONDON

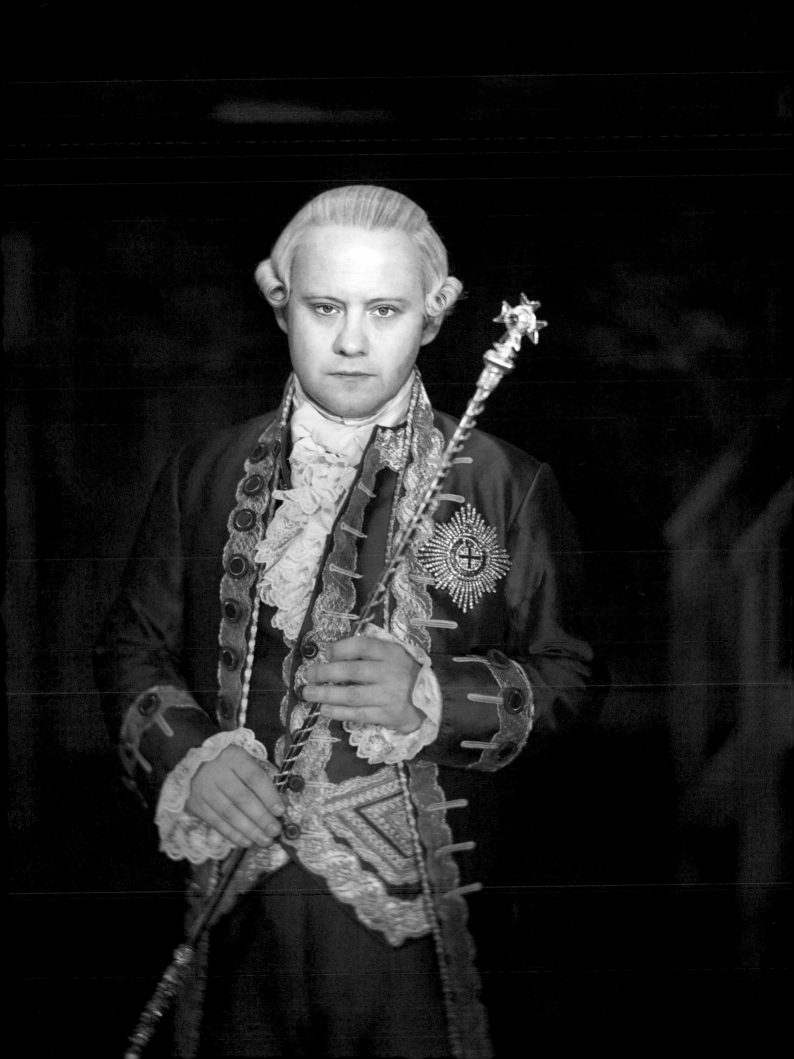

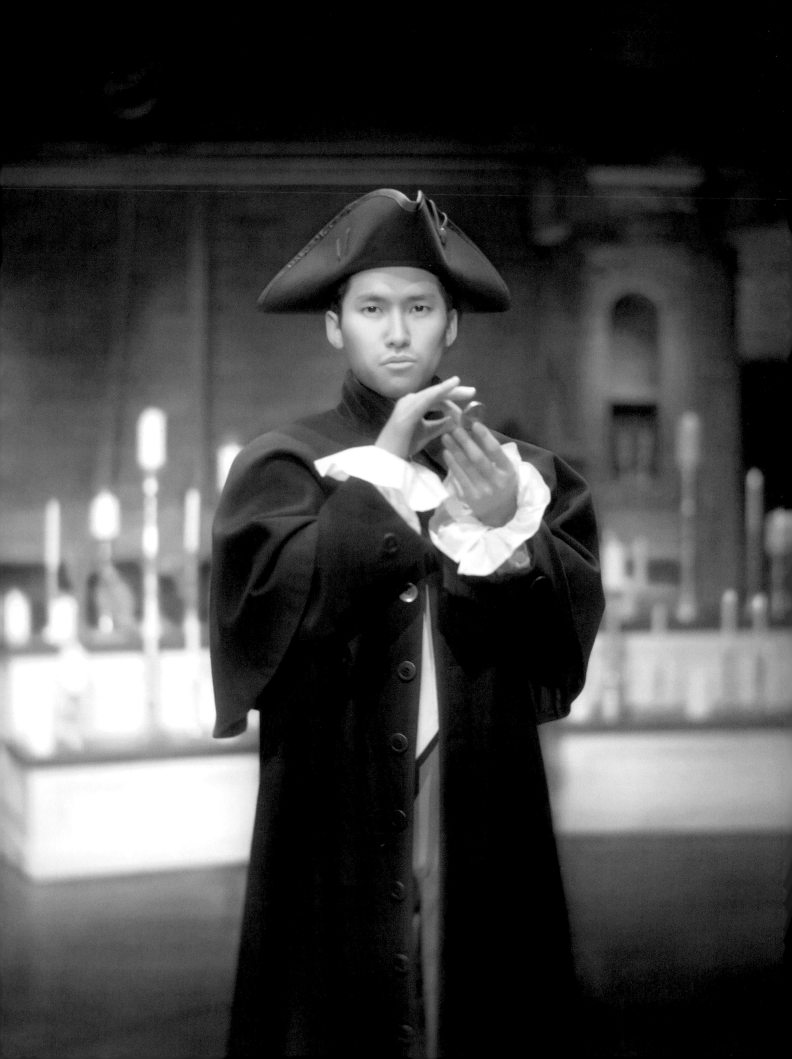

JIN HA *– Ensemble*

CHICAGO

LAUREN KIAS & DESMOND NUNN — *Ensemble*

TOUR

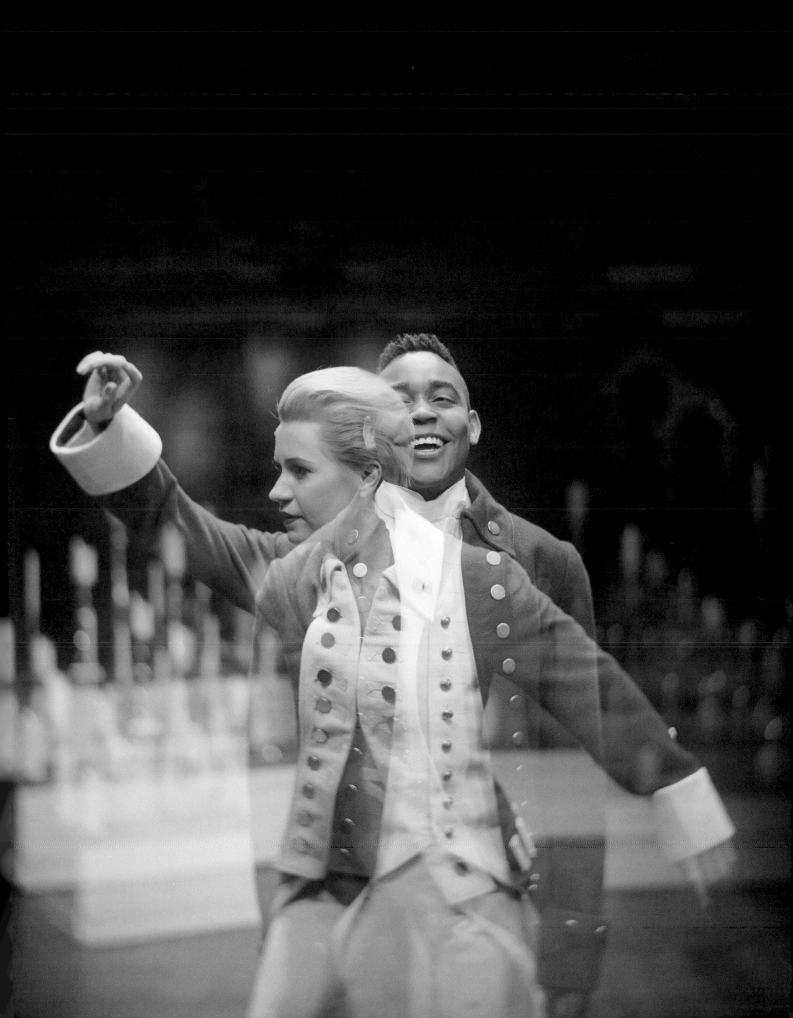

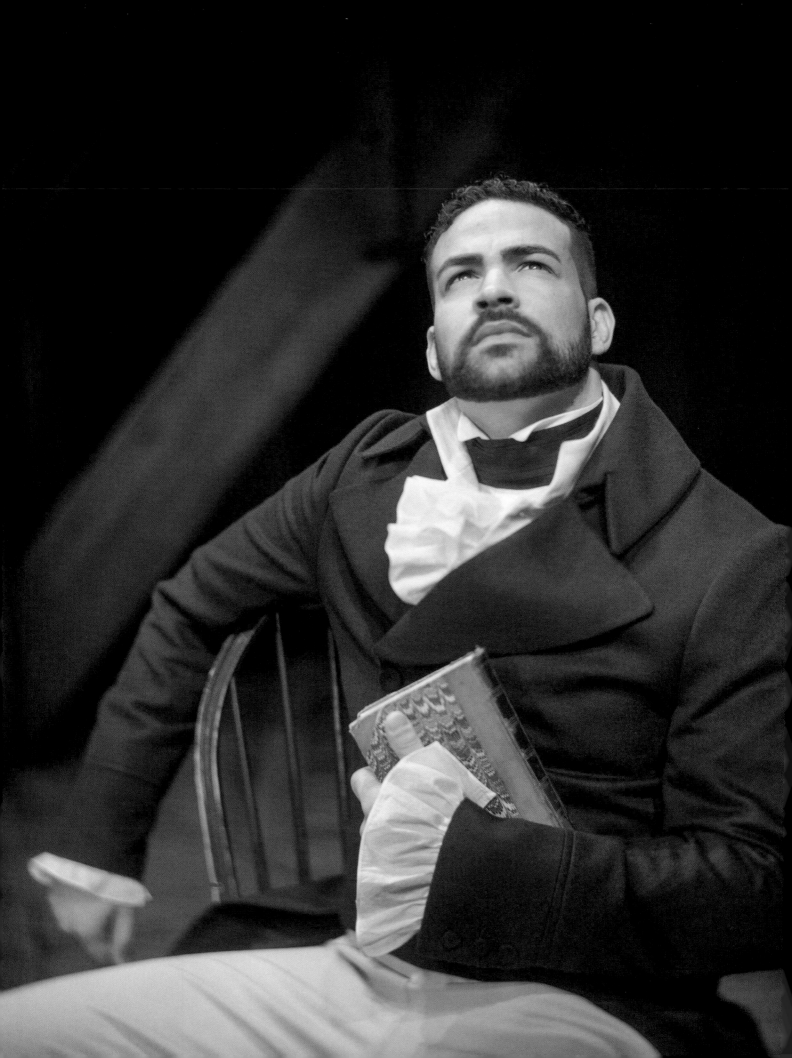

KEITH WEBB – *Ensemble*

CHICAGO

ISAIAH WAS ABLE TO SIGNAL THE
INCREDIBLE BURDEN OF LEADERSHIP
FELT BY WASHINGTON. HE KNELT
BENEATH THE WEIGHT OF BATTLE,
OF PAIN, AND OF HISTORY.

—
JL

ISAIAH JOHNSON – *George Washington*

TOUR

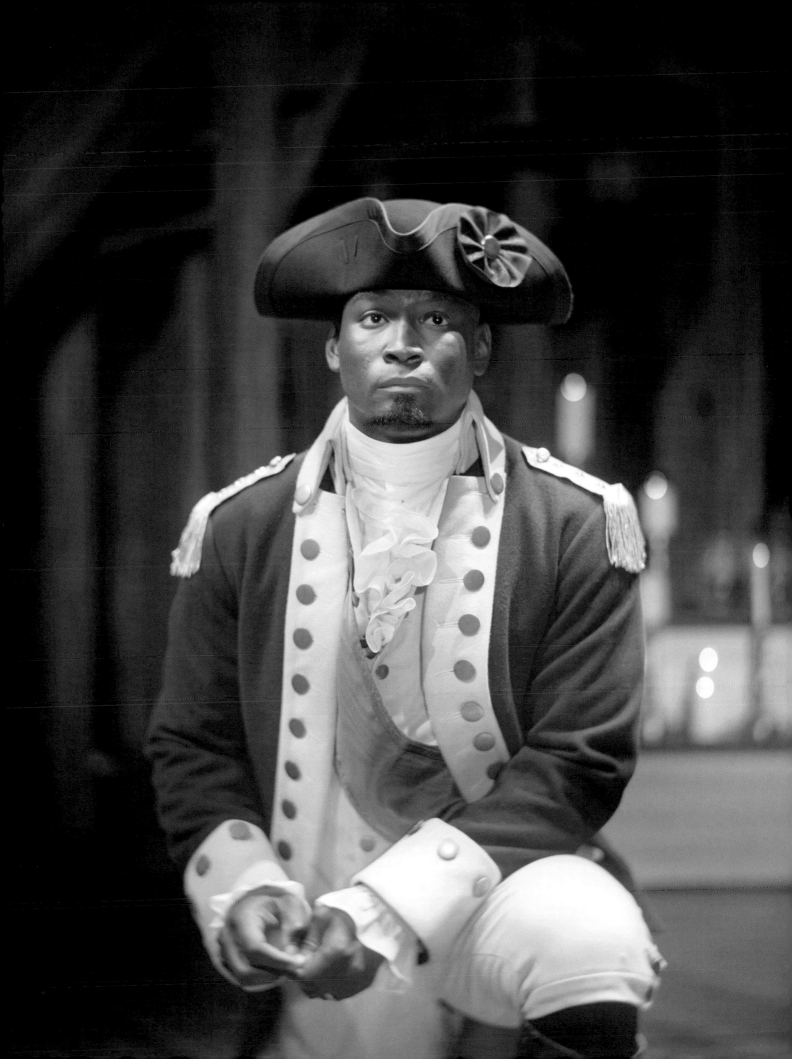

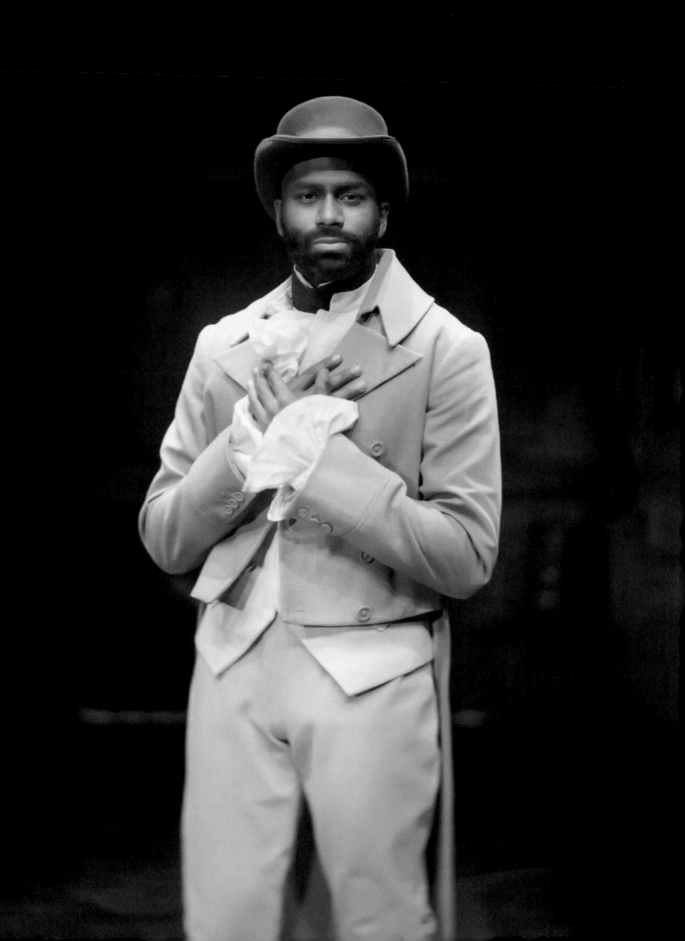

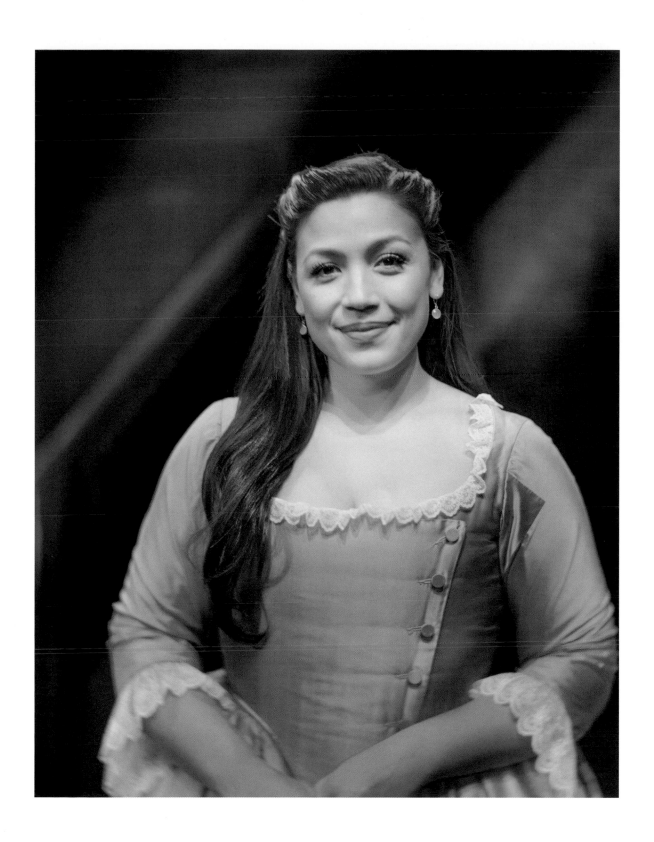

NIK WALKER — *Ensemble*

BROADWAY

JAMILA SABARES-KLEMM — *Eliza Hamilton*

CHICAGO

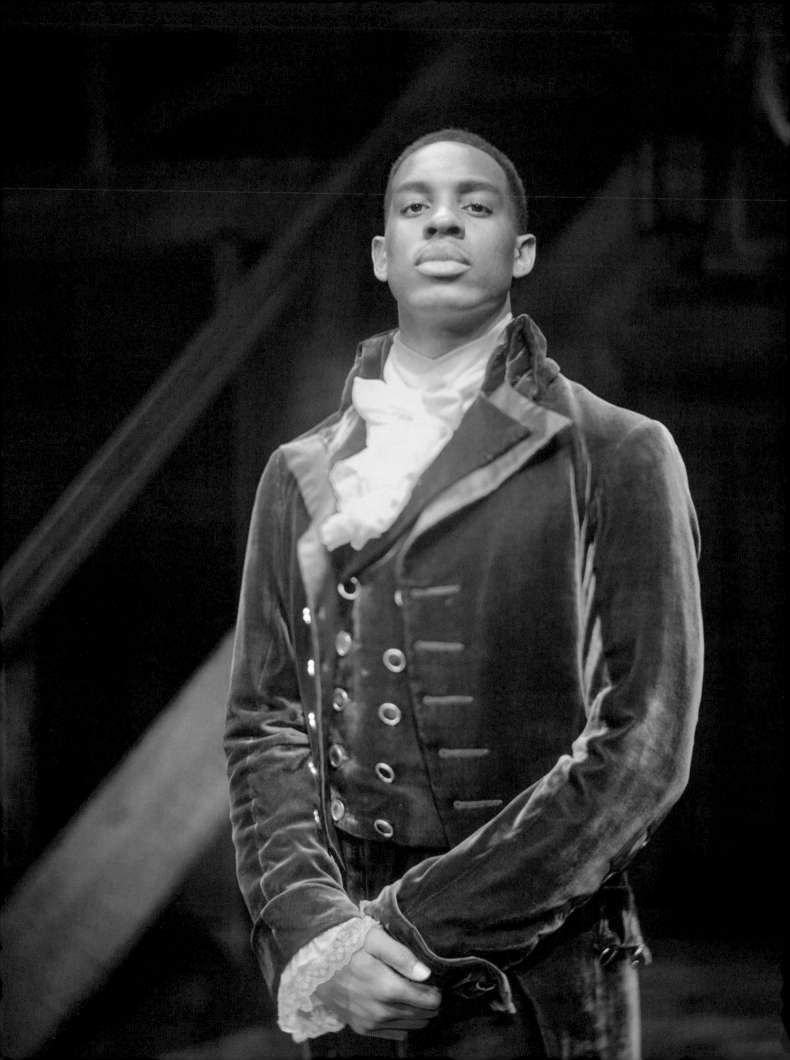

COLBY LEWIS – *Thomas Jefferson*

CHICAGO

ANDREW RANNELLS – *King George*

BROADWAY

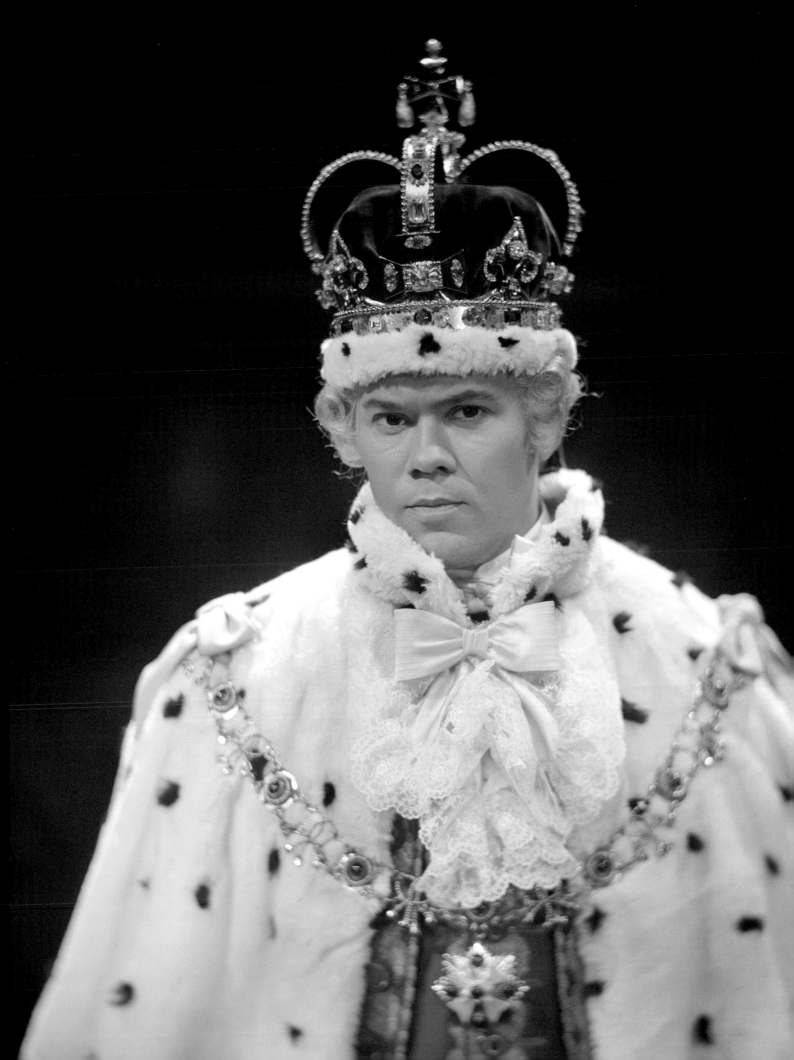

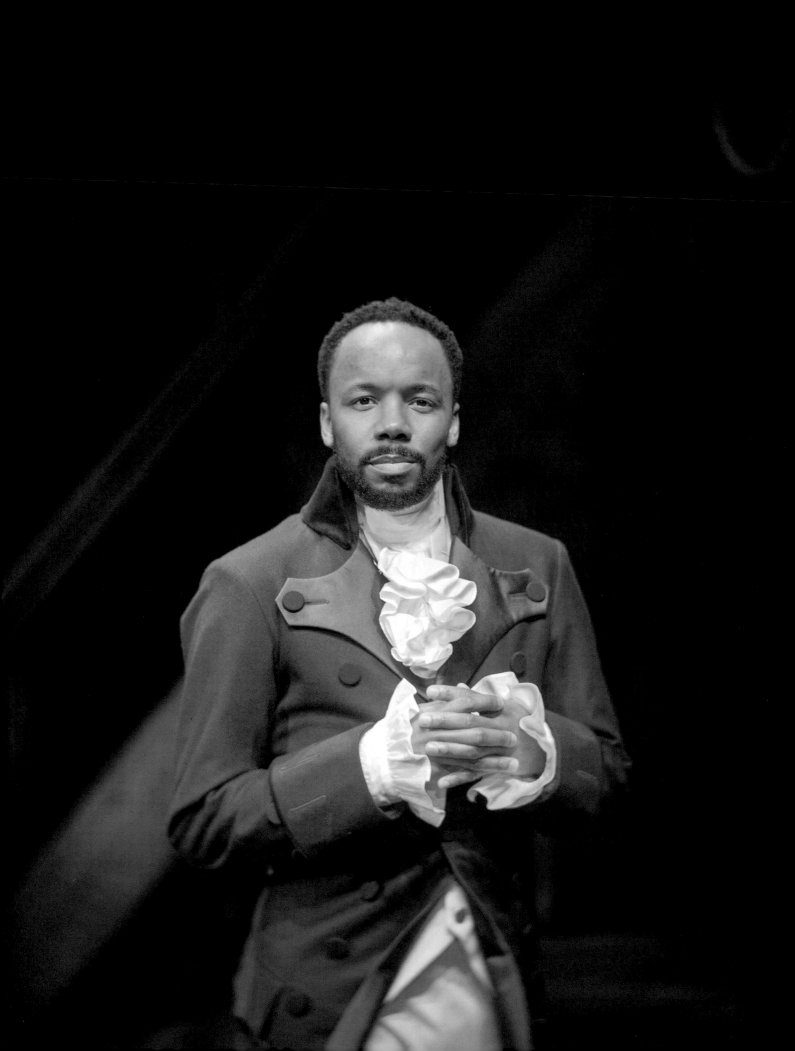

TOMMAR WILSON — *Aaron Burr*

CHICAGO

LILI FROEHLICH — *Ensemble*

TOUR

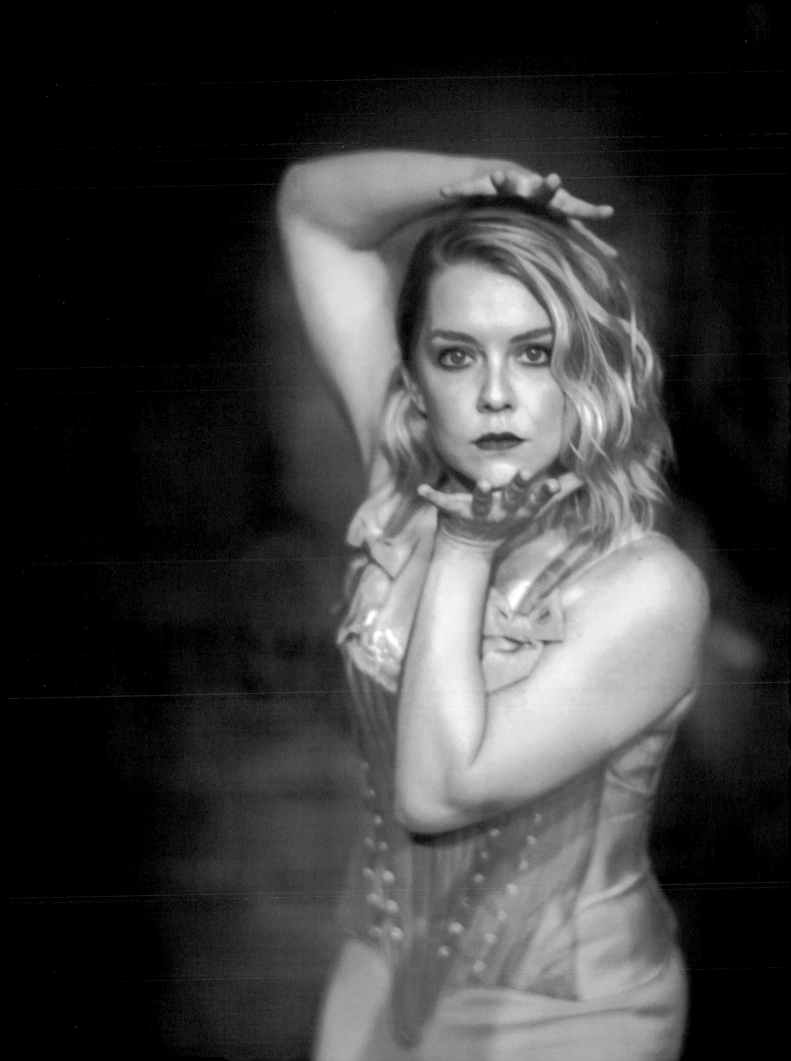

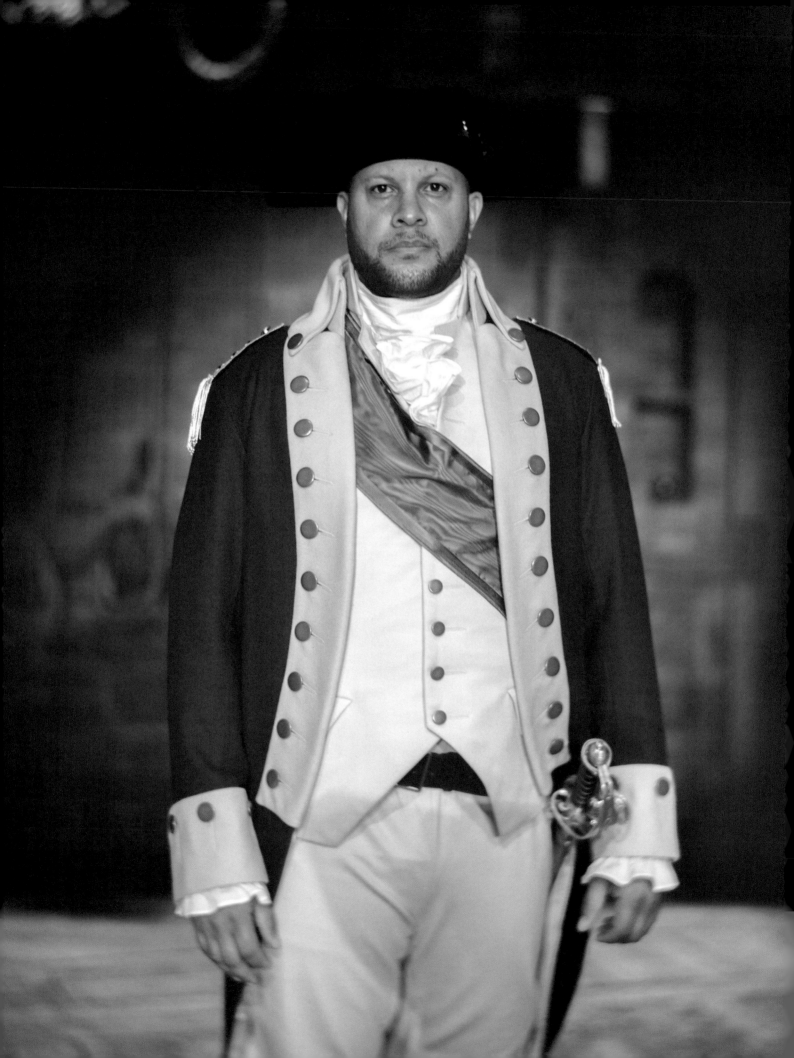

CONROE BROOKS – *George Washington*

TOUR

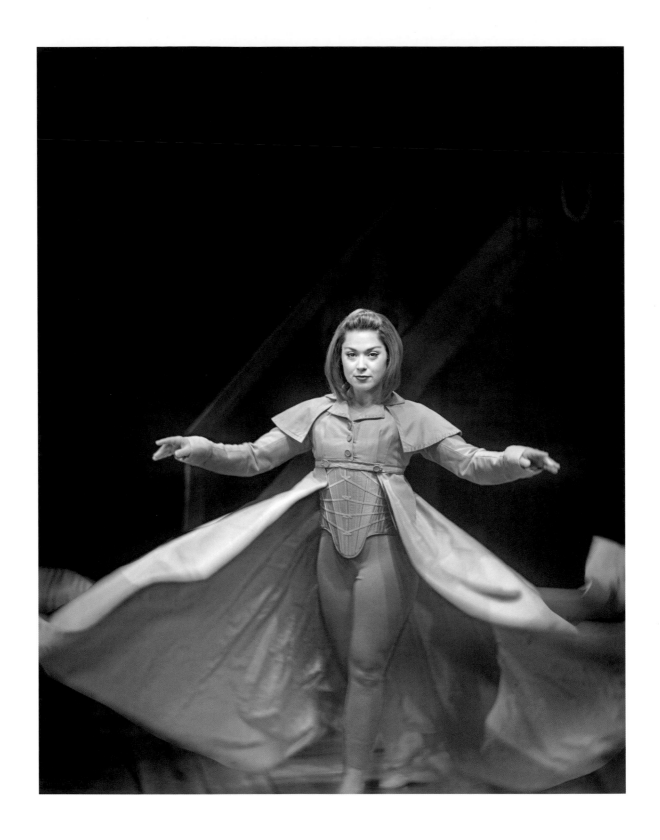

KARLEE FERREIRA — *Ensemble*

CHICAGO

MARCUS CHOI — *George Washington*

TOUR

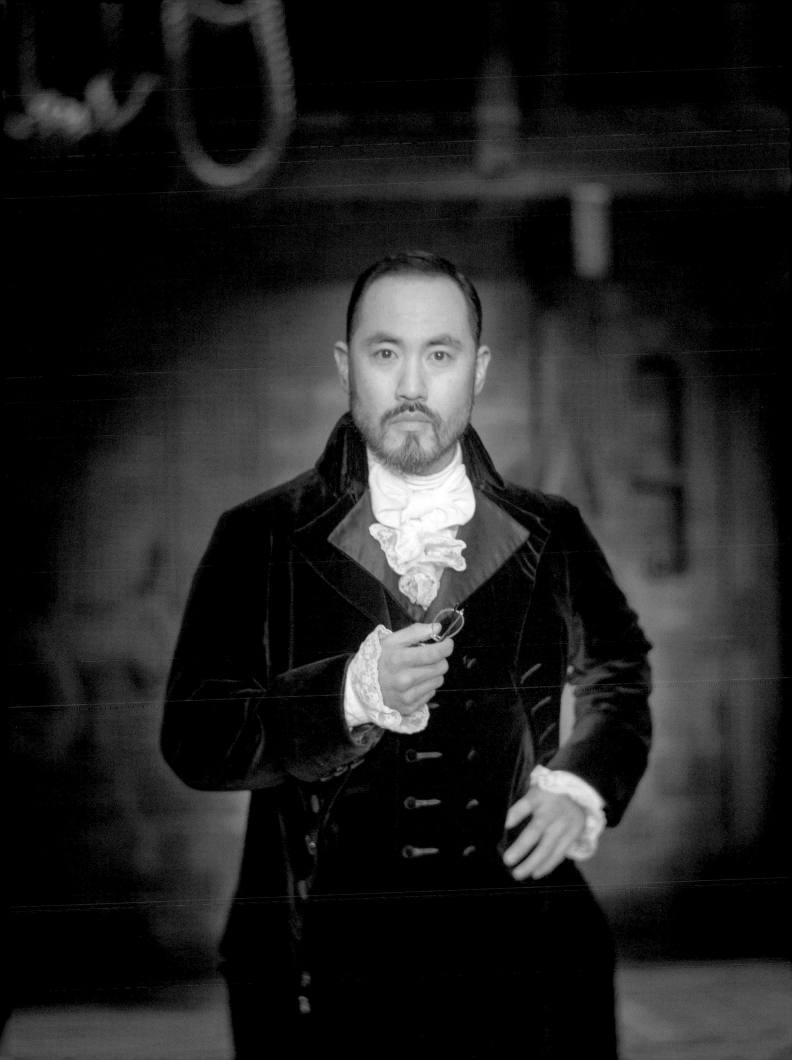

JOHNNY BISHOP – *Ensemble*

LONDON

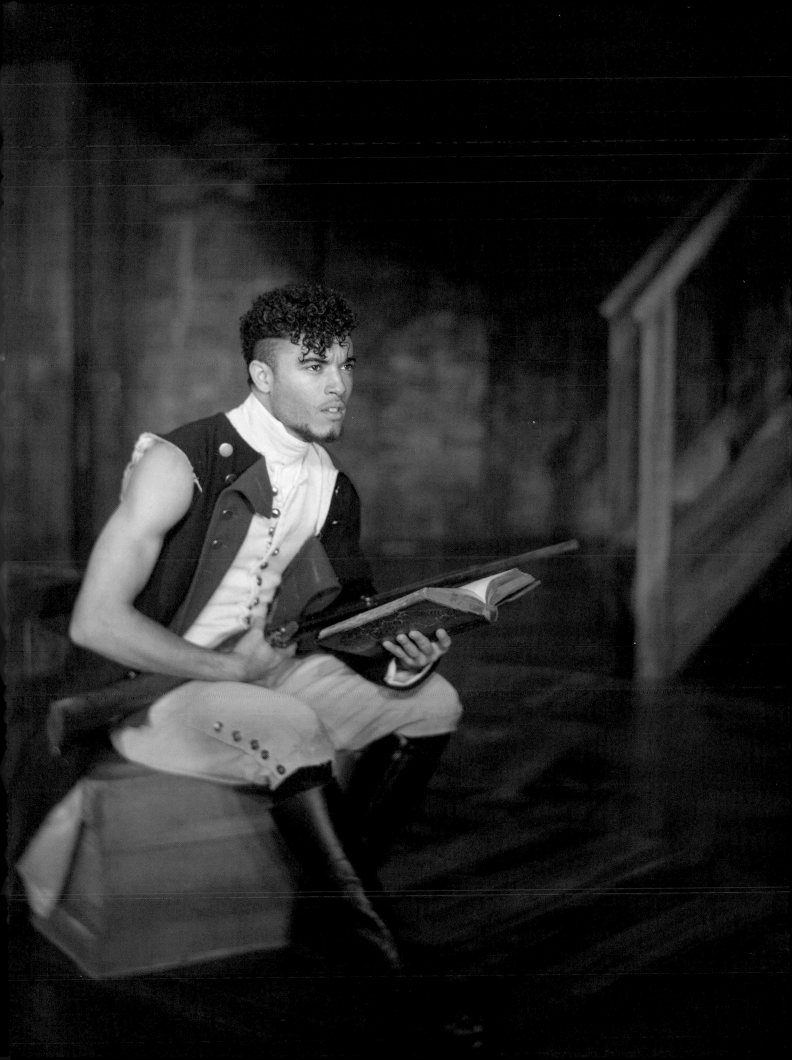

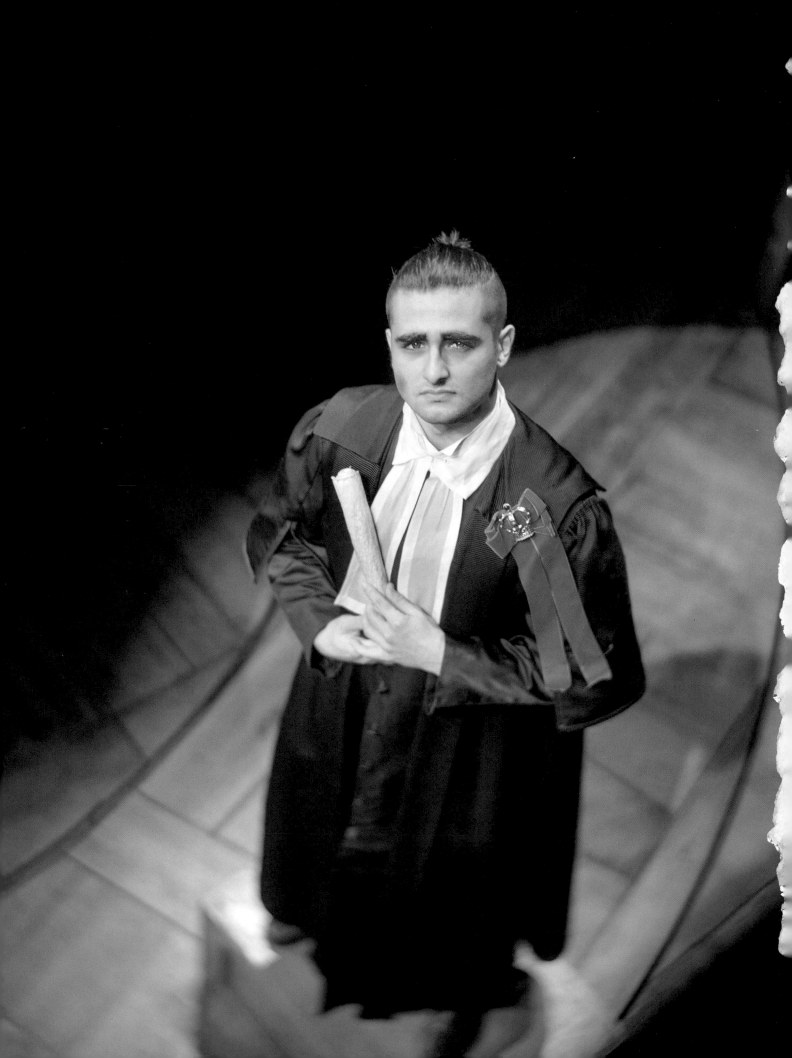

GIUSEPPE BAUSILIO – *Ensemble*

CHICAGO

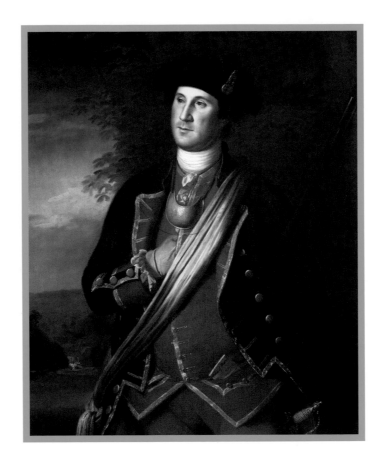

George Washington, 1772 by Charles Willson Peale

BRYAN TERRELL CLARK — *George Washington*

BROADWAY

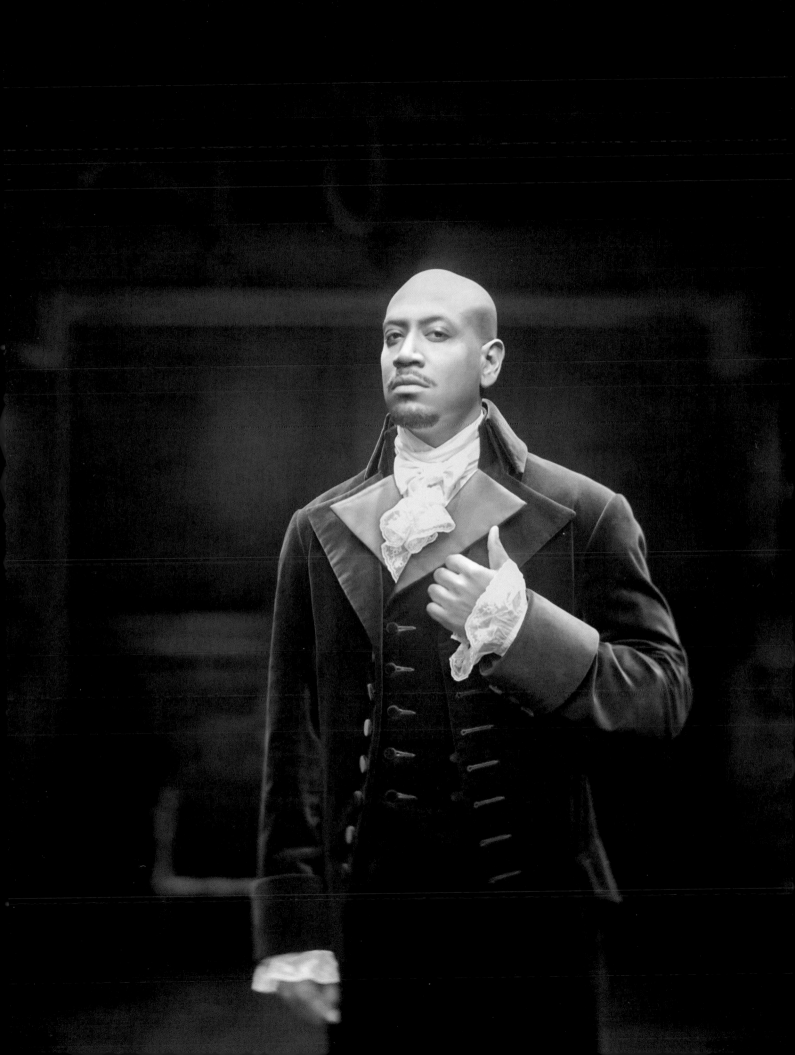

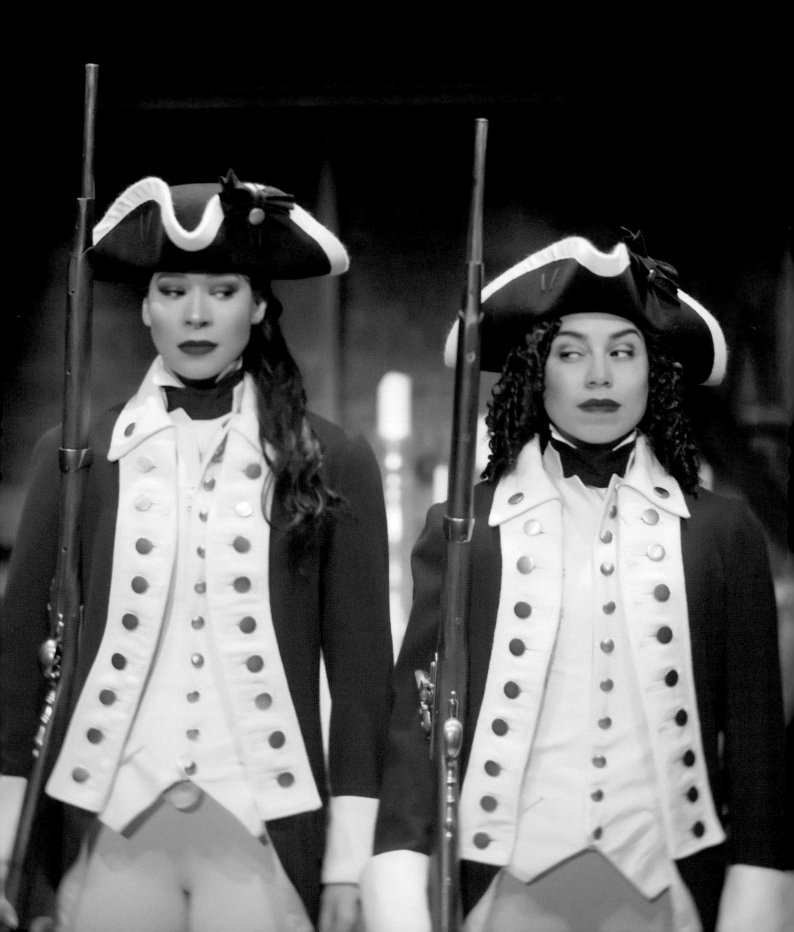

HOLLY JAMES & CHLOË CAMPBELL — *Ensemble*

CHICAGO

JIMMIE "JJ" JETER — *Alexander Hamilton*

CHICAGO

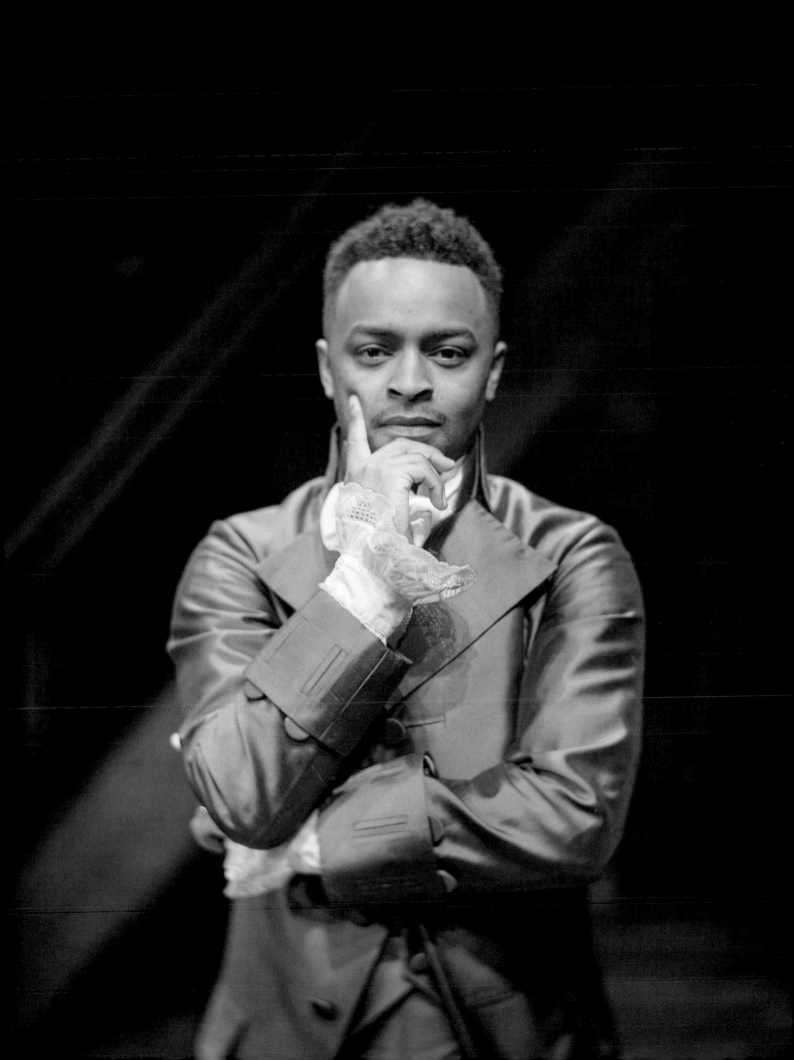

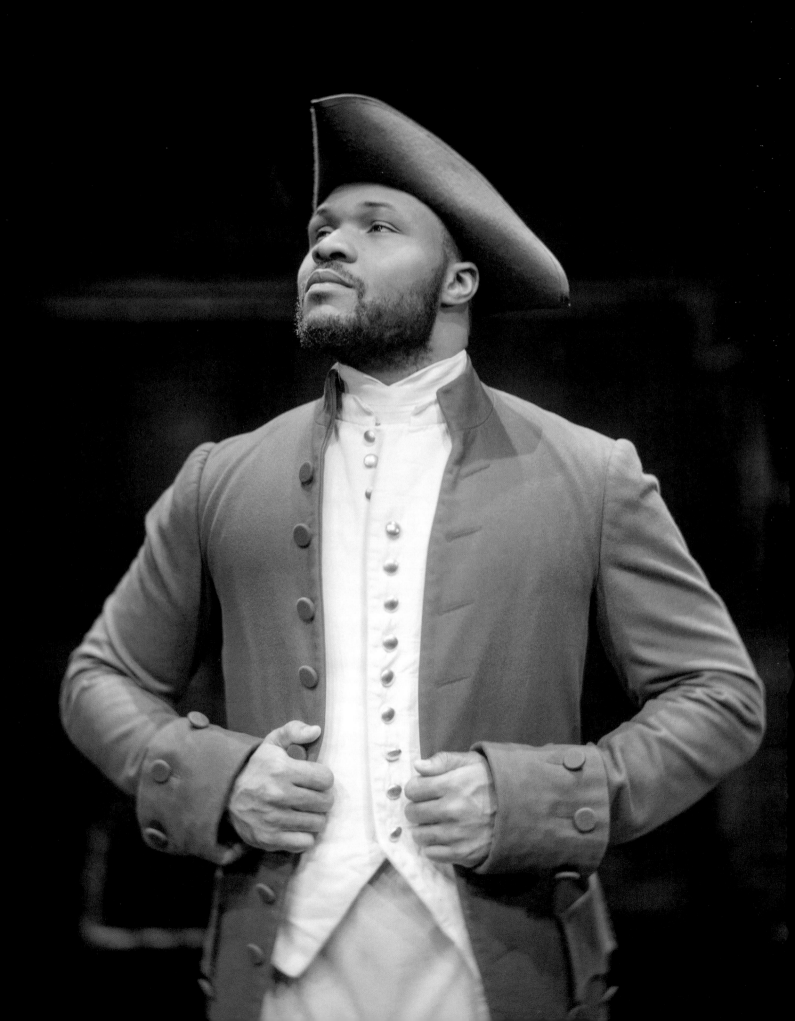

SEAN GREEN JR. — *Ensemble*

BROADWAY

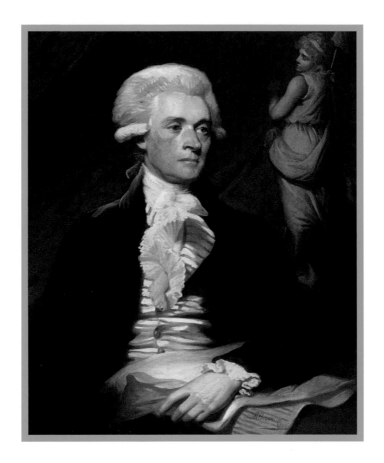

Thomas Jefferson, 1786 by Mather Brown

CHRIS LEE – *Thomas Jefferson*

CHICAGO

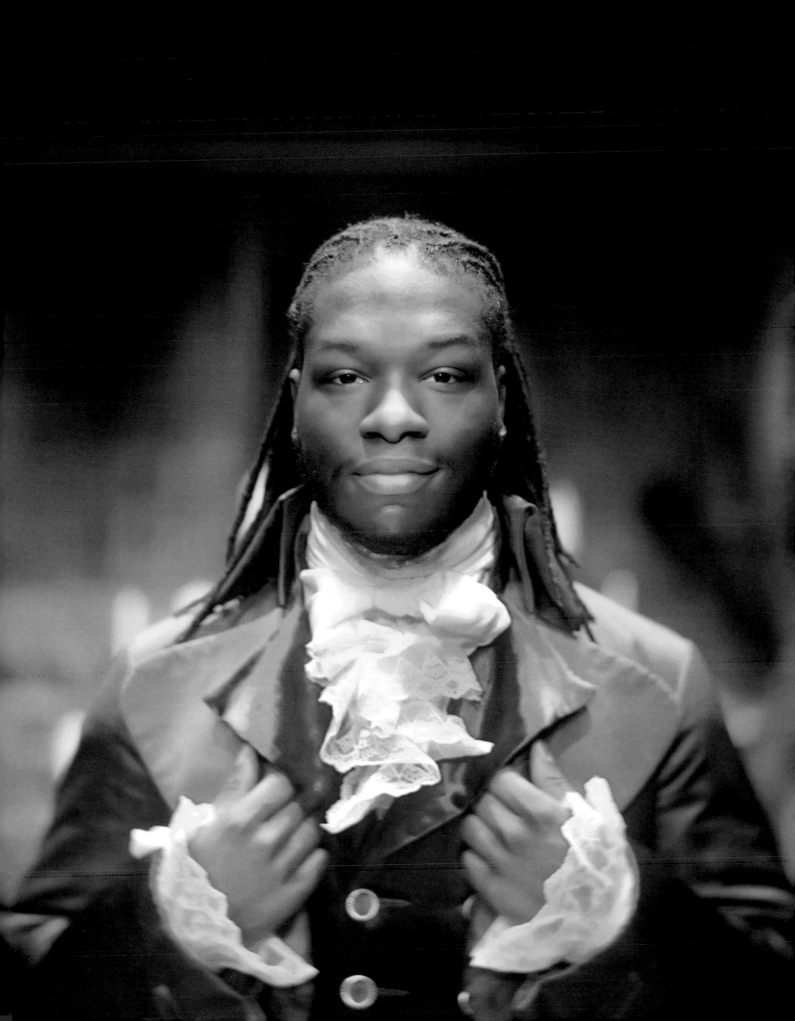

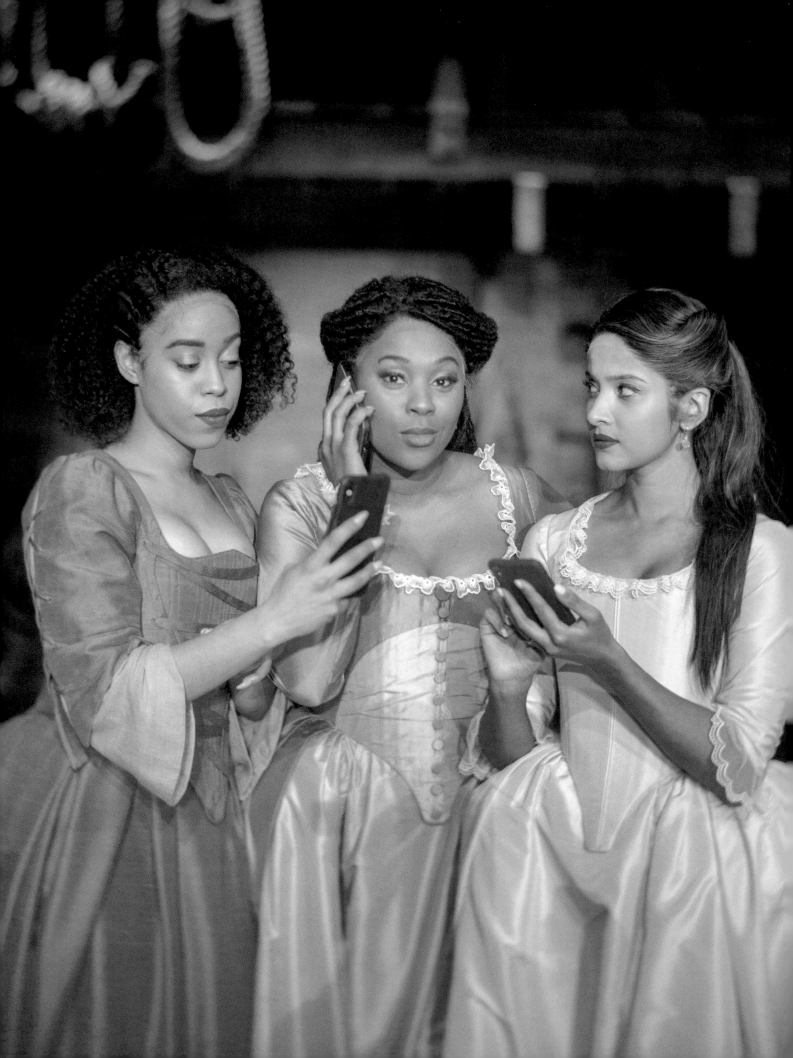

THE MEMBERS OF THE TOURING
COMPANIES ALWAYS STAYED
AROUND THE PHOTO SHOOTS.
THEY BECAME A FAMILY.

—

JL

NYLA SOSTRE, TA'REA CAMPBELL, SHOBA NARAYAN

Peggy Schuyler, Angelica Schuyler, Eliza Hamilton

TOUR

ACKNOWLEDGMENTS

—

Carrying heavy equipment, loading film, mounting cameras onto tripods, focusing a tricky camera, off-loading film in light tight environments, navigating airports, checking into hotels, finding stage doors and camera stores in new towns all require a great deal of assistance, patience and laughter. Thank you Gary Carrera, Phoebe Foley, Roman Barrett, William Killian, Millie Kingsbury, Jai Lennard, and Arion Doer.

Shooting in union theaters got done thanks to Company Managers Kaitlin Fine, Holli Campbell, Justin Gleiberman, Matt Sherr, Roeya Banuazizi, James Viggiano, Ryan Garson, Tyler Siems, Katy Bryant, and especially my dear old friend Brig Birney; Stage Managers J. Philip Bassett, Deanna Weiner, Amber White, Raynelle Wright, Cameron Holsinger, Rolando Linares, Kate Wallace, Sara Gammage, William Collins, Kimberly Fisk, Steve Henry, Katrina Stevens, Daniel S. Rosokoff, Eric Lee Tysinger, Hannah Sullivan, Anna R. Kaltenbach, Garrett Kerr, Jason Goldbourn, and Heather Teasedale.

Thanks to Scott Westervelt and Antoinette Martinez, the wardrobe supervisors who selected, repaired, steamed, cleaned, ironed, and assembled costumes, and the house staff at the Richard Rodgers Theater, included but not limited to: the house manager, Tim Pettolina, electrician Derek Healy, carpenter Kevin Camus, and prop master George Wagner. These photos wouldn't look like much of anything without scenic designer David Korins, Costume Designer Paul Tazewell, lighting designer Howell Binkley and hair and wig designer Charles G. LaPointe.

Thank you for the beautiful shows given for this work by Oskar Eustis at (fittingly) the Public Theater, Diane Rosenstein and her staff at her gallery in LA, and my first loves at PhotoVille.

Thank you, Drew Hodges, for first thinking of the idea to make a calendar featuring my photographs, and to Mike Karns for helping actualize it. Thanks to Robb Pearlman and Charles Miers at Rizzoli, who in addition to publishing the calendar, thought it would be cool to codify my, and everyone's, *Hamilton* experience in a book; and Jacob Wildschiødtz and NR2154 for their beautiful design.

Thanks to film processor LTI, scanner Julie Dunham, and Cooper Winterson at Gerard Franciosa's magnificent, "My Own Color Lab," Jeff Hirsch at Foto Care for his advice, and photo wizard Steve Rifkin of "Hank's Photographic," who made that first batch of gorgeous prints.

Creator Lin-Manuel Miranda, director Tommy Kail, choreographer Andy Blankenbuehler; without you there would not have been any photos to make.

And Jeffrey Seller, without you, I would not want to make anything.

First published in the United States of America in 2019 by
Rizzoli International Publications, Inc.
300 Park Avenue South
New York, NY 10010
www.rizzoliusa.com

Copyright © 2019 Josh Lehrer

Foreword: *Lin-Manuel Miranda*

Preface: *Thomas Kail*

Photographs: *Josh Lehrer*

Publisher: *Charles Miers*

Editor: *Robb Pearlman*

Design: *NR2154: Jacob Wildschiødtz, Elina Asanti,
Rachel Roth, Theresa Grill*

Production Manager: *Colin Hough Trapp*

Managing Editor: *Lynn Scrabis*

Printed in China

2019 2020 2021 2022 2023 / 10 9 8 7 6 5 4 3 2 1

ISBN: 978-0-7893-3680-4
Library of Congress Control Number: 2019942308

Visit us online:
Facebook.com/RizzoliNewYork
Twitter: @Rizzoli_Books
Instagram.com/RizzoliBooks
Pinterest.com/RizzoliBooks
Youtube.com/user/RizzoliNY
Issuu.com/Rizzoli